D0192874

Acclaim for Peter Steinhart's

THE UNDRESSED ART

"Revelatory. . . . Remarkably well conceived and well executed. Steinhart's theme is that drawing is one of the most fundamental modes of human expression. . . . His ability to incorporate numerous sources and diverse topics into a cohesive and pleasurable narrative is one of the most compelling aspects of the book." *—American Artist*

"Engaging. . . . Naturalist and author Peter Steinhart examines not only the impulse to draw, but the nature of drawing and the role it plays in and outside the world of art."
—St. Louis Post-Dispatch

"Skillfully and lovingly draws the reader into an exploration of humankind's urge to illustrate what we see and feel. There is no lecturing in this book. Instead, there is a warm invitation for the reader to form ideas about what art is, why it is created and what it means." *—The Post and Courier* (Charleston)

"Steinhart celebrates the collaboration between artists and models, between the eye and the hand that painstakingly renders the subtle curves of life." *—O, The Oprah Magazine*

"Charming. . . . The powerful urge to pick up a sketch pad is the subject of Steinhart's book, [which is] a tour through the landscape of this passion. We meet the models he draws, visit the classrooms he has sat in, and ponder the books and theories about drawing he has contemplated. . . . Steinhart suspects that there is a bit of the obsession in us all."
—Bloomberg News

"[Steinhart] smartly uses his own experiences [in drawing groups] to consider why drawing for its own sake, especially the act of committing the human figure to paper, so deeply matters, regardless of what style the art world favors."
—*San Francisco Magazine*

"This impassioned book on drawing and the world of the studio . . . will inspire non-artist readers to take up pencil and sketch pad and view the human figure differently—and for veteran drawers, will permit them to read about what they may have felt or practiced in their own studios."
—Artscope.net

"Combining reportorial virtues with the leisurely manner of a confident essayist. . . . Unrushed, yet unflaggingly interesting."
—*Books & Culture*

"A mix of psychology, philosophy and engaging descriptions of what happens between artists and models, between students and teachers and between an artist's brain and his sketch pad."
—*The Arizona Republic*

"*The Undressed Art* is a charming, illuminating study of our impulse to register the world by putting pencil to paper. From a child's drawing of a lopsided house complete with smoking chimney to the nuanced shadings of Thomas Eakins, Peter Steinhart reveals the fascinating workings behind this most unassuming art."
—Billy Collins

Peter Steinhart
THE UNDRESSED ART

Peter Steinhart is a naturalist and a writer. For twelve years he was an editor and columnist at *Audubon*, and his work has appeared in *Harper's*, *The New York Times*, the *Los Angeles Times*, *Mother Jones*, and *Sierra*. He has twice been a finalist for a National Magazine Award, and his essays have been widely anthologized. He has published four books, the most recent of which is *The Company of Wolves*. He lives and draws in Palo Alto, California.

THE UNDRESSED ART

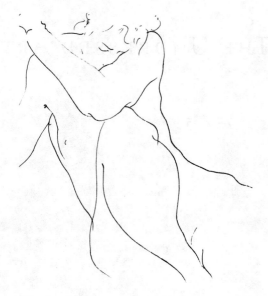

Ann Curran Turner, "Gesture"

THE UNDRESSED ART

Why We Draw

Peter Steinhart

VINTAGE BOOKS
A Division of Random House, Inc.
New York

FIRST VINTAGE BOOKS EDITION, SEPTEMBER 2005

Copyright © 2004 by Peter Steinhart

All rights reserved. Published in the United States by Vintage Books,
a division of Random House, Inc., New York, and in Canada by
Random House of Canada Limited, Toronto. Originally published
in hardcover in the United States by Alfred A. Knopf, a division of
Random House, Inc., New York, in 2004.

Vintage and colophon are registered trademarks of Random House, Inc.

Grateful acknowledgment is made to The Penguin Group (UK) for
permission to reprint excerpts from *The Letters of Vincent van Gogh*, edited
by Ronald de Leeuw, translated by Arnold Pomerans (Penguin, 1996).
Translation copyright © 1996 by Arnold Pomerans. Reprinted by
permission of The Penguin Group (UK).

The Library of Congress has cataloged the Knopf edition as follows:
Steinhart, Peter.
The undressed art : why we draw / Peter Steinhart.—1st ed.
p. cm.
Includes bibliographical references.
1. Drawing. I. Title.
NC720.S73 2004 2003065652
741.2—dc22

Vintage ISBN: 1-4000-7605-6

Book design by Soonyoung Kwon

www.vintagebooks.com

Printed in the United States of America
10 9 8 7 6 5 4 3 2

Contents

THE UNDRESSED ART

Eleanor Dickinson, "Yoshio"

Allure

Eleanor Dickinson's line is lively and lyrical, a flute passage from Vivaldi, confident and sunny. It flows from the end of her felt-tip marker in curls and ribbons to divide form from formlessness, to mark the places where light glances and clings, to define the subtle curves of life. It is a remarkably supple and observant line, full of information, full of understanding of how a wrist arcs or a finger bends, broad where shadows collect, finer as light intensifies, broken and invisible where light dazzles. It comes into a kind of miraculous life, born from the tip of the pen bold and finished, yet continually moving, continually revealing and describing: the back of a middle finger folding delicately away from the light, rounding down and darkening to the fingertip, then turning sharply where its contour meets the last knuckle of the index finger, now thin again in the light, down again to the index finger's rounded tip. By and by, a hand—or its contour—has appeared on the paper, and to my eye it has the exact proportion, the weight, the texture, the strength, the experience, the life of the hand across the room.

The hand across the room belongs to Yoshio Wada, a small, seventy-eight-year-old Japanese-born man with stooped shoul-

ders, strong sinewy legs, close-cropped gray hair and a red and weeping blind eye. He is seated on a faded beige divan that angles out from the wall of what used to be the dining room in Dickinson's 120-year-old San Francisco home. Behind the divan are cloths and draperies pinned to the wall to provide a backdrop for the model at Dickinson's weekly drawing-group sessions. Wada is lit from one side by three floodlamps clamped at various heights to a stand. His right side is washed in yellow light, his left fades into shadow.

The seventy-eight-year-old model is nude. He is not seductive, not in any way Rabelaisian. His body has a seriousness, a dignity, a flawed but compelling humanity. It tells a story. As a young man at the outset of World War II, Wada had been interned with his family in a series of relocation camps in the American West. He had hoped to become an artist, but his drawing materials were taken from him. At the conclusion of the war, he was deported to Japan, where he had no family to take him in, and for two years he wandered the streets of Tokyo, looking for food. Eventually, an aunt who had remained in the United States arranged for him to be returned to California. He enlisted in the United States Army, but he was not permitted to touch a gun, so he became a medical corpsman. After that, for thirty years he worked in San Francisco as a hospital orderly. In his sixties, he took up watercolor painting. Unable to enroll in local art schools, he began modeling, because it was a way to eavesdrop on the instruction art teachers gave at those schools. Without knowing any of his personal history, the six artists who form a ten-foot semicircle around Wada are busily drawing his pain, his determination, his glacial patience and battered wisdom.

Dickinson lifts the marker tip from the paper, sits back and looks at the drawing. At seventy she gazes through alarmingly big eyeglasses—lenses the size of tea saucers, behind which her eyes are searching and impassive, perhaps the eyes of a surgeon.

Shocks of dyed white and red hair drop over one side of her forehead, small exclamatory marks above an otherwise unconfiding face. She dresses in gypsy mode, favoring full-cut, dark-colored prints and the sturdy, comfortable shoes of one who works standing up. She is not given to lavish smiles or quick laughter. She doesn't offer unbidden opinions. She conveys the impression that all her attention is directed outward, that she has no self-consciousness at all. It is a characteristic I think I see in other artists in drawing groups, and I wonder whether it expresses a kind of selflessness or, just the opposite, is a mask designed to cover an overly sensitive self-consciousness.

Dickinson is one of the deans of figurative art in the San Francisco Bay Area. She has taught drawing at the California College of Arts and Crafts (now called the California College of the Arts) for thirty-three years, and her work is represented in many museums and private collections. The state of Tennessee is honoring her as a native daughter of rare artistic accomplishment with a retrospective exhibition in Nashville. She is always teaching, leaning over to look at my drawing, reminding me to measure, suggesting I leave some lines out or place the figure more effectively on the page.

She holds up her pen and uses it to measure off proportions on Wada's figure. Then she holds the pen over the drawing to mark off the units of measurement. She has said to me, "The ability to measure and the ability to see negative space are the greatest assests in drawing."

These are not the kind of words one expects from artists these days. Since the middle of the twentieth century, abstraction and expressionism have been the lodestones of fine art, and drawing has been diminished and disparaged. Commercial design and illustration these days is largely done on computers. When you ask the marketing director at Strathmore—a producer of art papers for more than a century—what's new, he talks about a

surge in sales of papers made for use with inkjet printers. At many art schools across the country, students may go through a four-year program without taking drawing or painting courses. More and more of the curriculum in art schools and more and more of the content in galleries and museums is video art, conceptual art and installation art. Less and less is actually based on drawing. And if you do get training in drawing, you're not all that likely to use it professionally. A local art instructor says he guesses that fewer than 2 percent of art school graduates go on to make a living as painters or sculptors or portrait artists or muralists. An apocryphal estimate passed on by artists in these drawing groups says only 4 percent of art school graduates go on to make a living as artists, and fewer than 20 percent go on to make art at all.

The place of drawing in the arts has declined to the point that one of the major current debates among artists is over whether accomplished draftsmen like Ingres or Dürer or Michelangelo or Caravaggio used optical devices to trace projected images. Some leading exponents of the theory are, perhaps not coincidentally, abstractionists whose own drafting skills are limited.

But it could be said that a kind of renaissance of figure drawing is occurring. It is not something you'd note in the galleries or museums, for it is practiced, more often than not, by amateurs.

Drawing from live nude models used to be something one had to enroll in an art school to do. Today, one does it in community art and recreation centers, in fine-art museums, in privately operated ateliers and in home studios and living rooms. The number of places that offer classes in life drawing seems to be steadily increasing. In just about any city and in many suburbs you can find a drop-in drawing session, where, without advance reservation, you can pay a modest model's fee and draw from a live model for two or three hours. You can draw this way,

for example, at the Minneapolis Drawing Workshop, the Truro Center for the Arts in Castle Hill, Massachusetts, the McLean (Virginia) Community Center, the Hui No'eau Visual Arts Center in Maui, Hawaii, the Northwest Area Arts Council in Woodstock, Illinois, the Tampa Museum of Art, the Art/Not Terminal Gallery in Seattle, the Art Museum of Missoula, Montana, the Community Hall in the Boulder Crossroads Mall in Colorado, the Creative Arts Center of Dallas, the Scottsdale (Arizona) Artists' School or the City Market of Raleigh, North Carolina. David Quammen, who models in Washington, D.C., knows of two dozen drop-in groups in the Washington, D.C., area. In New York City, there are Minerva Durham's Spring Studio, the Art Students League, the Chelsea Sketch Group, the Salmagundi Club, the Society of Illustrators, the National Academy School of Fine Arts, the Tompkins Square Branch Library and many others. You can find drop-in drawing groups in Canada, the United Kingdom, Australia, Hong Kong, Bali and Jakarta—indeed, all over the world.

There are at least eighty different drawing groups meeting weekly in the San Francisco Bay Area. They range from small, very private gatherings of four or five artists in someone's living room to large public drop-in sessions meeting once or twice a week in community centers. A group I have drawn with in Palo Alto for fifteen years sometimes has more than fifty people crowding into the city's Art Center, jockeying for space and a clear view of the model. There are Berkeley housewives' drawing groups and there are gay men's drawing groups—even a gay-men-drawing-naked group. There are recreational groups meeting after-hours in lunch and seminar rooms at high-tech companies in the South Bay. There are life-drawing classes offered at the Bay Area's twenty colleges and universities, as well as programs at the three major art schools and a handful of smaller private ateliers. There are regular at-work sessions for the various film-animation studios and electronic game design-

ers that have sprung up around the bay. It is possible to draw every day with a different group and to go on visiting new groups for four weeks before one either drops from retinal exhaustion or has to repeat a group. There are individual artists who hire their own models privately. All of this intense interest in depicting the human form supports at least two hundred professional artist's models, some of them managing to make a living exclusively from posing. There are two active and successful models' guilds in the Bay Area, through which schools, drawing groups, animation firms and individual artists can hire skilled and experienced models.

Says Betsy Kendall, a Berkeley chef who draws with a small group of friends regularly at her home, "There's a figurative tradition in the Bay Area. There's enough figurative art that you can look around and get inspired."

If you judged by what hangs in the galleries around San Francisco's Union Square or New York's Madison Avenue, you

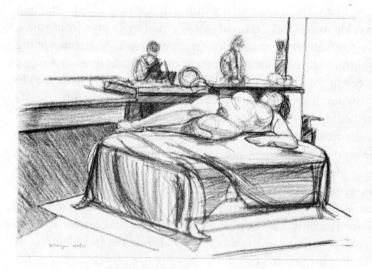

Mary Proenza, "Drawing Group"

would have no idea that any of this was taking place. The artists in these drawing groups acknowledge that pictures of nudes are hard to sell. Says Norman Lundin, who teaches drawing at the University of Washington, "It's a loaded subject. Any time you present a nude you've got the message of sex hanging around it. To escape that is difficult." On top of that, to many people nudes suggest out-of-date art. Says Minerva Durham, who has taught drawing in New York City for twenty years, "New York is the known center of art, so you have a lot of things going on. But I think figure drawing has struggled here. Figure drawing is considered passé." She is talking about the galleries and the fine-art schools. Outside the schools and the galleries, something else seems to be happening.

If there is a renaissance of drawing taking place, it is not driven by the art market, but by something inside the artists themselves. It is driven, I suspect, by something innate and human, by a constellation of long-standing behaviors and impulses shaped as much by human nature as by culture.

Look around Eleanor Dickinson's studio, and you'd get no clue as to why these people are here. Each one of the artists is wrapped in a bubble of concentration, silent, absorbed, alone. There is little conversation in these groups when people are drawing. There is little talk about the nature of the work going on during the breaks, when the model usually dons a robe and sits quietly on a corner of the stage, stretching sore muscles. And while the models can be articulate, perceptive and precise about what it is that they are doing, it is hard to find artists who can explain what they are doing when they draw.

Part of that inarticulateness, I think, arises from a lack of clear consensus among artists about what constitutes good art. Part arises from the fact that every artist is an individual seeking a deeply personal vision, and all visions are different. Part arises too from the fact that artists have varying degrees of access to words, that many of the most visually inventive and expressive

are not correspondingly adept when it comes to using language. There are visual minds and verbal minds, and they do not record experience and store it in memory the same way. And part of the inarticulateness arises from the fact that only a few of us consider ourselves successful enough as artists to profess a confident understanding of what we are doing.

Part of it, as well, is the intense concentration we devote to seeing what is there in front of us, to applying the right pressure to the drawing implement, to finding the forms in the model and placing them in the right proportions on the paper, to relating the figure to the background, to finding the lines that really count. It's not an easy thing to do, and, to all of us, good drawings seem supernaturally rare. Robin Schauffer, a Cupertino housewife who returned to school to pursue an art degree and has been drawing seriously for six years, says, "I don't look on my figure drawings as art. I look upon them as my scales and arpeggios. They're not good enough yet to say anything about the human condition."

We are less engaged in producing than we are in practicing. It's a refrain that runs through the work of even the best draftsmen and draftswomen. We do it not because we're good at it, but because there is some prospect that if we keep doing it, eventually we may be good.

That last idea is one that has run through the minds of many of the great artists. Hokusai declared at the age of seventy-three: "From the age of six I had a mania for drawing the form of things. By the time I was fifty, I had published an infinity of designs, but all that I have produced before the age of seventy is not worth taking into account. At seventy-three I have learned a little about the real structure of nature, of animals, plants, birds, fishes and insects. In consequence, when I am eighty, I shall have made more progress, at ninety I shall penetrate the mystery of things, at a hundred I shall have reached a marvelous stage, and when I am a hundred and ten, everything I do, be it a dot or a line, will be alive."

At seventy, Edgar Degas told Ernest Rouart, "You have a high conception, not of what you are doing, but of what you may do one day: without that, there's no point in working."

Henri Matisse claimed Henri de Toulouse-Lautrec one day looked down at a drawing and exclaimed, "At last I don't know how to draw!" According to Matisse, Toulouse-Lautrec had at that moment "left the means used to *learn to draw*" and "found his true line, his true drawing." It was a moment even Matisse might aspire to.

We live in a society that values quick and easy successes, a society that pays less attention to the effort hidden in a fine performance than to the acclaim that follows it. The words we employ to describe success in the arts or athletics or business don't seem to explain what we do in this room. If we come to these drawing groups with a curatorial view, focusing on the artwork instead of on the artists, we might miss the essential human meaning of what goes on in them.

What does go on in them?

I have continually wondered: what am I doing here? I have been a naturalist most of my life, scratched out a living for nearly thirty years by walking down forest trails or across desert playas to spend a few days with a wolf biologist in Alaska, a native subsistence hunter in Canada or a snake collector in New Mexico, and then writing about these encounters in magazines and books. I have walked with bears in Andean cloud forests and watched elephants play in Africa. I have seen Mount Everest and Cotopaxi and the Mountains of the Moon, boated on the Nile, the Ganges and the Kuskokwim. This room, one would have to say, is comparatively closed and small, not exactly the expected playground of the naturalist.

But there is an underlying unity. The naturalist and the artist are alike in their watchfulness. They are both servants of their eyes. A naturalist learns to look intently at things, to listen to them, smell them, touch them, to wonder what they are made of, what they do, how they are like or not like each other,

what they mean. I was early on fascinated with birds, not with their miraculous ability to fly, but by the combination of their liveliness and accessibility on one hand and their precise and complicated detail on the other. Watching such things forces one also to wonder about their comings and goings and purposes in the world; to consider what is revealed and what is hidden and how the two accommodate each other. It seems to me now much like what an artist does, looking for form and line and color and texture to define the relationship between spirit and substance.

Notable artists have seen the similarity, too. Paul Cézanne declared, "Art is harmony parallel to that of nature." And Leonardo da Vinci held that art brought "philosophy and subtle speculation to bear on the nature of all forms—sea and land, plants and animals, grasses and flowers," and was therefore "the true born child of nature."

I am not a biologist, not one who looks to reduce things to ultimate and demonstrable principles. A naturalist tries to relate those principles to unseen things, to our own prides and vanities, to our sense of story and consequence. But I have learned a certain amount of biology along the way, and it has shaped my thinking about all life. Ecology teaches a sense of the complex interaction and interdependence among things, a sense of the resilience of the world and the habit of asking how the world has developed such diversity. Evolution teaches a habit of asking how a particular behavior or structure might have come into being. And science in general teaches one that truth doesn't usually leap out at you, that good ideas may seem simple but finding them or arriving at them is almost always complicated and arduous. Both natural history and biology suggest that what happens on the surface of things might be very different from what goes on below the surface. It's like the bay by which I have lived most of my life: at the Golden Gate, a surface current runs out to sea; far below it, there's another cur-

rent, unseen by those standing on the bridge or the headlands, that runs upstream, back toward the mountains.

Which is to say that I am apt in the following pages to look at what occurs in the studio from an evolutionary point of view. And to assume that the most telling things about drawing are not obvious or easy.

I still feel at home in the woods. But lately something has happened to the story, or to the stories, I used to tell. Perhaps it would be more accurate to say something has happened to my ability to go on telling the story. Perhaps I have told that story—that nature is the fullness of our hearts and that we are draining it dry—too many times. Perhaps people have heard it so often that it no longer has the power to stir their hearts. Perhaps in the greed of the 1990s, when overnight fortunes were made on trivial inventions, we lost patience with the long and complex uncertainties of nature and biology. Perhaps we reached a point at which too few of us were still in contact with nature to keep a critical mass of opinion that what we were doing to it mattered. Perhaps the overweening power of corporate lobbyists and campaign contributions has worn down the hope that we can translate the story into meaningful action. As early as the 1980s, I noticed that a lot of environmental-beat reporters at newspapers got burned out on one kind of green and moved over to the financial pages.

Maybe it was all of these things. Maybe it was none of them. But I wasn't seeing the story the way I had years before, not seeing it as a tale of noble and far-seeing scientists and ethicists out there saving nature from being plundered by human greed and ignorance.

A few years ago, I made a trip to Alaska to look at some bears. They were big Alaskan brown bears and the location was remote: an hour on a floatplane from Kodiak to a boat waiting in the Shelikof Strait, and then a launch ashore to a broad, green, mountain-fringed meadow where these enormous bears

were grazing placidly on sedge. They were gigantic: to imagine how big, push your washing machine and dryer together and put a big bear head on one end. There were so many of them and they were so big that I felt at first I was watching buffalo. You could count two dozen in view at a time.

I had come at the behest of a bear researcher whose work I much respected and who told me, in a phone conversation, that if I wanted to understand bears, I just had to come to see this place with him. It wasn't until we were out in the meadow that it became clear to me that the main item on his agenda was a desire to touch one of these wild Alaskan grizzlies and live to tell about it.

Each day, we went ashore and walked among these prehistorically large bears. The entire meadow was a big chessboard with five- or ten-acre squares staked out by different bears, here a sow with cubs, there a young solitary male, and yonder a big, darker-colored adult boar. The sows moved constantly to keep their cubs away from the old males, which might slaughter them. The old males would rise every few hours from slumber, saunter over toward a female, disturbing and displacing each younger and smaller male, which moved out of the boar's way, and the females and cubs would move in sequence. So there would be the old male, its head low and swaying as it lumbered ponderously, almost ghostly, and a younger male looking anxiously over its shoulder as it beat a quick retreat into a clump of willows at the meadow's edge and the female frantically gathering her cubs and moving them off. The old male, finally ambling up to a spot where the female had urinated, sniffed it, licked it, raised its head with great ropes of drool coming off its snout, tested the wind for other scents, savoring the sensuality and indomitability of its afternoon. Then, finding no sign of estrus in the urine, the old boar would turn and drift slowly back to its chosen spot in the meadow, lie down and drowse into sleep. The other bears would slowly, cautiously, ratchet back to their original squares on the chessboard.

I watched bears come down to the mudflats to dig clams, watched them wade into the surf and catch halibut the length of my arm, take them up the beach, tear them into shreds and eat them languorously, leaving the heads and tails behind for eagles and gulls.

It was fascinating. But the story that kept asserting itself was the biologist's desire for contact. Each day, we'd get closer and closer, setting up a skirmish line of cameras on tripods, staying low so as not to scare the bears off, shooting pictures for an hour with one bear, moving on to the next, creeping closer and closer, sometimes within forty feet. The story that was laying claim to the adventure was not the bears' natural life, but the possibility that humans and bears would reach out and touch hand to claw and that this contact would have mythic impact on the world.

I was increasingly uncomfortable, not just with the possibility of death; the literature of Alaska is crawling with sensational stories of men and women who got too close to Alaskan grizzlies. One I had recently read, for example, blithely reported that the bear, in one swipe, took the man's head off. Several told how the bears kept on attacking after bullets had shattered their brains, as if the creatures were pure malevolence, beyond biology. What bothered me was that in trying to meld these stories with one of Quaker benevolence, we were still playing the old game of turning nature into a stage play, with man inevitably triumphant in the foreground.

We got the contact. One day six of us were laagered in the meadow behind a row of cameras trained on a female with two yearling cubs. One of the cubs had been making odd eye contact with us all morning—something wild creatures seldom do with humans—and at one point, the cub got up and strode directly and purposefully toward us with mischief in its eyes. The sow, which had seemed unusually calm and confident in our presence, protectively followed the cub. A woman lying on the ground behind the tripod closest to the approaching bears

buried her face in her hands and began to sob. The biologist scooted over between her and the bear, lay still, kept his gaze down and away from the bear, but held out a hand. The bear cub was by this point beyond its depth, rocking nervously back and forth three feet from the hand, not sure whether to come closer or to retreat, eyes darting as it hesitated. And then it came forward. It took the biologist's hand in its mouth, and the biologist deftly but calmly pulled it away before the cub could bite down. The bear lurched backward, then froze. The biologist got up and held a tripod between himself and the cub. The cub lunged forward and swatted the tripod, then bit it, then backed away. The biologist, who had been talking in a very quiet, even voice, then said to us in a strained kind of gargle: "Run. Run like hell."

We all stood up, stayed close together, making a collective mass about the size of the sow bear. The cub backed away. We backed away. The sow, though, kept coming toward us. It was not clear what she had in mind, whether she was angry or curious or intending to give us a lesson in bear etiquette. We backed away, she walked slowly after us, her cubs in her train. I thought about the old joke about two men looking up to see a big grizzly walking toward them, and one of the men stopping, digging into his pack and pulling out a pair of running shoes. "You can't outrun that bear," says the other. "Don't have to," says the first. "Just gotta run faster than you."

We turned, trying to stay together as a group, and walked faster. The big sow bear walked faster. We trotted, she trotted. We came to a gully and slipped down its muddy banks, having to stop and pick one another up, then turn and try to stall the oncoming bear.

The biologist bravely stood right up to the bear, faced her, talked firmly and evenly, told her there was no problem here, she had come far enough, and she stopped. As we continued to retreat, she slowed, and a gap opened up between us. The dis-

engagement took about forty minutes. Gradually, we put fifty yards between us and the bears, and the sow lost interest, stopped, sat, rolled over on her back and nursed the two cubs.

I never wrote the story, which seemed to me all wrong, a Fox television version of nature, too much focus on the jaw-dropping moment of surprise and ensuing tension and mouth-breathing fear, too little regard for the fact that we were humans in a place we didn't belong. Too little admission that we had gone thousands of miles out of our way to stage this encounter. Too little respect.

For a time it seemed to me that this was what had happened to my story, to nature writing in general. No one wanted to hear about how the natural system worked. The story being requested was about how close you could get, how you could take spectacular pictures, get out quickly and sell them to *National Geographic*. Dot-com biology.

As I wrote less, I drew more. I had drawn as a child, stopped in my late twenties and thirties and then came back to it in my forties. I've been drawing more and more, and I wonder now whether it has become a substitute for the exercise I used to give my eyes out in the woods, seeing new country, describing new creatures. And that has gotten me wondering about the whole phenomenon. Why do we draw?

I have been going to drawing groups for fifteen years. In these groups, I have made long-standing acquaintances and friendships, and it is clear to me that for many of us, drawing is a kind of compulsion. Every week, we drop family and work and go draw together. Most of the drawings end up in a trash bin. Few of us will ever draw the way Eleanor Dickinson draws. There is a dogged quality to what we are doing. We come back week after week, happy to see one another, grateful, I think, for our shared complicity in a doubtful activity. It is doubtful because its most noticeable attributes are nudity, desire, effort and failure. It's all funneled through a kind of meditative state

that is internal and private, for the most part incommunicable except in the drawings themselves. It is by turns erotic and puritanical, social and narcissistic, uplifting and depressing.

It seems, certainly in comparison to chasing Alaskan grizzlies, passive and bloodless and self-absorbed. But we come back to it like dogs to a bone, pigeons to roost, like waters to the sea.

What keeps us coming back?

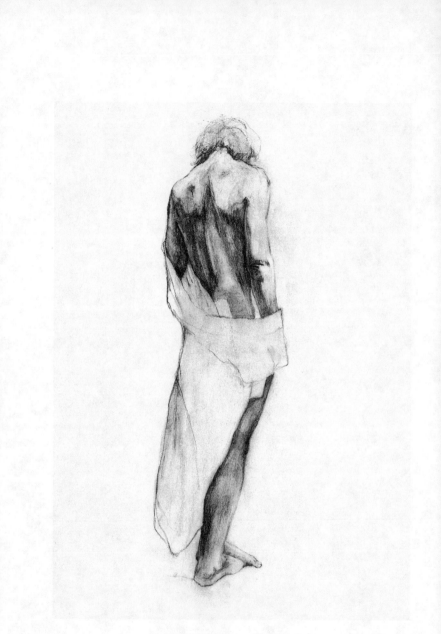

Michael Markowitz, "Untitled"

Ritual

Not long ago, a student scrawled in black charcoal letters on the white wall of one of the painting studios at the San Francisco Art Institute:

> *Whoever spoiled my painting*
> *I will throw acid in your eyes.*
> *Death is too good for you, Asshole!*

Artists are a testy bunch, perhaps testier in the last century; as aesthetic theories have urged them to find within themselves some natural spirit that expresses freedom, psychological theories have urged self-expression and economic theories have urged self-promotion. In theory, at least, we urge artists to set themselves at odds with prevailing values, to follow a different drummer, to challenge society and to compete with one another. This contentiousness is one of the things that has estranged the visual arts from mainstream culture, moved painting and sculpture into a lofty and elitist realm and left video and television to serve the visual interests of "ordinary" people. It's probably true today that more households hang

posters of rock musicians and sports celebrities than hang original artwork. Artists are expected by stereotype as well as by training to be angry—to criticize or declaim, to propose to reeducate the world.

Artists being artists, you'd expect to see this testiness in drawing groups. But you don't. There are groups where strong personalities hold sway, but you seldom hear criticisms of others' work. Few groups actually critique drawings.

I suspect a major reason for this is that drawings tend to be less calculated than paintings or sculptures; they tend to be more spontaneous and more personal.

Drawings are often distinguished from paintings with the statement that in painting you have color, but in drawing you have only tonal values. In fact, in exhibitions of drawings you see brightly colored pastels, drawings in colored pencil and drawings with ink and watercolor washes. But the distinction between drawing and painting is at least suggestive: a painting's color requires more decision, more thought. A drawing, says art historian Otto Benesch, "is an immediate emanation of personality, of the rhythm of life and its creative faculty." Drawing is more an act of discovery—of one's own feelings or of the world outside. A painting is likely to translate that discovery into something broader and more calculated.

A drawing is not expected to be complete or to be the definitive word on any subject. Its charm is its spontaneity, its freedom, its surprise. For many artists drawing is a way of exploring life. Edward Hill, professor of art at the University of Houston, declared, "The object of all drawing is to intensify experience." Indeed, many artists rely on their drawing to shape experience. Ten years ago, Eleanor Dickinson found that her mother, bedridden through a long illness, had died. The first thing she did was cry. The second thing she did was take out a sketch pad and draw her mother's lifeless face. "I experience things by drawing them," she says.

Drawing is a way of seeing. One test of whether you really understand something is whether you can put it into words in such a way as to teach it to someone else. Another test is whether you can draw it. A drawing is a picture of your understanding. Matisse declared that "to draw is to make an idea precise. Drawing is the precision of thought." As most understandings are flawed, most drawings are flawed. One draws chiefly to advance one's understanding.

Because its aims are gradual and cumulative, drawing is a discipline, an organizing and training and honing of the imagination so that one may be ready to work spontaneously whenever called upon. It is a discipline that requires constant exercise.

San Francisco artist Frances Binnington devotes most of her attention to resurrecting the medieval art of gilding and painting glass panels and screens. But if she neglects drawing for many weeks, she feels herself being pulled back into a drawing group. "I need it," she explains. "It's sort of a drive to keep in contact. Because it trains your eye and it's like a muscle: it gets slack if you don't use it. And like any other muscle, it tones the rest of you. I go drawing because I *need* to."

Drawing has been seen as preparatory to painting. Painters of the Italian Renaissance regarded drawings as merely the early outlines of a future painting and seldom kept them. Today, art historians can find few finished drawings from Venice before the eighteenth century; none of Masaccio's or Caravaggio's drawings survive; only a half-dozen Verrocchios and about thirty-five Titians survive. Painters of the northern Renaissance regarded drawings as autonomous works, and many more of their drawings survive. Gradually, as Europe's artistic vocabulary expanded, artists saw increasing value in drawings. Vasari collected them as examples of the way fine artistic minds worked. In the early seventeenth century, Federico Zuccaro suggested in his work *L'Idea de' Pittori, Scultori, ed Architetti* that the fewer strokes one used in a drawing, the closer it was to

being what he called "disegno interno," a purely spiritual thing. Matisse said, "If drawing belongs to the world of spirit and color to that of the senses, you must draw first to cultivate the spirit." Today, a rapid sketch is seen as an expression of the innermost personality of the artist. It is an offhand and revealing comment, while a painting is an oration, a stage play, a lecture, more formal and calculated.

But, like a painting, a drawing can be a finished work and a vehicle of communication. Matisse declared that through a drawing, "the feelings and the soul of the painter travel without difficulty to the spirit of he who looks on." And even if it is not immediately shown to someone else, a drawing is a record. Said Matisse, "Drawing is like an expressive gesture, but it has the advantage of permanency." Eleanor Dickinson says, "A lot of time it's assumed to be training for painting or sculpture. But I don't look at it that way. I'm a drawer."

A drawing can express things that may be inexpressible in a painting, for aesthetic reasons. Lack of color, simplicity of line, ambiguity of grounding that might be criticized in a painting—all can work to the advantage of a drawing. A drawing's thought can be vagrant, incomplete, merely glimpsed. The British critic Mervyn Levy wrote, "A drawing of the nude is a most revealing expression because it is at once the most private and the most personal. Often such drawings are made with no thought of public exhibition. They possess the intimacy of diaries."

But that very quality can make a drawing wonderful. Albrecht Dürer, the great German artist, wrote five centuries ago, "An artist of understanding and experience can show more of his great power and art in small things roughly and rudely done, than many another in a great work. A man may often draw something with his pen on a half sheet of paper in one day . . . and it shall be fuller of art and better than another's great work whereon he hath spent a whole year's careful labor."

Drawing is an undressed art, spontaneous, personal, undisguised, unaffected by the fashions of the marketplace. It can

be as natural as an unconscious gesture, as honest as one's heartbeat.

It is because drawing is so personal and provisional that artists exhibit in drawing groups a tolerance they might not possess in a gallery. It is not just an expression of attitude; drawing groups are structured to protect this toleration. There are rules of silence and personal spacing and self-restraint that aim at protecting the privacy of the artist. And since this is a collaboration between artist and model, the rules aim at protecting the privacy of the model as well.

Drawing groups are full of ritual. There are high rituals that have to do with the kinds of poses and the way a session begins, which I'll describe presently. There are smaller and more individual rituals: people have favorite chairs or favorite locations around the room, and they'll often show up an hour ahead of time to save the place or, when the studio isn't open early, race everyone else to get the chosen spot. Some have their own elaborate rituals of laying out pencils, brushes and inks or adjusting easels. Some sit for a while before the model climbs the stand, sharpening pencils or putting edges on vine charcoal and conte crayons. There are codes of silence, proprieties about how and when one gazes at the model or at others in the group.

Every drawing group has its own personality—its own sociability, its own seriousness, its own generosity or astringency of spirit. At the Mission Cultural Center for Latino Arts in San Francisco, there are rules posted on the wall of the studio that declare:

1. There will be absolutely no talking to the model. I am the only [person] who will be allowed to talk to the model. If you have a request you are to run it through me. . . .
2. Silence during the pose . . . the only talking that will be permitted are polite expressions such as excuse me or may I share this table or similar [courtesies].

3. I am in charge. Disrespectful behavior shown towards me, students or, more importantly, the model, will get you permanently dismissed from the class.
4. You are here to draw. If you are not drawing, you will be asked to leave.

Across the bay, at an evening group for students and graduates of the California College of Arts and Crafts (CCAC), the tone is much less formal, sometimes aggressively convivial. Students started the group fifteen years ago, hiring their own models and sneaking into the second-floor drawing studio on the campus at night after faculty and staff had gone home. The night security officers looking in on their appointed rounds for years took it to be an official school function, even though students coordinating the group had to leave a window unlocked late in the day and at night pile picnic tables and chairs up the wall to climb through the window and open the door. When school officials found out about the underground activity, they had to credit the students' initiative and dedication, and they have let it go on as long as it serves students and graduates. The group still has the air of youthful rebellion and college nihilism that attended its birth but also a seriousness and collegiality about drawing and painting. One sees spectacular work, hears generous exchanges of lore and technique. But the artist sharing his knowledge might be sliding across the floor on sneakers with built-in wheels, and the conversation bubbling up around the poses is apt to be barbed and sardonic. One night, while a tall, elaborately tatooed model sat like a statue on the stand, someone said something about the Guggenheim Museum in New York currently hosting a retrospective of paintings by Norman Rockwell, who had long been ridiculed by modern artists as a sentimental and cliché-ridden illustrator. Figurative artists have varied but sometimes strong views in the debate between abstraction and realism. Many of the regulars in this

group are aspiring or already professional illustrators who think a Norman Rockwell retrospective being held in the center of abstract expressionist art is a kind of vindication. Steve, an artist much interested in comic-book illustration, crowed triumphantly, "I'll bet that bastard de Kooning is spinning in his grave!"

"Saaaay, Steve," said Bruce Wolfe, a sculptor and CCAC teacher who coordinates the group, in a slyly baiting tone, "tell us what you think of Picasso."

"Picasso was an out-and-out *fake!*" Steve declares, bristling with anger. His vehemence leaves a hush of suppressed laughter in the room, but the collective has enjoyed his intemperance.

A few miles to the north, at the University of California's Kroeber Hall, the Bay Area Models' Guild schedules the models, and there is a volunteer monitor assigned to ensure that people sign in and pay the modest four-dollar fee. It is a difficult room in which to draw, as it is brightly lit by a wall of ceiling-high windows on the north side, leaving half the artists to squint at a model posed against the glare. And, like most college studios, it is apparently never swept or dusted; your clothes and drawing papers are apt to soak up the chalk dust and paint spatterings the students have left behind. The size of the group varies from week to week, but there are usually twenty to thirty people present, some of them undergraduates in their teens, others retired men and women who might be taking courses at local junior colleges, and still others artists of various attainment who come to keep their skills up. The disparity of age and income and interest leaves the room distinctly quiet even during the breaks.

Still in Berkeley, but down the hill and closer to the bay, another group meets once a week at night in a World War II–vintage Quonset hut that was probably once used as a chicken coop and now is a small studio, dimly lit and heated with a wood stove. The group has been meeting there for fifteen

years. They all know one another; few strangers show up here. In the limited space, eight or ten artists crowd close to the model's stand and jostle elbows at their folding chairs or drawing horses. There is a long-standing familiarity with some of the models who have worked with this group for years, and there is a lot of banter back and forth between models and artists. One night, Barbara Tooma, a large, ironic woman in her fifties who loves to talk while working, was modeling. All through her poses, she told sardonic tales of her adventures over thirty years as a model: how she appeared partially nude in a tableau of large models in a ballet and how she posed as a two-hundred-pound Valkyrie in horned headgear to advertise a bicycle helmet. "One day," she said, "someone asked me to pose with their pet boa constrictor. I drew the line. I don't like snakes. I told them I wasn't Natassja Kinski." Laughter and comment from the artists egged her on. She launched into a story about being hired with another large woman to act as naked sumo wrestlers in a movie. Some nights, she says, the back and forth in this group has gotten so lively that the more introverted artists have complained that they can't draw amid such chatter, and Peter St. John, the group's coordinator, has had to rein it in.

At San Jose State University, there is a group called Shrunken Heads that provides animation students with the opportunity to produce large numbers of drawings. Their instructors require them to submit fifty drawings a week. The poses are held for a short time, the prescribed routine being twenty minutes of thirty-second poses, a break, twenty minutes of one-minute poses, a break, twenty minutes of two-minute poses, a break, and then the same routine in reverse. The model or models (there are sometimes two) may thus have to come up with 160 poses in an evening, and the artists' emphasis is on abbreviation and getting the gesture down quickly. Students who bring a quick facility into the room seem confident and

comfortable, while those who lack fluidity will draw with a tongue-biting wince. During the breaks, there is a lot of visiting and talk, and students crowd around the more accomplished members of the group, admiring drawings, while those who struggle may sit quietly, almost panting with regret. During the pose, there is no sound other than the soft rasp of pencil and charcoal on paper and the occasional turning of pages.

Drawing groups have a wide variety of musical styles. Most small groups have music going in the background. Some are completely silent, and even whispered conversation during the pose may be shushed or glared into submission. I think those who draw to music do so because it is felt that music harmlessly draws off those leaks in concentration that might otherwise cause one to be thinking about family, finances, love affairs and other mundane issues, and so interrupt the focus on drawing. Some groups draw only to classical music, others to jazz. One group I attended played a Johnny Cash album of throbbing, bass-beaten laments about prisons and shootings and unfaithful lovers, and it seemed to make the model, a dull-eyed, muscular young man, uninspiring. Another group played overamplified taiko drumming while, during the breaks, the coordinator delivered a sermon to the effect that realism, in the style of the old masters, was the way to draw in this group, but the resulting clash of values was too much for comfort. I have been to groups where the models brought their own music, and as it seemed to inspire them and put them at ease, it seemed to me to make sense, pretty much whatever their taste. A model I like to draw sometimes pulls out a flute and plays while he poses and that seems to give us even more of him to draw. I can imagine that drawing a naked cellist or saxophonist or tuba player might be a pleasure, but that a naked kettle drummer or pianist might be over the top.

There are long-pose groups, where most of the people are painting, and short-pose groups, where most are working in

pencil or charcoal. In both types, the group establishes the format and the model chooses the poses. In a long-pose group, the model might start with five or ten one- or two-minute gestures, take a five-minute break, then go into a pose that will be kept, in twenty-minute sittings separated by five-minute breaks, for the rest of the evening. Just as often, the model will skip the gestures and go directly into the long pose.

In short-pose groups, the model typically starts with five two-minute poses and two five-minute poses, a break, then two ten-minute poses, a break, and different twenty-minute poses separated by five-minute breaks for the rest of the evening.

Many artists prefer the one- and two-minute poses, the gestures that allow a model to be more dynamic and expressive. In gestures, the model can do weight shifts, pose on one foot, pose with weight out away from the body, can bend and put strain on bones and muscles that can't be tolerated for five or ten minutes. In gestures, a model can be lively and athletic, can perform dance movements or comic-book postures of bodies stopped in midmotion. Some male models pose in pugilistic postures; some even bring fantastic broadswords or quarterstaffs to use as props. A fair number of models are dancers who exhibit stunning grace and power in these poses. The gestures require the artist to work quickly, to simplify, to forgo precision and fussi-

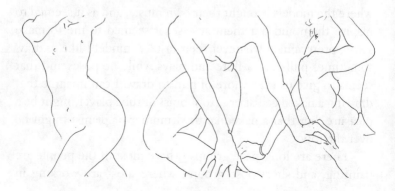

ness. It makes one work more loosely, spontaneously, more abstractly, with more emotion and less reason or self-criticism.

In longer poses, you are more apt to worry about likeness and realism, more likely to worry about the exact relationships between features or about perspective and foreshortening and the subtler ranges of value from light to dark. You tend to draw more rationally, to work with tighter, more cramped muscles and, if you're not practiced, to lose your emotion. Even a twenty-minute pose seldom gives you a chance to finish a drawing. And if you are interested in likeness or detail, a three- or four-hour pose is probably what you need. Some instructors who extoll the techniques of the old masters hold that few artists know how to finish a drawing and urge their students to spend six or eight hours on a single copy of an old master's drawing or an antique casting.

Whatever the variety, all drawing groups have in common a single ritual. It's not scripted or even much recognized, not like a church ritual. But it goes on nonetheless in every group. I have seen it so many times I hardly notice it anymore, but I think everyone in a drawing group becomes aware of it at some time or another, and it is, to my mind, one of the anchors of the experience.

Ann Curran Turner, "Gestures"

If there's a single telling moment that begins to reveal what drawing is about, it occurs at the beginning of a session, when a model drops her robe or tugs her blouse over her head and stands naked in front of a room full of strangers. At times, I watch not the model, but the eyes of the artists, and I see in them a variety of appraisals. Almost always I'll see flickers of desire flash about the room. I'll see men blush at the sight of naked bodies, both male and female. I'll see people wrestling with their thoughts. Rarely, a man will raise his eyebrows and roll his eyes as if to say, "Man, we're lucky tonight." But it is usually as longtime Bay Area artist Bill Theophilus Brown puts it: "The sexuality is the first thing the model and artist are aware of, and that vanishes very fast."

For a moment, it's clear there are acts of appraisal going on. The models often feel it. Model Marianne Lucchesi says she recognizes it as a part of every session. "They're going, 'Nice . . . not so nice,'" as their eyes inventory the body in front of them, and the implication Marianne sees is that they're comparing that body with the stereotypical images of sexuality and power they have learned through movies and other mass media. Some are feeling desire, some envy, some shame, some longing, perhaps also some anger at their own discomfort.

And then, in an instant, all those flickering desires and longings die out. The appraisal is quickly over, and people start to draw. And what has quietly passed around the room, from model to artist, is not a sublimation of desire, but a movement beyond it.

We are taught most of our lives that naked bodies symbolize either desire or shame. The two are tangled together, shade into each other, in most of our minds. Adam and Eve are usually represented as idealized bodies and simultaneously as embodiments of shame. It's one of the great stumblings of our culture, one of the great conflicts in all of our lives. We love and hate our bodies. But here, in the studio, looking upon the warm

immediacy of the frankest human form, we realize that there is much more to it than desire or shame. What seemed prosaic or ordinary under clothing can become beautiful and powerful and full of new meaning. There is dignity here. There is intelligence. There are modesty and compassion, pride and humility. The body projects character, not just in the mere form, but in the way the model carries and displays it.

It can be subtle and complex. Model Solveig Roberts sat down in an armchair in an Oakland studio one afternoon. Her back was straight, and she leaned slightly forward, knees pressed together, one foot in front of the other, hands crossed in her lap. Tight-lipped, eyes fixed on something in the distance, she declared rigidly but quietly, to herself rather than to the artists, "I'm very prim and proper." (It was one of the few times I have ever heard a model explaining a characterization.) You could hear the irony she intended, but she need not have verbalized it because you could see the intent in her pose. She held the pose for the next twenty minutes, very determined, playfully but convincingly conflicted between her announced self-discipline and the implied indiscipline of her nakedness.

What you may see is the whole range of human possibility—harmony, energy, pathos, humility. You may see baseness or nobility, depending on the model and depending on your own frame of mind. You may see desire. You may see nuance and complexity. You may see triviality and embarrassment. You may see divinity.

Edi Bergmann, who coordinates a drawing group in Sonoma County, says, "It's us. It's who we are. It's the source, the beginning of everything."

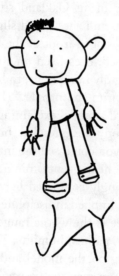

Jay Borgwardt, "Self-Portrait"

Learning to Draw

At Kroeber Hall one morning, Kate Bennett, a sixty-one-year-old pianist from Oakland, looked down at the lines she had made in charcoal on her newsprint sketch pad with a mix of pride and disappointment. She had just taken up drawing, enrolling in a class and attending the Saturday-morning drop-in sessions for practice. A moment before, she had felt that first-glance infatuation that artists have with the drawing as it emerges onto the page. And then, at the break, a more critical part of her mind spoke up, and she began to notice flaws. The legs were too short, the arms too wide, the head too small, the eyes too close together. She didn't know what lines to look for and felt frustrated, because when the pose was over, the drawing seemed half done. She turned the page in her sketch pad and waited for the next pose.

But she remained hopeful because her motives were strong. She said she had taken up drawing "because I wanted to see. I'm seeing it, but I'm not translating it into anything meaningful, into anything that has to do with my life." It is a view held by other drawers: we see things we don't understand, and we see them too quickly and indistinctly to develop clear feelings

about them. The urge to draw is a desire both to understand and to clarify and deepen our feelings. Bennett felt that if she could draw something, she would have *seen* it, which is to say, felt and understood it on a level that really mattered.

It is much the same longing that lured Henry David Thoreau to Walden Pond, and that, since then, has tugged countless naturalists off into the woods. The hope of seeing in clear outline and distinct form, and seeing for ourselves. The hope of shedding the blindness that overtakes one in the artificiality of commerce, the dissemblances of politics and the banalities of mass entertainments. San Francisco artist John Goodman says, "We draw to find our own originality."

It seems like something that would be easy to do. Making images is one way we clarify thought and feeling, and we all have some experience doing this: after all, we all dream, and when we dream we feel deeply and originally.

But dreaming isn't drawing. Drawing is much harder.

Humans are the only animals that draw. While showmen and hucksters have gotten elephants and chimpanzees to drag paintbrushes across paper and canvas, so far as we know the animals are simply manipulating materials and not making representations of things. As rare as the ability is in other species, drawing is almost universal among humans; it is as human a quality as speech and bipedal locomotion. Practically every human being draws at some time in childhood. As adults, we draw maps to direct people to our houses, diagram schemes for seating guests at a dinner party, sketch plans for the bookshelves we intend to build, make graphs of corporate performance.

The qualities that separate the human mind from the minds of other creatures are those that enable us to make images and symbols. Other animals vocalize, but we develop complex languages. That the ability to symbolize with words is built on brain structures that evolved long before humankind did is sug-

gested by the fact that, under laboratory conditions, chimpanzees and gorillas have acquired human sign language. Even African gray parrots have proved able to hold human words and their meanings in mind. But we humans imagine things in far more complex ways.

Syracuse University physicist Erich Harth theorizes that the human brain developed the ability to formulate mental images and to place them under the control of other brain functions as a way of extending short-term memory of details, sequences and relationships. Humans who elaborated these abilities could thus see more complex patterns in the world around them and could store information in a way that allowed them to compare and contrast things and to understand causes and consequences. Humans with such abilities could manipulate these images in such a way as to solve problems.

Harth suggests that other species have limited abilities to do this. A dog that winds its leash around a tree may not be able to see that it can free itself by backing up. Our closest primate relatives share some of our imaginative abilities. A chimpanzee, for example, can see that by moving a box judiciously, it can reach a banana placed out of reach on a shelf. Dolphins also seem to have some abilities in this regard. The late marine biologist Kenneth Norris told me that captive dolphins would prankishly splash water onto humans standing outside their tanks, and that made him wonder, "How do they know we're dry?"

But humans elaborate these extensions of memory into complicated ideas and processes. We do it in at least two ways: we make mental images, and we store and manipulate them as words. And we interplay the two, transforming image into word and symbol and word and symbol back into images. We do this with a quickness and completeness that, so far as we know, leaves all other earthly creatures far behind.

We have traditionally sought to explain the evolution of human language as a communication system. Harth points out

that the language centers in the human brain are not the same areas that are activated when, say, a monkey sounds a predator alarm or chatters peevishly at a fellow that has encroached on its personal space. Harth believes speech and visualization both evolved not as communication skills, but as thinking skills. By giving us the means to fix and manipulate details in the mind and even, in a sense, out of mind, these abilities gave us revolutionary new tools with which to assure security, find food and in general exploit the opportunities the world has left within our reach. And ultimately, those same abilities are the things that make us philosophical, introspective and psychologically complex.

Harth points out, too, that visualizing is a private activity. When we dream, we do it alone. He adds that children often vocalize their thoughts unself-consciously, doing their reasoning in public as if there were no one around. We learn soon enough to keep our internal monologues to ourselves, because society generally takes a dim view of anyone who appears to be so beset by internal demons as to lose the distinction between what is inside us and what is outside; but when stressed, we often forget this refinement and go on talking aloud to ourselves. Harth also argues that the way language unfolds in individual mental development suggests that it is part of our inherited cognitive development. He observes that feral children and children who are abused in such a way that they do not learn language by the time they are ten or twelve generally do not learn it at all.

Unlike Harth, most evolutionary scientists have thrown up their hands when confronted with questions about the origins of art. Steven Pinker, in the 1997 book *How the Mind Works*, dismissed art as "biologically frivolous and vain." Denis Donoghue in his 1983 *The Arts Without Mystery* speaks of "the uselessness of art." But it is, as Harth argues, immensely "useful." It's the very imaging and symbolizing that distinguish

humankind from the rest of creation, the very constellation of faculties that makes us dominant and dangerous, the very capacities that require of us a wisdom and compassion we may or may not ever attain.

Art is an extension of our human abilities to make mental images and to hold ideas in the form of symbols. Art thus increases our abilities to record and manipulate experience. We draw to assemble more complicated details than we can assemble in memory alone—just as we draw plans for a house we intend to build or sketch a map to direct employees to the company picnic at the beach. And some of us draw to assemble even more complicated details, for example, the details of a natural landscape that, appropriately recorded and properly arrayed, give insight into the environment around us. Or the details of a person's face, which give us insight into the character of that person. The gestures and postures of the human figure, carefully observed, can give us insight into the nature of humankind. We draw, too, to make sense of our own feelings. As University of Nevada psychologist Robert Solso says, "Art bestows upon eyes the vision to see inward."

But not all of us can translate images meaningfully—in dreams or outside them. Fewer of us can translate those images onto two-dimensional surfaces. And fewer yet can do so in a way that makes meaning both clear and heartfelt.

One thing that makes drawing seem deceptively within our grasp is the fact that all of us have drawn as children.

It seems to happen in the same way at the same time in all cultures. It is apparently ordained by the structure and development of the brain and unfolds the same way in each of us, much as an insect metamorphoses or an embryo develops through identifiable stages. Every child learns to scribble at about the age of two. A two-year-old lacks the coordination to draw a circle but by the age of three is drawing shapes contained in outline—ovals, triangles, rectangles and squares.

A certain amount of what ensues is ordained by the architecture of mind and body. Right-handed people draw counterclockwise circles, usually starting at eleven o'clock, while lefties draw clockwise circles, usually starting at one o'clock. Right-handers will draw radii from the circumference into the center of a circle from between twelve o'clock and three o'clock, lefties out from the center to between three and six o'clock. In Rembrandt's drawings, the crosshatching strokes made to indicate shading typically go from one o'clock to seven o'clock; in his engravings, which are mirror images printed from plates on which he drew, the hatch marks go from eleven to five.

At the age of four, a child draws a human. It's almost always the first pictorial drawing a child does. Three- to four-year-olds draw a circle with a dot inside it, and then slowly the circle becomes a sunburst, with rays bristling out from the edges. Gradually, the number of rays reduces to four, two each for arms and legs. Then more small circles or dots appear in the circle to represent eyes and mouth. The head is usually larger than the body. These early drawings are symmetrical, full-frontal faces, sometimes with hats added by perching a triangle or a square on top of the circle.

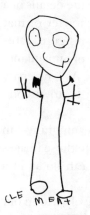

Clément Blehaut,
"Self-Portrait"

After human representation, a child will branch out, drawing in much the same way—a basic shape embellished with other basic shapes to form a symbol. A rectangle resting on two circles becomes a car; a house often evolves out of a face, with a door for a mouth and windows for eyes. Animals often begin as people with extra legs, and gradually come to be depicted in profile rather than frontally. And once a child has worked out a conventional person or house or kitten or dog, that child will go on drawing the same version over and over again.

Once you thus learn a set of lines to express something, they seem to stay with you. Minerva Durham says a fair number of adults come to her Spring Studio wanting to learn to draw and "most people dropped drawing when they were eight or nine. Most people when they come in draw like eight- or nine-year-olds." Even after years of learning to draw more carefully, the lines once perfected as a child will sneak into your drawings if you aren't looking carefully and exercising self-control. Once the brain lays down these connections, they may hold on to their franchise forever.

The child, however, is drawing a symbol and not a likeness. A child draws what he knows, not what he sees. It's not a case of observing and translating what one sees into line and texture within some scale of perspective. It's the laying down of images largely from inside. James Sully, an English psychologist, in 1895 reported a child telling him, "First I think, then I draw my think."

At this stage, children are not able to draw a model. If presented with the task, they will hardly look at the model but will draw instead their own convention of the object. Give a child a teacup with its handle hidden, and the child will draw a side view with the handle visible. Only as the brain develops later in childhood can they begin to observe and analyze in such a way as to break the visual impression into parts. A five-year-old has difficulty drawing a diamond because he or she can't detect and correct the errors in line and angle early enough in the drawing to make the four strokes come out with the opposite angles equal and the four sides approximately the same. Five-year-olds seem to lack the planning abilities needed to strategize. Nor can they represent three-dimensionality by overlapping body parts or foreshortening or shading. A five-year-old asked to draw two apples when one is placed in front of the other will draw them side by side, neither's outline occluding the other's. A seven-year-old will sometimes put the farthest apple above the nearest, but will doggedly include the entire contour of

each apple. Three-dimensionality is seldom mastered by a child younger than eleven.

At five or six, a child's designs begin to be pictures in that they tell a story and involve several objects. At about six, a child stops constructing drawings from circles and squares and begins to outline whole forms. At six or seven, there is increasing interest in humans and animals, and a tendency to depict people in other than full-frontal forms, say, running or sitting. And a child of seven has the abilities to strategize and separate the parts of a model. By seven, children start taking chances with line and form to try to relate what is outside themselves to what is inside their minds.

But by this age, as they are thus trying to expand their visual vocabulary to express more of the world around them, they face increasing frustration on two fronts. On the one hand, adults are offering well-intended advice and criticism, but on the other, they are offering it in such a way that it seems a disparagement of the children's ability to represent things. Children who draw stick figures have learned the technique from those adults. By the age of seven, they feel disapproval from adults and from other children who have been similarly instructed and urged to take up adult modes.

At the same time they are also feeling their own disapproval. They are not yet very adept at observing and analyzing what they see in such a way as to break down the visual impression into manageable parts. But the verbal centers of the brain are developing rapidly, and the child is becoming able to interpret the world more precisely and more powerfully in words. The two ways of coding and memorizing things—images and language—compete. To draw representationally, one must increasingly evade the grasp that language tends to place on the mind, must, in a sense, replace knowing with seeing. This is something many accomplished artists have noted. Monet once said he wished he had been born blind and had vision opened to

him later in life so that he could see form without knowing what the objects were that he saw in front of him. Matisse declared, "The artist has to look at everything as though he saw it for the first time; he has to look at life as he did when he was a child. . . . The first step toward creation is to see everything as it really is, and that demands a constant effort." At about the age of seven, most children find language more effective than drawing as a way to interpret the world, and they grow less and less confident about drawing.

Whatever we are as a species will be determined by—or will leave its tracks on—our brains. We are a visual species, and nearly half of our cerebral cortices are devoted to visual tasks. So, to really understand what we do when we draw, we need to consider what goes on in the brain.

Most of the brain centers that are active when we draw are in the cerebral cortex, the rounded, deeply folded upper part of the brain that is divided into right and left hemispheres. It is thought that the visual centers of the brain develop on the right side, while the verbal centers develop on the left. As a child approaches adolescence, by about the age of ten, the brain lateralizes—that is, the connections between the right and left hemispheres seem to close down, or perhaps the tasks undertaken by the verbal and visual centers become so complicated that the opposite hemispheres stop talking fluently to each other. The left hemisphere works in logical and analytical ways that stress categorization, naming and symbols and is more concerned with time, while the right hemisphere is more intuitive and works more with spatial relationships.

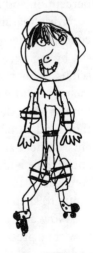

John Lynch Kenney,
"Self-Portrait"

For child artists, lateralization poses a challenge. For, just as the brain begins to lateralize, children are becoming more interested in representing specific characters, for example, identifying the subject of a drawing as a specific individual. They'll start by simply adding symbols, say, drawing identifying tools or uniforms, and by trying to put bodies in different positions. But they also become more and more aware of individual character and appearance and want to include those in the drawings.

For most, the task of representing the immense and subtle differences they see in the outside world is overwhelming. Most grow so frustrated by their failure to capture these details that they stop drawing. Meanwhile, the language centers of the brain are making thousands of new connections daily and asserting dominance. What a child may have expressed in drawings is increasingly expressed with more fluency and precision in words. By the time lateralization is complete, most people rely on verbal perception and memorization more than visual perception and memorization.

Girls mature earlier and are ahead of boys in verbal and conceptual development. They are ahead by a year at the age of six, by eighteen months at age nine. They are also more conscious of their own bodies and tend late in childhood to be including more body parts in their drawings than boys do. Boys tend to keep their edge in mathematical and spatial skills, and they tend to be more preoccupied in their drawings with the environment around them. Because they are less self-conscious about their bodies, and perhaps also because verbal dominance comes later for them, boys may have a longer stretch of opportunity to keep drawing than girls.

Now and then, I ask artists how they bridged the chasm, how they pressed on with their desire to see more expressively and accurately as the visual centers of their brains were increasingly slighted by their verbal centers and their drawing abilities

were slighted by critics. The males tend to give more definite answers than the females, and the answers suggest that their relative lack of interest in their own bodies was an advantage. Many of those who recall this time in their lives say they drew cars or airplanes, images of power and speed that allowed them to both indulge their own fantasies and draw simple real-life models of wheels and fenders, tail fins and windscreens. A few others say they were sustained by cartooning, which allowed them to draw bodies fancifully, whimsically or even aggressively, in ways perhaps denied to girls. Several, like myself, discovered artists Jack Davis, Harvey Kurtzman and Don Martin in the pages of *Mad* magazine and copied their wildly expressive lines and stunning visual pranks. Pat Carey, an eighty-one-year-old graduate of the Chouinard Art Institute who draws at the Mission Cultural Center, learned crosshatching as a girl by copying Frederic Remington illustrations. Richard Gayton, who has taught drawing at the California College of Arts and Crafts for forty years, copied Superman comics as a boy.

Peter Paul Rubens at the age of twelve or thirteen bridged the gap by copying woodcut illustrations of Bible scenes by the Swiss artist Tobias Stimmer. Published in 1576, Stimmer's Protestant teaching book featured massive, sculpturally cut figures in twisting, gesticulating, active poses drawn in big, broad spaces. Highly dramatic, with strong lines, they were the kind of thing a twelve-year-old today might find in comic books. And one can see how they could have been a defining encounter for Rubens, how they could have led him from childhood symbols to the detailed and particular naturalism to which the young artist aspired.

Few artists, however, are self-taught. To make that transformation—to see and represent the external world clearly enough to drape it in one's own feelings—usually requires instruction. Rubens went on to study with a series of teachers—Tobias Verhaecht, Adam van Noort and Otto van Veen—and

then at the age of twenty-three traveled to Mantua, Florence and Rome, where he could experience more directly the things Michelangelo, Leonardo and Raphael had learned from antiquity. Most of the people in drawing groups have either taken classes or are currently enrolled in some course.

Without instruction we are likely to go on drawing as children draw, depicting what we know rather than what we see. Robert Solso, long interested in what makes artists different from nonartists, had his college-age students draw cups and saucers and found that almost every one of them drew them in profile with the handle to the right. He found that if he showed someone a picture of a horse viewed from the side, the image was quickly comprehended, but if he showed the same horse viewed from above, it took the viewer much longer to comprehend. He concluded that we hold in our memories "canonic" forms of familiar objects. If you draw what you know, rather than what you see, you'll draw the canonic form.

Drawing isn't learned quickly. Some people regard it as chiefly a matter of coordinating hand and eye, but probably the manual dexterity required is already developed by the age at which you want to be able to depict precise and detailed things. Others talk of drawing as a matter merely of sharpening the eye, but that, too, is a simplification. Semir Zeki, professor of psychology at the University College London, points out that one sees not with the eye, but with the cerebral cortex—of which the eye itself is merely an extension. Seeing, perceiving form and depth and texture, and translating what you see into line segments and tones, then directing the hand to make even tiny line segments, requires one to communicate all these things to various parts of the brain. It is a complicated and challenging complex of behaviors, requiring one to perfect and coordinate a wide array of different mental skills, and then to perform a variety of difficult tasks simultaneously, or at least in precise and rapid sequence.

Many psychologists believe drawing requires one to disengage or divert the left-hemisphere functions. The textbook most widely used today to teach drawing, Betty Edwards's *Drawing on the Right Side of the Brain*, emphasizes the role of hemispheric dominance. Edwards, now professor emeritus at California State University at Long Beach, starts with the idea that the spatially oriented right hemisphere of the brain is usually dominated by the verbally oriented left hemisphere. She observes that at adolescence, one hemisphere usually becomes dominant over the other and that left-handed people are less often strongly lateralized than right-handed people. She points out that, perhaps more than coincidentally, Michelangelo, Leonardo, Raphael and Picasso were all left-handed. Her teaching technique is to try to shift control from the left side of the brain to the right. She has her students draw faces, because the right side of the brain is also specialized in the recognition of faces. A key exercise is to copy a Picasso drawing of Igor Stravinsky upside down so that the student is not tempted to name the parts or call up associations that would cause the verbal centers of the brain to reassert control. She also borrows the practice of drawing pure contours from Kimon Nicolaïdes' popular 1941 instructional book, *The Natural Way to Draw*, because "it provides the deepest shift into right brain subjectivity of any exercise." She emphasizes drawing negative space, because the right brain has no name for such spaces and is less likely to be lured out of its leisure. Using such techniques, she has been able to get untutored students to draw recognizable portraits in a few weeks.

Edwards's approach isn't the first to emphasize seeing over knowing. Instruction books since John Ruskin's 1857 *The Elements of Drawing* have emphasized that one must draw what one sees and not what one knows. Harold Speed in his 1917 *Practice and Science of Drawing* urged upon students "the Japanese habit of looking at a landscape upside down between the legs" as a

way of seeing it without the deadening influence of knowledge. But unlike the earlier texts, *Drawing on the Right Side of the Brain* has the advantage of recent brain research and offers a picture of what is going on inside the brain when one draws.

There are other corroborating strains of evidence that language and artistic vision compete with each other. There have been a number of studies of autistic children who developed extremely limited language skills but elaborate drawing skills at an early age. One celebrated example is Nadia, born in Nottingham in 1967, who by the age of six had a vocabulary of only ten words, which she used rarely and only in one-word utterances, but who drew astonishingly lifelike pictures of, for example, rearing horses. And Nicholas Humphrey, professor of psychology at the New School for Social Research, argues that the wonderful animals depicted on the walls of Lascaux and other Stone Age sites may have been possible because early humans had so little language that the visual areas in their brains could attend more freely to artistic tasks.

Simply focusing on right-brain/left-brain dominance probably leaves us with an inadequate picture of what goes on when we draw. Probably both hemispheres are working simultaneously—the left being more oriented to detail, breaking a visual configuration into more convenient parts, while the right looks at the whole pattern of the configuration. John Gabrieli, a Stanford University neuropsychologist, thinks the brain is too complex to be purely right- or left-hemisphere oriented. He believes there are more connections and interplay between hemispheres and that in drawing, interplay between front- and rear-brain areas may be just as important.

It does seem clear that learning to draw is much a matter of developing control over the way one's brain processes visual information. There are many different skills to perfect, each involving specific brain functions.

Drawing at least requires the ability to separate a figure

from its ground or setting and the abilities to detect shapes, forms, sizes and orientation. It requires some mechanism for storing that information on a short-term basis and for passing it on to other parts of the brain that will translate it into line or shape or value, or all three. We are severely limited as to the amount of information we can hold in mind at any one time. (That is, in fact, one of the reasons we draw.) You have to transfer what you have perceived in one area of the brain to other areas of the brain where it is translated into line, and then to areas where motor neurons instruct the hand to draw that line segment on a page. The impulses must go to parts of the brain that allow you to judge whether you have placed the line or shape appropriately. Put it too far to the left or right and the error will distort everything that comes after it in the drawing. Other parts of the brain will probably judge whether you have drawn it too large or too small.

To do all this, an artist is not just memorizing. An artist is reprogramming the circuitry of the brain. There are more than ten billion neurons in the human brain, some of which connect to as many as a hundred thousand other neurons. Neural cells transmit impulses in a few hundred milliseconds across these connections, passing signals from areas of the brain that have to do with, say, perceiving the shape of an object, to areas that compare the perceived shape with those of similarly shaped objects from one's own experience, and then to areas that summon words to connect with the shapes. The primary visual cortex is comprised of many different visual areas that specialize for given attributes and probably sequence in a similar way in each of us—color being seen before form, form before motion. When drawing, one is also processing impulses through areas of the brain that have to do with intentionality and self-control, areas that keep one focused on the purpose and feeling of one's work. One is also processing impulses through areas that direct arm and wrist and finger movements. The visual areas are at the

rear of the brain, the areas that keep one focused on a task at the front. Areas that have to do with the perception of spatial relationships are largely in the right side of the brain, while areas that have to do with naming things are largely in the left side. When you are drawing, your body is still, but your brain is crackling with alarms and errands.

Learning to draw is learning to control these alarms and errands. And that is not a matter of knowing but a matter of practice. A good instructor can critique drawings and propose drawing exercises that lead one through particular tasks and techniques. But in the end instruction aims at getting the artist to pattern the behavior of nerve and muscle cells. And while we can talk about the values and meanings of the art that is produced, we seldom can talk about the patterning and sequencing of skills that goes on inside the artist as he or she produces such works. Kenneth Beittel observed in *Mind and Context in the Art of Drawing* that "a person's drawing process is quite often unknown to him insofar as any clear account of what took place and when is concerned." Edward Hill added, "The processes [of many artists] are nearly inscrutable. It is an apparent paradox that drawing is formed by visual intelligence, yet the processes are largely a mystery. The greater the drawing, the greater the mystery. The visual mind can only partly be measured by words."

What one seeks to learn really are those processes by which we draw successfully. R. G. Collingwood in his 1938 *Principles of Art* declared, "What a person learns in art school is not so much to paint as to watch himself painting."

You watch yourself, in a sense, to see yourself changing. One of the first changes is development of sufficient patience to commit the time needed to draw. An artist must find stillness so that for twenty minutes or more there is a single point of perspective from which to view the model. If you tilt your head even a little, you alter your view of the object. Finding stillness

is not as easy as one would think. Paul Valéry, the French writer and critic, pointed out that "a sustained act of will is essential to drawing. The eyes wander, the hands curl—you must control them. . . . A drawing that is meant to resemble its object as closely as possible requires the most conscious application. Nothing could be more opposed to reverie, since the requisite concentration must be continually diverting the natural course of physical movements, on its guard against any seductive curve asserting itself."

An artist must develop tricks that help one to see things. Artists simplify what they see. Squinting or half-closing the eyes eliminates some of the detail and helps to simplify the values. Some artists use a darkened glass to do this. Some close one eye to minimize the challenges posed by depth. You find a scale—large or small—that works for your vision and style. A six-inch drawing is easier than a larger drawing because it will be less detailed and because it lies entirely within one's field of vision. If you scale up, you'll have a harder time controlling the proportion and accurate measurement, and you'll have a harder time making the values of light and dark meaningful.

One has to train a new relationship between eye and memory. You can depict things from memory, but the more you rely on what you recall, the more inaccuracy you'll have. An artist looks from the model to the picture surface constantly. When British artist and teacher Francis Pratt compared the way art students looked at objects with the way untrained students gazed at them, he found the artists made many more glances at the model. Video studies of art students show them looking half the time at the model, half the time at the drawing.

Glances, too, are varied. Pratt found that one-third were less than half a second long, one-third were one-half to one second, and a third were longer than one second. The glance is short, because even when you think you are holding your head still, your eyes are making small, rapid jumps, called saccadic

movements. Saccadic movement is not subject to conscious control. Even with a longer gaze, one can't focus on a single thing. An eye fixation on a scene or a model lasts about 250 milliseconds, and then moves on. There is a 100-millisecond lag before the next fixation.

And you can only remember so much of what you see while you are trying simultaneously to transfer images to other parts of the brain that will translate them into line or tone, instruct your hand in the movement and pressure needed to produce that line and judge whether lines are being drawn in the right places. Many instructors believe it is possible to extend one's visual memory. While teaching in Paris, James McNeill Whistler put the model on the ground floor and the easels upstairs so that students had to observe, then walk up a flight of stairs before drawing. As the school term progressed, he gradually moved the easels higher, ultimately to the sixth floor. Nicolaïdes had his students draw three or more thirty-second poses from memory by having the model take three or more poses in quick succession and requiring the students to observe all three before starting to draw. These techniques may not increase memory but may merely teach students to look more discriminately for the line or tone that works for them and teach them to pick what is essential out of the noise of ordinary experience. But memory is clearly important. Delacroix was reported by Baudelaire to have said, "If you are not skillfull enough to sketch a man falling out of a window, during the time it takes him to get from the fifth story to the ground, you will never be able to produce monumental work."

You also increase your knowledge of what you are drawing. There are clusters of cells in the brain so highly specialized that they respond to only one view of an object, say, a side view of a face or the back view of a hand, and will not respond when the head or hand is rotated. With practice, one stores more and more views. An artist draws and draws and draws, seeking

to expose himself or herself to as many views of the object as possible so as to amass a brain record from which to draw combinations that suit a new drawing's need. One uses these memories when drawing quickly.

One also has to practice to position the various elements on the paper in such a way as to end up with appropriate distances between features. A beginning artist may put the eyes too close together or make the legs too short or the head too narrow. An instructor can give you average measurements—for example, when a face is viewed from the front, the distance between the eyes is the width of an eye, or the average male is seven and a half to eight heads high. But some of these convenient measures, such as average height, vary individually. Many artists constantly measure, holding a pencil up to the head, marking with the thumb its height, then moving down the body and making mental notes where the mark would fall, dividing the whole figure into head heights and noting where the marks would fall over the breast, above the hips, across the thigh, below the knee, and so on.

You learn which elements to look for and which you can ignore. Because drawing simplifies what you see, you have to learn what is important and what can be left out. You learn, for example, that the pattern of light and dark, illumination and shadow, in a face will give more likeness than the individual lines, say, of lips or eyes, because our brains recognize familiar faces largely through patterns of light and dark. You learn that the line separating the lips is usually more telling than the lines separating the lips from the parts of the face directly above or below them. You learn that the shadows at the corner of the mouth tell more than the lines delineating the lips.

You learn to see differences in value between light and shadow and to translate those differences into tones. You learn what sort of line works for different tones, that a thin line is appropriate where light is strong and a thicker line where

things fall into shadows. You learn what kind of pressure applied to charcoal or crayon gives you the particular gray or black you need to express a certain shadow.

You never really gain anything that seems like perfect self-control. A dream is probably not a fully realized picture, like a movie scene, but the suggested sum of a few perceived elements, a kind of connect-the-dots game being played in one's imagination. Similarly, a drawing is not the representation of a fully developed conception already in the artist's head. When you draw you see parts of the vision, and you may see them emerge only gradually and in unexpected ways. Development of a drawing is unpredictable. Says psychologist Peter Van Sommers, "Artists can almost be likened to spectators of the cumulative efforts of their own actions." When you get a drawing you like, it is apt to be a surprise.

As you develop these skills, as you reprogram your brain, you may find you are not quite the person you knew before you began drawing. An artist's brain works differently than a nonartist's. Robert Solso put well-known British portrait artist Humphrey Ocean into a magnetic resonance imaging scanner while Ocean drew and then compared his brain activity with that of nonartists who also drew while inside the scanner. Their brains lit up quite differently. That is, while the nonartists seemed to exercise the visual areas of their brains in particular, Ocean seemed to exercise areas that barely registered in the nonartists, areas in the front of the brain that have to do with intentionality and focus, with holding goals in mind. The contrasting scans suggest that Ocean was coordinating his brain in ways the nonartists did not. Says Solso, "An artist thinks the painting as much as he sees the painting. With Humphrey, the frontal parts of the brain were more active than they were in the non-artists. It's pretty good evidence that a truly outstanding artist is really looking inside."

Solso is cautious about asserting that these skills are just the

result of a retraining of the brain. "I hesitate to use the word 'train.' I suspect a great deal of it is within his genetic makeup. But it would have been nice to be able to MRI van Gogh as he developed as a painter and see [whether there were changes in his brain behavior]." And John Gabrieli, who collaborated with Solso on the experiment, adds that scanning the working brain of another artist, say, one specialized in landscape instead of portraits, might reveal a different pattern. "If you compare that to Jackson Pollock, who is doing something more intuitive," he says, "you might get a very different picture." It is likely not only that artists are different from nonartists, but that each artist's brain behavior is unique.

In the end, you may never really feel you have retrained your brain. The harder truth of the matter is that most drawings are failures and that almost all drawing is merely practice. One draws especially to learn. You learn and you learn and you learn. You are constantly making new connections in your mind. You are constantly trying to stop old connections from redirecting your pencil or from talking your drawing into a muddled death. You are concentrating in a specialized and extraordinary way. And in the end you are drawing in order to grow within yourself. Matisse said he drew "to liberate grace and character" and saw the work as "that of understanding myself."

You are exploring in much the same way you might be if you were walking a trail in the Sierra Nevada or the Adirondacks. When you are drawing well, you are seeing something for the first time. You may not have the sense of tired muscle and bone you get walking an unfamiliar landscape; but you have the same concentration, the same focus, the same sense of self-control, the same sense of pleasurable surprise. You are touching the world in an original way. You have a sense of youth and comprehension and dominion and freedom. And all that is addictive. You keep at it.

And if you do, the activity takes on a power of its own. Valéry declared, "Conceivably, drawing may be the most haunting obsession the mind can experience. . . . Things stare us in the face, the visible world is a perpetual stimulant, constantly maintaining or arousing the instinct to master the outline or the volume of that thing which the eye constructs." The point is that one starts out as Kate Bennett has started out, and one day you look up from your drawing and feel it possesses you. You draw as if you *have* to draw, much as a long-distance runner runs or a mountain climber climbs, because without frequent resort to that endorphin-induced euphoria, one does not feel fully alive.

You meet people in these groups who have been drawing fifty, sixty, even seventy years. At ninety-one, Teresa Hack recalled all-women groups she drew with in the 1930s. She still drew at the San Francisco Art Institute's open drawing studio when she could get someone to drive her there. "I feel I *have* to draw," she said. "It's like needing to hear music. You don't stop."

Drawing, in the end, redefines you. For some it becomes so integral a part of life that a day without drawing is like a day without air. Degas was so deeply committed to his drawing that even though he lost his eyesight and could no longer practice it, it remained at the front of his mind. When a close friend died, he asked to be led to the deathbed, where he traced the contours of the dead man's face with his fingertips. When himself died, at his request, the only words uttered at his graveside service were "He greatly loved drawing."

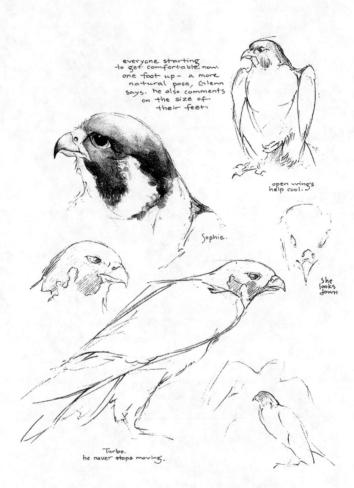

Jenny Wardrip Keller, "Peregrine Sketches"

Connecting

Drawing is a way of communicating with the world, of listening to what the world has to say and answering back. I doubt anyone has done the research to prove or disprove this, but I'd guess many children who contrive to draw naturalistically do so because there is something in the world that they have an intense interest in, something that is not shared enough by those around them to be the subject of conversation and so is something they get to know privately.

John Ruskin, whose criticism shaped Victorian England's aesthetic views, grew up an only child in a stern, puritanical Scots household where he was permitted neither toys nor playmates. Alone much of the time, he looked intently at nature and saw in it not just biological form or meteorological fact, but a set of connections to deeper powers and mysteries. Before he was ten, he was writing poems about it. And drawing it. He would draw landscapes, trees, cathedrals. He loved to draw clouds. He felt, he later recalled, that "there was always more in the world than men could see, walked they ever so slowly; they will see it no better for going fast." His "entire delight" had been "observing without being myself noticed." By the time he was an adult, he said, his ambition was to become a "pure eye."

With me, the interest was animals. Something in their sumptuous variety, their elaborate design, their quickness and their purposeful otherness, captured my imagination. Since no one else in the family shared my interest, it was not something we talked about. But the earliest drawings of my own that I have saved are drawings of birds, done when I was eleven or twelve. Later I drew cartoons, probably because they could not only be shown to others, but won laughter and approval. I drew them more to be seen than to see. When a more serious interest in drawing revived itself in my early twenties, animals again beckoned, and I spent weekend hours drawing in museums and zoos.

So, sometimes when I meet a person who draws animals, I feel a sense of kinship, and I'll stop to watch.

On a sun-drenched May morning, the faint spice of seawater rides the beach-town air of Santa Cruz, California. Glenn Stewart, program manager for the Predatory Bird Research Group at the University of California at Santa Cruz, which helped rescue peregrine falcons from the brink of extinction by releasing nearly one thousand captive-bred birds, has just leashed two falcons to ten-inch-high, saucer-shaped platforms on his backyard lawn and shaded them with a patio-sized canopy of semitransparent mesh. The female, a third larger than the male, is a bird he raised at home to be tame enough to take into grade-school classrooms, and it doesn't seem to mind the handling. The smaller male is more skittish and raises its wings in alarm and glares apprehensively as Jenny Keller steps into the yard.

Keller, a science illustrator and instructor in the university's Science Illustration Program, especially loves to draw birds. Stewart has invited her to sketch these two. It's a rare opportunity, because peregrines in the wild are remote, uncommonly quick (they stoop at speeds of over two hundred miles per hour) and haughtily intolerant of human company.

Keller unfolds a three-legged camp stool eight feet from the birds, sits and talks with Stewart awhile to let the birds settle down and to get a sense of what kind of intrusion the birds will tolerate. She is thin, pale-complected, with long brunette hair falling over the sides of her high cheekbones. She wears dark glasses to protect her eyes from the glare of the paper when drawing in direct sunlight. After a few minutes, she opens a sketchbook, takes a sky blue pencil out of the belt pack hanging over her lap and starts drawing the male bird. She doesn't draw circles or ovals to indicate the general form of the bird but works right from the start to find the contour. She makes short, back-and-forth strokes shading in a broad, stencil-like halo to approximate the bird's silhouette. It is more like a warning track around the emerging shape than a definite contour. She's timid about the line, and that's why she starts with the pale blue pencil. "I really like the noncommital nature of the first strokes being light," she says. Her comment implies that drawing is a bit of a gamble and that she'd prefer to wade cautiously into it rather than dive right in.

In fact, she has even prepared for this morning's sketching by making practice drawings from Louis Agassiz Fuertes's paintings of a peregrine. "I wanted to familiarize myself a little bit with the bird," she explains. "The more you know about an animal, the quicker you can see and recognize shapes."

The drawing she outlines is about four inches high on the page. Keller says, "I always draw life-size." She means she draws objects not as large as they actually are, but as large as they appear to her view, a practice known as sight-sizing. She adds, "In teaching drawing I've found there are three types: people who draw bigger, people who draw smaller and people who draw at size. It's really hard to break whatever habit they have—to get them to draw larger or smaller." Some teachers urge students to work in three sizes to learn flexibility.

Once she has a rough profile of the bird, she puts down the

blue pencil, takes out a fat ballpoint pen and begins to draw a finer, more definite contour over the blocky blue halo. She does that in short, quick, disconnected strokes rather than with a single bold line. But it makes a reasonably sharp continuous edge.

Before she can finish the sketch, the male turns its back on her, raises its wings and flaps them nervously. Then it hunkers low and ignores her, like a sulking child.

She starts a second drawing, next to the first, focusing instead on the head and shoulders of the female. She draws this one only with the ballpoint pen, in quick, short lines, roughly but more confidently outlining the roundness of the bird's crown, then arching down to the left into the bird's strongly curved beak. She gets the head and then the breast thus outlined, but decides that the beak seems too parrotlike. So she starts a third portrait below the incomplete outline of the male. She blocks in a more accurate version of the female's head quickly, taking shorter glances at the bird as she draws, having much of that information already in memory.

Keller has been drawing animals since she was a child. "My mom was an artist," she says. "So is my sister. My great-grandmother illustrated a book on Indian life and set out to paint all the missions of California. My grandmother finished the mission pictures and painted portraits. We would draw our dog together."

She came to Santa Cruz as an undergraduate in 1980, expecting to major in art, but found that "by the time I got here, they were discouraging drawing." She says she took a figure-drawing course, but the instructor never said a word about anatomy, never offered any instruction in materials and did little more than arrange the pose and wander quietly around the room while people drew. One of her instructors said she "lacked imagery development," meaning she wasn't abstract enough.

She wanted to draw. So she petitioned successfully to create an independent major in science illustration. She took the core biology courses and a selection of art courses and set up a succession of study projects. "I'd drum up business on campus," she says, by doing illustrations for professors. She did a series of botanical paintings for the university arboretum. She illustrated a book about dolphins by reknowned whale expert Kenneth Norris. She has gone on to do illustrations for *National Geographic* and *Scientific American* and to teach science illustration at Santa Cruz.

The falcons are never still. They focus on an object for several seconds, as rigid as statues, affording Keller one or two glances as she draws, and then, while she is looking at the line segment she is laying down on the paper, they cock their heads at a different angle.

There is much else going on in the yard to distract the falcons. A house cat slinks through a flower bed ten feet away, but it shows little interest in them and the falcons don't seem to mind it. Two chickens strut and peck about the yard, and the peregrines seem quite conscious of them. Stewart remarks that the male falcon once sunk all its talons into the back of one hen when it came within the radius of the falcon's leash. Stewart had to rescue the hapless bird.

And while Keller has her head down, the female peregrine's head snaps up to follow the path of a dove that is streaking high across the sky directly above. It takes only a fraction of a second from the instant the dove comes into view for the falcon's gaze to turn and lock on its hurtling form, and it takes only a second of this tracking before the dove is out of sight again. Keller, having dropped her gaze to the drawing, looks up to see the falcon's eyes back on her, missing the quick drama that has just unfolded.

The falcons are intensely present, acutely aware, focused all

the time, and it is that intensity of consciousness that Keller is connecting with in the drawing. Five minutes into the session, she is concentrating especially on the eye and its relation to the overshading brow, the powerfully curving beak and the echoing curves of the crown above and the rounded breast below.

She goes back to the second portrait and resketches the beak. She draws the outline of the eye and finds the highlight, the bright point of reflected light. She remarks on how large the eye is, and Stewart replies, "Their eyes are so big, I tell my schoolkids, that if they were as big as humans their eyes would be the size of tennis balls."

The male again peevishly turns its back and spreads its wings, this time catching the veiled sunlight in such a way as to show off a cool slaty gray with a velvety arabesque of darker blue-black markings. It pauses in the gesture, and the pose is so elegant it forces Keller to gasp in admiration. But it is gone before she can even think of drawing it.

She takes out a second, darker blue ballpoint pen and inks in the darker parts of the eye, leaving a highlight high on the curve, and suddenly the eye has a very lifelike appearance. She darkens the nostrils at the base of the beak and then the more deeply pigmented tip. With the same pen she inks in a more precise contour line for the crown and side of the head. The drawing is acquiring weight and depth.

She works on several drawings simultaneously. The technique takes advantage of the frequent movement of the subject—allowing the bird to come back to something like the earlier pose if that's necessary.

After half an hour, she has five different sketches going, moving from one to another as the birds change their poses. And by then, the falcons have relaxed noticeably. The female starts to preen and then settles into a ledge posture, very erect, wings opened a little at the shoulders because of the warmth of the day, wing tips meeting over the tail, feathers loose over the

lower part of the abdomen, one foot pulled up and tucked under a skirt of down. She hunches her shoulders, protrudes her face as if she were swallowing hard, pulls it back sharply, and a swelling slowly migrates down her breast: she is digesting this morning's mouse.

Keller is thinking all the time about how the birds regard her. Even before unfolding her chair, she asks how close she might get without disturbing the falcons. When Stewart puts his face six inches from the female's to demonstrate her placidity and the female corkscrews her head back at him as a kind of reflection of his movement, Keller still sits respectfully eight feet away. She says, "I worry about how the creature I'm drawing feels. It's really good that there are two of them, because I'm not looking at one of them all the time." She feels that animals find steady eye contact unnerving. "With cats," she says, "I remember to blink. Blink really slowly. Long exaggerated blinks," such as a cat might make drowsing on a window seat in morning sunlight.

This kind of empathy is an important part of the way she draws. To draw anything she has to find some point of emotional contact, some connection with the subject. Says Keller, "You have to find that spark. You have to be able to put your finger on that thing that beckons you. It might be something visual, like how the tip of a bird's tail is darker than the white of the sky behind it. But there's got to be a hook, either an emotional attachment to the subject or an excitement about the process."

She has homed in on the peregrine's eye because it says something about the character of the bird, says something to her about curiosity and knowing and seriousness of purpose. One might wonder what an artist could see if possessed of such eyes.

To draw anything you have to find a connection with it. You have to turn off the noise that keeps you from focusing. You

have to let the object stir you to empathy or ennoblement or joy or compassion—even to fear. You must see that things are a part of your world in some special way before you can attend to them.

Matisse told an interviewer, "Take that table. I do not literally paint that table, but the emotion it produces upon me."

"But, if one hasn't always emotion," the interviewer asked. "What then?"

"Don't paint," replied Matisse.

Connecting with things is part of the training of an artist. The first lesson is to slow down and look, to lend yourself to time and to the world around you. "It is harder to see than it is to express," Robert Henri, the painter and celebrated teacher, used to tell his students at New York City's Art Students League. Seeing takes time; it requires patience.

Keller often takes her students to zoos and watches to see how they sustain their interest. "I think people start out with a certain excitement at zoos, and then, when they exhaust the possibilities they have—what they can see at a certain distance—they get bored and think there's nothing left to draw. So I try to insist they bring binoculars and a little chair." The chair is an aid to patience, a device for anchoring eyes in one place. The binoculars allow students to give those eyes a deeper focus.

It is possible, too, to see the focusing as a matter of confidence: confidence that the things of the world are hospitable and confidence in one's own ability to see. Without such confidence, one cannot develop the patience or the good manners to stop and converse with things. Without such confidence, one will lack the interest to begin drawing.

It works both ways. Drawing is also a way to find your interest, a way to pull your mind out of the inattentive dither that is, more often than not, its customary state. You drift along with the noise of the herd, your eyes on the back in front of you,

your consciousness devoted mostly to keeping up and not bumping into things. Drawing pulls you out of the lockstep by focusing you on the things you're otherwise passing blindly by.

Robert Henri urged his students at the Art Students League to become sketch hunters: "The sketch hunter has delightful days of drifting about among people, in and out of the city, going anywhere, everywhere, stopping as long as he likes—no need to reach any point, moving in any direction following the call of interests. He moves through life as he finds it, not passing negligently the things he loves, but stopping to know them and to note them down in the shorthand of his sketchbook. . . . He is looking for what he loves, he tries to capture it. It's found anywhere, everywhere. Those who are not hunters do not see these things. The hunter is learning to see and to understand—to enjoy."

Drawing urges you to make all kinds of connections. Van Gogh especially enjoyed this aspect of it. Extolling the ideals of a Japanese painter who began with studies of a single blade of grass, van Gogh observed, "But this blade of grass leads him to draw every plant and then the seasons, the wide aspects of the countryside, then animals, then the human figure. So he passes his life, and life is too short to do the whole."

Some people draw to explore their own inner latitudes, doodling shapes or patterns that may evoke or define their feelings. Others, like Keller, draw more objectively, and do so to evoke and define their relationships with things. Asked why she draws animals, Keller recites some lines from Henry Beston's *The Outermost House:* "Animals . . . move finished and complete, gifted with extensions of the senses we have lost or never attained, living by voices we shall never hear. They are not brethren, they are not underlings; they are other nations, caught with ourselves in the net of life and time, fellow prisoners of the splendour and travail of the earth." Keller draws to try to hear those voices, to try to understand the splendor and

travail of the earth. She finds the most insistent evidence of these things in birds and mammals and flowers.

So did John James Audubon, who declared that he struggled for years to draw birds accurately. "Oh! What bills and claws I did produce, without speaking just now of a straight line for a back, and a tail stuck on beyond the natural sweep like an unshipped rudder," he recalled later in life. Encouraged to keep trying by his father, who counseled that "nothing in the world possessing life and animation is easy to imitate," Audubon decided he'd do better if he drew the birds "alive and moving." He took his sketch pad outside and tried to draw living birds. He could draw only quick, crude outlines. But, he later wrote, "On I went with forming hundreds of outlines of my favorites. . . . How good or bad I cannot tell. I continued for months together in simply outlining birds as I observed them, either alighted or on wing, but could finish none of my sketches," because the birds never gave him a long, uninterrupted pose. As he watched, he found he connected with each species in a different way. He began to see personalities emerge. When flycatchers stood still, he wrote, "The attitude is principally pensive. . . . They sat uprightly, now and then glanced with their eyes upwards or sideways to watch the approach of their insect prey." He saw that herons "waded with elegance and stateliness."

John Goodman, "Hen"

Much of Audubon's accomplishment as an artist lay in finding these intimate points of contact. He advised both the artist and the ornithologist that whatever they did must be "a journey of pleasure. Each step must present to the traveller's view objects that are eminently interesting, varied in their appear-

ances, and attracting to such a degree as to excite in each individual thus happily employed the desire of knowing all respecting all he sees."

Drawing, then, is a way of fostering interest in the world. It is a way of making connections with the things that surround us and with the forces that shape and animate and move them. It's a way of taking in the world's strangeness and power and finding comfort in it. Draw the intense alien stare of a peregrine's eye and you express your admiration and respect for it, while you find a way to live with its power and quickness and total disregard for you. Draw a spider and it will cease to be something monstrously secretive and venomous. Draw a rock by a riverbank and you'll feel the warmth of the sun that shines down on it and you alike. ("If you can draw the stone *rightly*," advised Ruskin, "everything within reach of art is also within yours.") Drawing is a way to know things, and the more one knows about the world around one, the more one feels at home in it.

In this sense it is not the finished drawing that counts. It is the time spent outside oneself, of which the drawing is merely a record, the ticket stub in your pocket after the concert. "The sight is a more important thing than the drawing," declared Ruskin. What counts most is the intensity of one's connection. In an hour and a half Keller does eight drawings. None of them is finished, but she accounts it "a wonderfully well-spent morning."

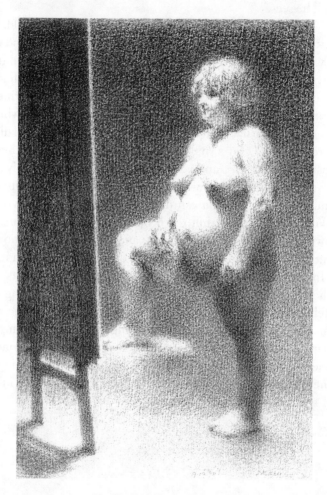

Fred Dalkey, "Diane Observing"

Why the Figure?

Four times a year, the Bay Area Models' Guild throws itself a benefit. Twenty-five or thirty models sign up to work, and seventy or eighty artists pay to draw them in a daylong session, usually in a sunlit, gymnasium-sized drawing studio at an East Bay college. The models, twelve to fifteen of them in the morning, another crew after lunch, rotate around four sides of the room, posing in groups on raised stands, one- and two-minute poses here, fives and tens there, twenties on the other side of the room and a ninety-minute pose along the far wall. The artists crowd elbow to elbow in the center of the room, those in the rear crabbing at having their view blocked by drawing boards and easels. But there are lots of models, and there is always something worth drawing in view.

One of the chief attractions of the event is that you get a wide variety of bodies and characters to draw. There are slim-hipped young women with dancer's legs, overweight women with double chins and ponderous stomachs, pale, muscular college boys and middle-aged men whose jawlines are disappearing. There are ascetic-looking African Americans in dreadlocks and balding Anglos who might, if clothed, be hardware-store

clerks. There are models of Chinese and Philippine and Tongan descent. There are housewives and cheerleaders and vamps and clowns. Ricardo Gill, a three-foot dwarf who models, brings his own nursery-sized chair to pose in. Some models will haul out costumes and props and launch into character—or more accurately, caricature. A muscled-up African American puts on a cruel-looking wrestler's mask and wrestler's boots and raises an enormous comic-book-quality broadsword over his head. A pale, thin-lipped woman sprawls provocatively in a black bustier and red ballet slippers. A demure brunette poses in a cowboy hat, black cowboy boots and a pink ballerina's tutu. The event has the energy and exoticism of a circus, the confident humanism of a Renaissance pleasure fair.

And, despite the grumblings of those who arrive too late to get a preferred seat in the front row, it is always packed. Figurative artists want to draw as many bodies as possible. They want to experience different ages, races, sizes, shapes and postures. It is not just a matter of knowing that a dwarf's hands and feet are stubbier, rounder, have different proportions than an ordinary mortal's set of extremities, or of knowing how flesh sags on a seventy-eight-year-old woman's arms and legs. It is because there is a wide range of expression in the human form—not just in terms of size and shape and color, but in terms of the way each of us displays it in posture, gesture and facial expression.

Even if you weren't drawing at such an event, I think you'd find yourself staring. You'd begin somewhat slack-jawed, because, of course, all the models are so brazenly naked and you don't see ordinary bodies unclothed and your curiosity about other bodies is assertive, a fact that most of us find embarrassing. But I imagine that even without the protective cloak of pencil, pad and artistic errand, after a few moments of poleaxed stupefaction, you'd forget that these people are naked and go on gazing, at first fascinated with the variety and immense range of difference in bodies and then struck with how expres-

sive they are. You would quickly feel a human connection, a kind of compassion with them. You might also begin to feel that there is immense dignity, energy, even beauty in them. And somewhere along the line you might realize that you are more or less abandoned to your gaze, that there is something fundamentally human in your curiosity.

We are highly social creatures, and we depend on close and careful readings of one another's facial expressions and body postures so that we may understand one another's moods and intentions. Our brains are programmed to give us an intense interest in faces and figures. Babies only a few minutes old will focus intently on a facial pattern presented to them but ignore a featureless outline. Within hours of birth newborns recognize their mothers and will make sucking responses to videotapes of their mothers' faces but not to the images of strangers.

The brain cells dedicated to envisioning the human face are in the fusiform and inferior temporal gyri, but brain scans have shown that when one is presented with a human face, groups of cells all over the brain start firing off messages. One area in the left temporal lobe will summon a name for the face, an area in the front of the temporal lobe will send up memories of one's experience with that person and an area nearby will contribute an emotional response to that particular person based either on memory or on other parts of the brain interpreting the expression and body posture of that person.

The mechanisms underlying this behavior were probably established in our brains long before we became human. David Perrett of Scotland's University of St. Andrews and other neuro-anatomists have found clusters of cells in the temporal cortices of macaque monkeys that respond only to specific views of another monkey's face. Some respond only to the faces viewed frontally, others only to a face in profile, others to a view of the back of another's head. One cluster is excited only by a face looking up, another only by a face looking down. If experi-

menters rotate the image being presented, the cells fire less intensely as the image turns away. Other groups of cells in the macaque brain respond to specific facial identities, such as the faces of mothers or siblings or troupe members. There are cells that are sensitive just to the gaze of another individual. And there are cells that respond specifically to certain aspects of posture or gesture, for example, the turning of another individual's head to look at the monkey. There are cells that respond to particular body orientations or to particular movements of the hands—say, a hand grasping an object or a hand pushing an object away.

It is likely that these specializations go back far into the evolutionary past. Other creatures show quick responses to one another's postures and movements. Jays respond by turning their heads when other birds turn their heads, and a jay will respond even more rapidly when a more dominant jay fixes it with a binocular stare.

While scientists haven't done the invasive experiments that would be needed to locate a vast array of these cells in human brains, it seems clear that we do have them and that we may use them in more elaborate ways than do macaques. We humans also recognize familiar individuals by body posture and characteristic movement long before that individual is close enough to reveal a face. In 1973, Gunnar Johansson of the University of Uppsala made films of individuals with lights attached to their shoulders, elbows, wrists, hips, knees and ankles, leaving the contours of their bodies hidden in darkness. Only the twelve lights were visible in the films, but when he showed them to test subjects, they perceived that they were viewing humans within one hundred milliseconds. With as few as six lights on a performer, subjects could readily tell whether the performer was walking, running, jumping or dancing. Subsequent studies by other researchers showed that observers could discern the sex of these light dancers and even identify themselves or roommates in the films in less than two seconds.

A fair amount of research has focused on parts of the brain devoted to the recognition of another's facial expressions. Patients with damage to the amygdala (an almond-shaped structure in the temporal lobe) show impairments in recognizing expressions of fear, anger, disgust and sadness on other people's faces, even though they can still make these expressions on their own faces. Victims of Huntington's disease often lose their ability to recognize these expressions. One interpretation of autism is that it involves a defect of the amygdala, because autistic individuals cannot read others' facial expressions.

Certainly, says David Perrett, "there's evidence that humans are specifically tuned to body parts. We've looked at cells sensitive to particular postures—hand or leg postures—or particular articulations. We've shown that cells are tuned to particular parts of the body and specific views, like the back view or the side view. Even a good drawing of a hand could be expected to excite the same cells."

And Perrett believes humans hone and elaborate the connections between these specialized cells all their lives. "Because we spend a lot of time looking at other people," he says, "our brains get rewired. They get rewired to look at a posture and tell what's what. We need to know what that position means, what their intentions are. Because it's so important, there's a lot of brain tissue devoted to it."

Looking at other people may be as essential to growth and maturity as eating and sleeping. Giacomo Rizzolatti and other Italian researchers studying the brains of macaque monkeys have found a specialized type of cell they have named "mirror neurons." These cells activate when the macaque is performing a specific hand gesture, some when the monkey is picking up an object, others when it is grasping an object in a power grip and others when the monkey pushes an object away from itself. The same cells will also activate when the macaque sees another individual perform that specialized movement. Each cell responds only to a very specific gesture, but the cell responds

both when the macaque performs the gesture and sees it performed. It's monkey see, monkey do. A macaque seeing the movement in another individual is apparently urged by the action of these cells to perform the same action, and that, Rizzolatti speculates, may be the origin of learning. He sees this area in the macaque brain as a homologue to the Broca's area in the human brain, which is especially concerned with the production of speech. He hypothesizes that these cells will turn out to be a key mechanism in all kinds of imitation essential to learning language and behavior.

That mirror neurons exist in human brains is supported by several lines of evidence. Studies have indicated that human subjects show an increase of motor evoked potentials (the electrical charge passing along neural pathways) in hand and arm

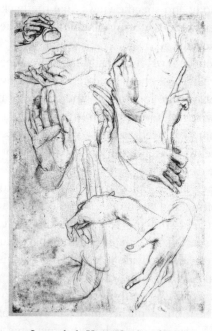

*Leonardo da Vinci, "Studies of Hands
for the Uffizi Adoration"*

muscles when they see another individual grasp something. And PET scans show increased cerebral blood flow to areas of the brain where mirror neurons are believed to reside when a subject observes another person grasp an object. About 5 percent of patients whose right-hemisphere strokes have rendered their left sides completely paralyzed deny their paralysis, and some of these patients also deny that others suffer the paralysis, even though the paralysis is clearly visible to nonstroke victims. V. S. Ramachandran, a University of California, San Diego, psychologist and neuroscientist who noticed this phenomenon, declared, "It is as if anytime you want to make a judgment about someone else's movements you have to run a virtual reality simulation of the corresponding movement in your own brain, and without mirror neurons, you cannot do this."

There are presumably mirror neurons in our brains that code for facial expressions. A 1982 study showed that infants will look less at faces when expressions on those faces remain constant than when expressions are repeatedly changed. And studies have shown that newborn babies will imitate facial expressions such as mouth opening and tongue extruding. Rizzolatti suggests that mirror neurons come into play when a newborn baby sticks its tongue out in response to an adult making the same expression.

University of Iowa professor of neurology Ralph Adolphs explains that recognizing emotion in another person activates areas in the brain "that may simulate how one would feel if making the facial expression shown in the stimulus." Whether such behavior is learned or hard-wired into the brain at birth is not yet known. Adolphs thinks it's possible that "certain facial expressions may be linked to innate somatosensory knowledge of that emotional state, without requiring any extensive learning."

We are particularly interested in faces because we are particularly expressive with them. Humans have forty-three facial

muscles, more than any other animal, and all of them are used to express feelings, moods and intentions. An individual human is capable of thousands of different facial expressions. There are six basic expressions. In 1872, Darwin listed them in *The Expression of the Emotions in Man and Animals:* enjoyment, anger, fear, surprise, disgust and sadness. Studies in different cultures and languages confirm that all healthy humans recognize the same meaning in these expressions. All of these expressions are inborn. Even babies born blind and deaf will have them. All expressions are matters of degree, so that one can express mild enjoyment (amusement), moderate enjoyment (eager attention), intense enjoyment (raucous laughter) and any number of stages in between. We can mix expressions, too, so that one can register combinations of surprise and disgust, sadness and anger, and so on. Paul Ekman, a University of California psychologist, estimates that there are about ten thousand different facial expressions, some three thousand of which reveal specific feelings.

We are programmed to recognize an almost limitless range and quality of expression and to convey the same range in our own faces. Our very ideas of beauty are to some extent hardwired. We'll respond differently to a woman who has wide cheekbones, narrow cheeks, a broad smile, wide, high-placed eyes, large pupils, high eyebrows, a small nose and a short distance between mouth and chin—all of which are indications of high estrogen and low androgen levels and therefore are indications of high fertility. And we are programmed to some extent to judge one another's bodies. Our gazes linger longer on bodies that seem strong and healthy, steal away from those that seem gaunt or sickly or sexless.

We all go beyond the rudimentary types—beyond stereotypical images of beauty or basic expressions of feeling. We all learn to read expressions that are complex and subtly nuanced. There is a premium on being able to read them fluently, on recognizing fine levels of precise meaning, for the better we read

expressions, the better we coordinate with others and the more likely we are to be fed, sheltered, esteemed and sexually successful. Different people probably have different degrees of facility and attainment in reading others. But in each of us large parts of our brains are devoted to registering, interpreting and responding to one another's movements, postures and facial expressions.

There is reason to believe that as a species we have grown increasingly reliant on these faculties. For most of our evolutionary history, we have lived in small groups and had little experience of strangers. But as populations have grown, we have adapted to greater human densities and more frequent experience with strangers who are not bound by family and community obligations to act civilly toward us. Among the adaptations to greater density has probably been an increasing reliance on our abilities to read one another's character and intention quickly and from a distance. And we have probably had to place increasing importance on being able to control our own faces and postures.

Our intense awareness of our own faces and postures is a quality older than humanity. The brain structures needed for self-recognition seem to be present in apes, which, daubed with red eye stripes and provided with mirrors, will touch their foreheads and sniff their fingers. Chimpanzees and orangutans alike will make faces at themselves in a mirror. But humans take self-awareness much further than any other creatures. Humans will look for responses to their own faces or bodies in the face of another, and thus seek to get others to display respect or fear or amusement in their facial expressions. Humans alone among animals habitually alter their natural appearances, through costume or cosmetic, ornament, tattoo, scarification, filing teeth, or cutting and shaping hair. The antiquity of the human belief that character is stamped in one's appearance is vouched for by the presence of body ornaments in ancient graves.

In all cultures, our deep human interest in body posture gets formalized in dance. And, in most cultures, men and women fix images of human character into clay or stone or wooden carvings. The images may be stylized and generalized, such as the masks used in African dances, which often embody gods or goddesses or ancestral spirits. Or they may be as naturalistic and individualistic as the portraits adorning a corporate boardroom.

The large amount of cerebral activity devoted to people-watching perhaps explains why television is so addictive to some. Television is a people-watching technology, especially adapted to looking at the human body and its gestures and at human faces and their expressions. Its forte is the tightly framed human head, and its next favorite view is a human body in motion or in gesture, showing apprehension or affection, surprise or anger.

Inevitably, our interest in bodies and faces expresses itself in individual portraiture. The oldest-known human portrait might be a twenty-six-thousand-year-old ivory and clay statue of a Czech woman whose bone disease caused her face to droop, a feature in both the sculpture and the skeletal remains buried with it. Naturalistic treatment of human character seems to be a relatively recent addition to our culture. Paleolithic artists could paint wonderfully naturalistic animals on the walls of caves and yet would depict the human hunters pursuing them only as crude stick figures. Perhaps when our remote ancestors moved around in hunting-gathering bands of fifteen to twenty-five individuals and seldom encountered strangers, individuality seemed fixed and familiar—not as complicated or as worthy of artistic representation as the wild animals that appeared and disappeared so mysteriously. The desire to represent human forms realistically seems to assert itself after human cultures cease to be based on hunting and gathering and humans define themselves as being separate from nature. That transformation

perhaps caused humans to question their own nature more deeply, to ask what is shared by all humans and what is uniquely individual.

Looking for individual characteristics in a portrait is a Western pastime. You see occasions of it in Indian, Chinese and Japanese art, but it is much more at the center of Western artistic interest. It's tempting to guess that at the heart of this is a Western tradition of quarreling with the gods, of questioning and challenging religious views—to the point of considering what is human in the gods and what is godlike in humans. That tradition has also made nudity in art largely a Western form. African, Asian and South American painting and sculpture has seldom shared the Western interest in combining realism with attention to the human form. While Ife sculptors of Nigeria made lifelike portrait busts of tribal chiefs a thousand years ago, and even contemporary wood carvers working in traditional forms shape breasts and bellies and genitals and hips into their work, individualized nudity isn't often seen outside the Western tradition.

Four thousand years ago, the Egyptians had an intense interest in portraiture. In Egyptian tombs are likenesses of the pharaohs, their families and their servants. Egyptian art is an odd mix of naturalism and convention. A person may be portrayed with much individuality and detail, but some features remain stereotyped. Faces and feet are generally seen in profile, but shoulders and eyes in the same figures are shown frontally. There is a mixture of image and symbol, suggesting that the artists sometimes viewed humans as conventional creatures, created alike by the gods, and sometimes viewed them as self-willed individuals.

The Greeks built on Egyptian technique to perfect a more naturalistic style. The ancient Greeks and Romans were so interested in the human face and figure that great value was placed on artists who could capture individual likeness and

character in their work. Pliny, the Roman natural historian who in the first century A.D. chronicled the development of Greek art, held that "realistic portraiture, indeed, has for many generations been the highest ambition of art." He praised the accuracy and realism of Greek painters such as Apelles and credited them with developing perspective, the precise rendering of light and the ability to paint individuality, character and feeling in their figures. Pliny said Apelles' portraits were so realistic that physiognomists could use them to foretell how long the sitter had to live.

Greek painters attained celebrity. The painter Zeuxis became so proud that he had his name embroidered in gold letters on his garment and paraded around Athens like a modern prizefighter walking into the ring. According to Pliny, Alexander the Great made frequent visits to Apelles' studio and commissioned the artist to paint a nude portrait of his favorite mistress. When Alexander viewed the finished portrait, he saw that the artist had fallen in love with his mistress and made a present of her to Apelles. (Pliny moralized, "He conquered himself and sacrificed to the artist not only his mistress, but his love.") Even models became celebrities. Phryne, a courtesan who posed for Apelles' picture of Venus rising from the sea and for Praxiteles' Cnidian Aphrodite, also had a reputation for going through men's fortunes but was so celebrated as a model that a gilded monument was raised to her at Delphi. It is recorded that Lais, a prostitute-slave who modeled for Apelles, slept for nothing with Diogenes, but refused even for money the attentions of the famed orator Demosthenes. The Greeks thought enough about the relationship between artist and model to come up with the myth of Pygmalion, the artist who, convinced that mortal women were grasping and deceptive, carved an ideal beauty in marble that was so perfect that the gods gave it life.

The Greeks and Romans were inspired by the idea that mortals and gods were similar, and they idealized faces and

figures. The Greeks thought spirit and body were one, that the gods appeared as mortal men and women and that some human forms were more nearly divine than others. So they searched out idealized forms of male and female beauty. Zeuxis is remembered for lining up a procession of naked girls and choosing five from which to assemble, feature by feature, an ideal figure. Greek depictions of Apollo were intended to convey the restraint, balance, modesty and proportion of perfect beings and to show confidence in the power of their physical beauty. They were young, muscular men, eight heads tall, athletically posed but given a gentle and benevolent bearing. Greek Aphrodites were equally idealized. A fourth-century B.C. Aphrodite was seven heads tall, the width of one head between the breasts, the height of one head from breast to navel, another head from navel to the division of the legs. The Greek artist sought to pose her at an exact point between balance and motion, resting on one leg, the other bent as if to move, shoulders turned with one slightly elevated. The aim was to express desire but to express it in such a way that it had a religious, rather than a merely libidinous, feeling. These ideal forms, discovered in the fourth century B.C., held men and women in their thrall for more than two thousand years. The Romans repeated them. The painters of the Italian Renaissance copied them.

With the Renaissance painters one can begin to see why Western tradition comes back again and again to nude figures. Western artists believe that clothing individualizes and temporalizes. It locks a figure into a particular time and place. And the gods and goddesses are timeless. So, we would like to believe, are human virtues and vices. If we remove the clothing, we remove the extenuating circumstance, the questions of political motive or class or economic advantage. We draw what we perceive to be universal and eternal, what we perceive to be human nature or divine gift.

Renaissance artists shared, or wanted to share, the Greek view of human figure as divine form. They often conflated this

desire with the belief that mathematics offered timeless perfec-
tion, and they drew up charts of ideal human proportions. But
they did not see individuals walking around who resembled the
Aphrodites and Apollos of the fourth century B.C., and that puz-
zled them. Dürer, for example, believed that Adam and Eve were
created perfect in form and character and that their imperfec-
tions came with the fall, so henceforth no living human would be
perfect. He learned Italian canons of measurement from Jacopo
de' Barbari when he traveled to Venice, but he kept on searching
for ideal human forms, drawing from live models and frequenting
the Nuremberg bathhouses where naked figures could be stud-
ied. He imagined the ancient Greeks knew more than Renais-
sance painters about perfection and lamented the destruction of
their works and their texts on drawing and painting by barbar-
ians—and later by Christians—who "if they saw figures traced in
a few lines they thought it nought but vain, devilish sorcery.

"The sight of a fine human figure is above all things pleas-
ing to us," Dürer wrote. But no single man or woman could be
taken as a model of perfection. "For no man liveth who uniteth
in himself all manner of beauties." The artist had to draw all
sorts of figures, tall, short, young, old, thin, fat, strong, weak,
black, white.

Perfection itself remained, in Dürer's mind, undefined.
"There liveth no man upon earth who could give a final judg-
ment upon what a perfect man is," he wrote. "God only
knoweth what is the perfect figure of a man, and he knoweth
likewise to whom he revealeth it." Dürer drew, as have most
artists, as a search for that perfection.

Perfection was not simply a physical dimension; it was a
matter of character. So Renaissance artists were interested also
in individuality. Leonardo was increasingly concerned with
drawing "the mental state of the creatures that make up your
pictures, rather than . . . the beauty and perfection of their
parts." Leon Battista Alberti, who in 1436 wrote one of the ear-
liest instructional painting books, placed great emphasis on

representing "the movements of the mind" through the movements, gestures and postures of the human figure. That meant understanding the body that moved underneath the garments. He urged that "before drawing a man we must first draw him nude, then we enfold him with draperies." He recommended always drawing from live models. Raphael generally followed this practice.

Renaissance artists studied the body closely. They drew from cadavers and even dissected them to try to understand how bones and muscles worked underneath the skin to make the surface so expressive. (Leonardo kept cadavers and parts of cadavers in his studio, drawing them despite the paralyzing stench.) Live female models may have been hard to come by. Michelangelo's figures of Night and Dawn on the Medici tombs are females drawn from male models, the artist afterward simply adding breasts.

The Christian outlook that supplanted the Roman worldview was less enthusiastic about the potential of human nature, which it viewed as mired in sin. Christian artists did not depict the gods in human form, found little to be ennobling in the human figure and for a thousand years did not see a need to work from human models. Most representations of humans during the Middle Ages were stylized forms, symbols rather than portraits.

In the end, the Christian view much constrained the Renaissance painters, who would have liked to have reasserted the divinity they found implicit in the human form of ancient statues. Art historian Kenneth Clark pointed out that the nude form that survived as canonical in the Renaissance was not Venus or Apollo, but the undraped form of the crucified Christ. The nude survived in the Renaissance less as an expression of joy or confidence than as an expression of pathos, in scenes of the crucifixion, the pietà and the expulsion.

Our sense of what the body means changes with the times. If the nude was an important subject during the Renaissance, it

was so because the artists and their clients viewed human nature as good and felt the gods shared their divinity with mortals. And if nudity thereafter declined into nakedness, if the unclothed body ceased to have noble meaning and fell increasingly into the realms of shame and desire, it was because our views of human nature and human spirituality had changed.

The northern painters, much more deeply affected by the Protestant Reformation and its less generous view of human spirituality, couldn't see the human form in the same way the Italian painters saw it. Kenneth Clark pointed out that while Italian Renaissance painters emphasized the curve of Aphrodite's hip, which gave her an expression of energy and control, Dutch and German painters tended to emphasize the curve of the stomach and drew bulblike bodies that drained the power and control from the character of their Eves.

Through the seventeenth and eighteenth centuries, academic painters continued to preach the ideals that had endorsed nudity during the Renaissance, but to a world that no longer shared Renaissance optimisms. They were, in effect, copying dead forms, and one can imagine the dreariness of artists' studios as female models stood on a dais posing as Aphrodite or Diana, but feeling and expressing none of the meaning their Greek and Roman predecessors felt and expressed. They posed before artists who believed in the achievement of the old masters, but not in the worldview it represented. The nude remained powerful in works that were straightforwardly about desire, for example, the drawings of Boucher and Prud'hon. But when Victorian Englishmen tried to resurrect the nude by painting it as gods and goddesses, the work often lacked conviction; looking at such paintings today, we sense a conflicted mixture of moralizing and concupiscence, and the work seems disingenuous or wooden. By the middle of the nineteenth century, academies were teaching the nude chiefly as an exercise in seeing forms—a kind of technical workshop in which the nude body was separated from its vast array of possible meanings.

The nineteenth century saw a change in the market for art, as a rapidly growing middle class replaced aristocratic clients as patrons of artists. With that, too, came changes in the way artists viewed their place in society, particularly in France, where democratic ideas flowered through the Napoleonic era. Artists were increasingly moved by the romantic notion that humanity originated in nature and that natural forces were powerful and good. They found themselves looking for the beauty and nobility of humanity not in ancient gods and goddesses, but in workers and peasants. In 1848, when the Pre-Raphaelite painters John Everett Millais, William Holman Hunt and Dante Gabriel Rossetti broke away from the British Royal Academy, they forswore the use of professional models and their repertoires of formal poses and gestures, and sought to find their own models from agrarian and working-class families. With this development emerged an idea that the model brought to the artist a wild spirit that would inspire him, and this feminine energy was celebrated both sexually and artistically.

You can see this view expressed in paintings of the period. In Gustave Courbet's *The Artist's Studio*, painted in 1855 and described by Courbet as "a real allegory summing up a period of seven years of my life," the artist sits before a canvas on which he is painting a landscape. A nude model stands behind him, watching over his shoulder as he works. The message is that the model is his muse, that desire is a part of creativity. In Jean Auguste Dominique Ingres's *La Source*, a frontal nude in a classical pose, hips cocked, one foot slightly raised and forward, has one arm over her head holding a ewer, which is pouring a steady stream of water. Woman is the source not just of fecundity, but of the artist's inspiration. The painting was displayed in London in 1862, where it rekindled British interest in the nude. And the idea that feminine sexuality is a source of artistic energy has been with us ever since.

These developments sparked a renewed interest in the human form. And as artists drew ordinary people, they found

more and more to say. Toulouse-Lautrec drew in brothels, Degas in dance theaters. Rodin hired his own models and had them stroll naked around the studio so that he might find natural poses in their movement. By the time Picasso began to draw his own model-mistresses, he was not interested in feminine divinity as much as in the artist's relationship to the inspirational power of feminine form. He drew more than one thousand pictures of artists and models together, in many of which the artist is also nude, but appears to be intellectualizing, bloodless, incapable of seizing or understanding the natural beauty before him.

Just as drawing and painting the figure was regaining respectability, something else came along to make it seem irrelevant: the camera. Originally an instrument for passing light through a small hole to cast an inverted image on a wall

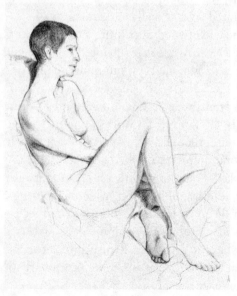

or drawing surface, the camera had been employed by artists to reduce three-dimensional reality to two-dimensional forms as early as the sixteenth century. Leonardo da Vinci described (and used) such a device. Eighteenth-century physicists found methods of coating glass plates with salts of the element silver, which changed color when exposed to light in such a way as to pre-

Margaret Wade, "Cynthia"

serve the image. Early-nineteenth-century inventors figured out ways to fix the image almost permanently. Artists were among the first to embrace the new technology. William Talbot, an amateur artist who developed a method of making negatives and printing images from them onto paper, wrote, "Already sundry amateurs have laid down the pencil and armed themselves with chemical solutions and with camera obscurae."

In 1837, Louis Daguerre, a French artist who had painted scenery for opera and stage productions, perfected a technique for capturing images on a metal plate. He declared he had invented "a chemical and physical process which gives Nature the ability to reproduce herself." Daguerre's apparatus required an exposure time of from five to forty minutes, depending on the intensity of the light illuminating the subject. Improvements in the sensitivity of plates and in lenses that gathered more light soon made portraiture possible. By the 1850s, portraits were the daguerreotype's chief subject matter. In 1853 New York City boasted eighty-six portrait studios.

Daguerreotypes were fragile, expensive and irreproducible. During the 1840s, processes of making negatives and printing their images positively on paper were improved. Almost overnight, the technology made it possible for laymen to capture images from nature more accurately than most trained artists could, and then to reproduce and distribute these images almost without limit.

Photographs changed the way we looked at visual images. They created a new standard of truth. A photograph took in so much more information than a painting, had all the forms and exactly reproduced the proportions between forms. A photograph's dogged honesty gave it a credibility that drawing could not equal. Even the least educated photographer could capture images superior in accuracy and precision to those produced by an artist. So photography took over much of the interest in the body and face that artists had hitherto served. With motion

pictures (early in the twentieth century) you could also more realistically and more accurately capture action, and so film displaced the sketch pad and canvas as the document of historical moment. When photography evolved into television, it made human images so easily available, so numerous and so diverse that one could indulge one's interest in the face and the body endlessly without the services of an artist. Today, if you compare the proceeds to gallery owners and painters with the fortunes amassed by the television and motion-picture industries, drawing seems quaint and archaic.

Photography, of course, did not completely replace the artist. Drawing could still bring more emotion to a picture and more emotional access to a subject. An artist could relocate a subject, distort it or simplify it to give it greater emotional content than most photographs could afford. As a result, though the camera displaced the artist as a portrayer of likeness and scene, it also pushed the artist to move inward, and that had much to do with impelling artists to impressionism, cubism and abstraction.

The photograph widened everybody's experience. Cheap reproductions of photographs, sold as stereopticon views of Paris and Cairo, took people to distant cities in the comfort of their own parlors. Photographs brought celebrities and politicians into a purview that approximated intimacy. Actors and actresses routinely posed for publicity photos in the 1850s. More to the point of this discussion, the photograph largely claimed the nude. Much as the Internet a century and a half later made private sex acts public, the photograph gave nonartists the experience of looking at unclothed bodies, though not in a way likely to help them understand the tasks of the artist, blurring as it did one kind of body gazing with another. Gradually, over the course of the twentieth century, images of undraped bodies would be circulated widely, as pinups, calendar art and magazine centerfolds. Today, sexually explicit pictures are a billion-dollar industry, but it is not one in which artists participate.

Photography hijacked so much of the artist's vocation that it is worth asking why people keep on drawing. If you look at drawing from a market point of view, considering that cameras make pictures more accurately, more rapidly and in a way that can be quickly and widely reproduced and sold, drawing makes little sense. But if you look at the act of drawing as a reflection of the human need to look deeply and expressively at things, drawing still makes eminent sense. There are at least three good reasons people still draw the human figure.

The first is that photography in some sense inadvertently created a new need for drawing. Photography has vastly multiplied the number and frequency of images to which people are exposed. With television, we have access to hundreds of thousands of images a day. All this has probably made us more visual, less verbal—or at least visually more complex. It seems also to have shortened our visual attention span, because the accelerating cascade of quick images allows us less and less time to dwell on any one image in particular. Imagery is competitive, and there is an ever-increasing demand for sensation to hold a viewer's attention. That has pushed movies into more sex, more violence, bigger explosions, louder noise, and correspondingly into less discussion, less storytelling, less subtlety of character. It leaves to the artist the longer, quieter, more contemplative, more idiosyncratic and individualistic view that stands less chance of surviving the corporate worlds of film and television production. It offers the possibility of a more considered, more original vision.

The second reason is that the artist still has these brain cells clamoring for views of people and still wants to exercise his or her eyes. Cameras capture images mechanically, and do so increasingly without human intervention. You can put a camera on a timer and leave the room. But you can't be absent and draw. In drawing you have to translate everything into your own line, your own values, your own spaces. An artist is present

in a drawing in a way a photographer is seldom present in a photograph. Many find that presence enlivening.

The third and most insistent reason to draw the figure is this: if we're going to draw, the human figure is still the greatest challenge, both because it is familiar and because there is always more to it than one can readily see. Psychologist Rudolf Arnheim wrote, "The human body is a particularly complex pattern, not easily reduced to the simplicity of shape and motion. The body transmits compelling expressions. Also, it is overloaded with non-visual associations. The human figure is the most difficult vehicle of artistic expression."

It is difficult, too, because we have spent so much of our lives looking at figures that we have a higher degree of discrimination and judgment about the human body than we have about any other complicated object. We know right away when a figure drawing is inaccurate or ill-observed. Hawaiian artist Herb Kane says, "Humans are the most difficult thing for the artist to do, because the human eye is more perceptive to humans than it is to anything else. You may not be able to distinguish one flower from another, but you certainly can distinguish one person from another." Says Marin County artist Kathlyn Free, "If I can draw a human figure and make it look like a human being, then I know I can draw anything. If you do a tree no one can see that it's wrong, including you."

Part of the challenge is that there is so much in the human form that is not tangible. Says Edward Hill, a figure holds within it "the mysteries of energy, articulation, growth, mobility, organic construction and unity . . . the qualities of living things." Says Eleanor Dickinson, "The human body is the best image of the human soul."

And clothes are, of course, intended to hide much more than shame. We put on costumes to hide what we are afraid the world will see, which is not our sexuality but our character. Paul Valéry, explaining our fascination with the nude, wrote that

"man conceals from his kind both what he feels to be weakest in himself and what he holds to be most precious; often enough, between these two things, different but identically hidden, confusion can easily arise. Every man keeps his sores and his money hidden." Clothes are meant to trade artifice for naturalness, calculation for candor. It is one of the aims of fashion to let one hide behind someone else's idea of character when one's own idea of character is in doubt. Says Dickinson, "You just don't express an awful lot in clothes."

And when you draw, you begin to see that the social conventions you entertain about the body are inadequate. You see that stereotypically "beautiful" bodies are often drained of meaning because they are so self-consciously fashionable. You find that the models who don't fit Hollywood ideals of beauty elicit the better drawings. Model Ashley Hayes recalls working one day at the Brentwood Art Center in Los Angeles with a woman who had surgically enhanced breasts, long legs and a tiny waist. Hayes said to the manager, "I wish I looked like that." The manager assured her that the artists preferred her to the centerfold. "She said, 'I think you have a perfect body. It's better to draw.' "

Says Marin County artist Ann Curran Turner, "The less 'perfect' models are the ones that I think have the best energy. They have more definition. And someone who weighs two hundred pounds and is willing to take her clothes off has to have a certain something—a sense of irony, a sense of drama, a sense of confidence—that they project, or they couldn't do it." Seeing these invisible things in the model or in ourselves and putting them into visible form is the heart and soul of drawing.

Drawing the figure is a kind of exploration, a search for our own nature, our origins, our souls. If we just wanted images of the human body, we could rely on other people's photographs. Or we could draw from their photographs. But we don't draw from photographs because we would simply be reproducing

someone else's vision. It would just be more stereotyped thinking, more of what we absorb through advertising slogans and political hype. It would not enable us, in Kate Bennett's words, "to see." We draw the figure because it offers us the possibility of seeing deeper into one another's nature, into ourselves, into human nature in general.

There is a lot of whimsy and laughter in a Bay Area Models' Guild drawing marathon. But the eighty artists clustered around fifteen nude models are all deeply engaged with what they are doing, delving deeply into their own hearts and minds, and into the hearts and minds of others, earnestly seeking to know for themselves what it means to be human. It's a very serious business indeed.

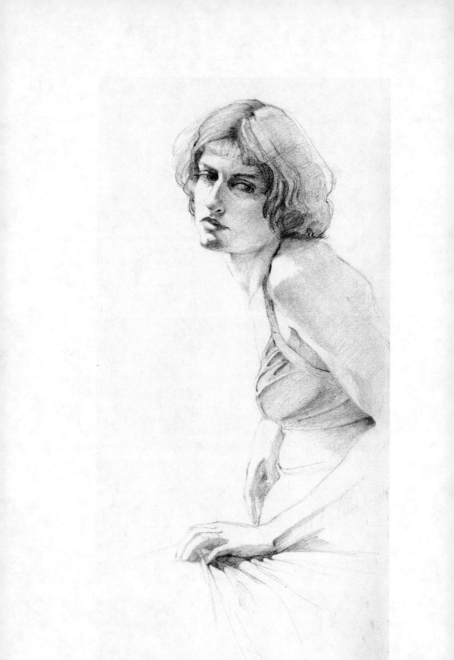

Margaret Wade, "Merav"

Faces

At the "blockbuster" 2003 Matisse Picasso show at the Museum of Modern Art in Queens, the visitors stood back from the big paintings, held off by their scale and their loftiness of purpose. The pictures did not convey to the viewers feelings of familiarity or intimacy. The paintings were great art; they were also sonorous and, to many, baffling art. A middle-aged woman stood in front of Picasso's *Mandolin and Guitar,* a vast, bright, abstract still life, and said, "It's very interesting because you can actually recognize things." Certainly not the response Picasso hoped for. In front of most of the paintings, the visitors stood silent and apart, Acoustiguides pressed to their ears, listening for clues to what they should be looking for.

But in one corner of the exhibit, apart from the paintings, hung a cluster of drawings, most of them portraits of the artists' friends. The visitors moored themselves around these drawings like ships taking refuge from stormy seas. Their body language changed—their shoulders relaxed, their heads were held higher. They pressed close to the drawings, stopped and looked lingeringly. It was as if they had run into old friends. They stood before Picasso's naturalistic *Woman with a Pitcher* and marveled at the life in it, untroubled by the redrawn lines or the day-

dreamily tentative contours of the woman's shawl. At some time in their lives they had all tried to draw something, and these drawings put them onto familiar ground. They could see Picasso's struggle in the drawing, see his second thoughts as well as his unerring accuracy and penetration.

But it was not just the act of drawing that they connected with; it was the subject. They lingered most especially upon the portraits. A man and a woman stood in front of Matisse's drawing *Lorette's Sister*, talking as if the woman in the picture were alive.

"What's happened to her nose?" asked the woman.

"He didn't like her," the man said.

"They knew how to draw. I'll tell you that," said a man looking over their shoulders.

They looked at the faces intently, unblinking, with a concentration, a frankness and a questioning they could not bring to a living visage, because here it is not impolite to stare. Drawings let us gaze into people's faces in ways we otherwise cannot, let us take long, quiet looks that are not challenged by the subject's desire for privacy.

Faces contain everything. They are expressive of all human emotion and all human experience. We look into them to judge one another's character. We look at a portrait with the thought that we can see beyond the surface, into the heart and soul of the sitter. When we look at faces, we are looking for essences. Sometimes we find them. Consider how some drawn and painted visages—for example, Leonardo's *Mona Lisa*, Velázquez's *Aesop*, Manet's *Olympia* or Sargent's *Madame X*—take on lives of their own, stir one's heart and live on in memory.

Once one starts drawing as a way of seeing, faces become a commanding subject. Vincent van Gogh is probably remembered most for his irises and sunflowers, his wheat fields and cypress trees. But he wanted especially to paint portraits. "I would sooner paint people's eyes than cathedrals," he wrote.

"For there is something in the eyes that is lacking in a cathedral, however solemn and impressive it may be. To my mind, a man's soul, be it that of a poor beggar or a streetwalker, is more interesting." He kept on drawing fields, but constantly wanting "to put a small figure into it." His deepest aspiration was to establish himself as a painter of Dutch and French peasant life. And increasingly he wanted to focus just on faces. "What fascinates me much, much more than it does all the others in my trade," he wrote, "is the portrait. . . . I should like to do portraits which appear as revelations to people in a hundred years' time. . . . I am not trying to achieve this by photographic likeness, but by rendering our impassioned expressions, by using our modern knowledge and appreciation of color as a means of rendering and exalting character."

One can invent a landscape. One can to some extent invent human figures. But one can't invent portraits. For that, you need company. The French painter Ingres declared, "One must not attempt to produce fine character, one must discover it in a model."

Faces are hard to see. They're visually complicated. They are three-dimensional forms that catch and reflect light at all kinds of different angles. They are constantly changing expression, and expression itself is a complicated and subtle thing. Faces hold things back so that you have to look carefully to see what a face is revealing and what it may be concealing. They are immensely challenging things to draw.

There are uniform qualities in faces that can help you to start. There are measurements in faces that are unvarying between individuals. The average head is five eyes wide. If you draw a triangle connecting the outer corners of the eyes with the middle of the lower lip, all sides will be the same length. In a face viewed frontally, the width of the mouth is the distance between the centers of the eyes. Leonardo filled notebooks with lists of such recurrent proportions.

But each face is so precisely different, and our human ability to see these differences is so acute, that drawing faces requires even more accuracy than drawing figures. The smallest errancy in line or tone or proportion will destroy likeness or expression.

The challenge of drawing faces is compounded by the fact that they are almost always in motion. When people are together, their faces become semaphores, constantly signaling mood and meaning to one another. People continually move their heads, changing their vantage points, being observant or expressive most of the time. The head is heavy, the neck thin, and the very physics of this arrangement work to the artist's disadvantage, as people fidget and shift just to take the strain off their necks. Humans can't sit still for very long. They are built to be either searching or acting.

What most defines likeness and expression in a face is the pattern of light and shadow, so the way light falls upon a face is crucial. When you start to draw the face, you often seek three-quarter light, a single source of light at a forty-five degree angle to the front of the face, which will give you the full range of features combined with the most sharply defining shadows. You can do that in a studio with a posed model. In real life, the head is constantly moving and the light is constantly changing. To draw a human face outside the studio, you have to see it quickly and remember it well.

Leonardo da Vinci advised the artist to carry a notebook "when you are out walking" and jot down "the positions and actions of men in talking, quarreling, laughing and fighting together" with rapid notations, a circle for a head and stick-figure limbs and torsos to indicate gestures, and later flesh them out in drawings at home. He advised the artist to memorize types of facial features, for example, ten different kinds of noses, so that when drawing a stranger in the marketplace one might pull the subject's nose from one's memory and thereby save time.

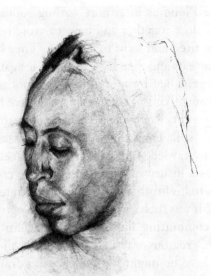

Michael Markowitz, "Untitled"

But to see even types of features, one needs experience. One must, Leonardo advised, "make an effort to collect the good features from many beautiful faces." Most of us have to draw a considerable number of them before we begin to understand what features we are looking for and what lines work for them.

When I began to draw again in my forties, it was character that most occupied my mind, and drawing faces was a way to explore character. I began carrying a sketchbook and tried to draw people as I found them in parks or restaurants. I was simply not fast enough. I had drawn too few faces. I knew too little about anatomy. I had not yet found simple lines with which to quickly note the forms of eye, nose and lips.

But I found that in certain places, people slowed down. I was traveling a lot as a journalist, on the road one week out of every four. I spent a lot of time in airport waiting rooms. And there is perhaps no place on earth where people's heads hold so

still for so long as in airport waiting rooms. The people are crowded close together and have to avoid one another's gazes. They are tired and want to sit down. They have to stay put or lose their seats and then have to struggle again with their carry-on luggage. They are more often than not traveling alone and they are not talking, so their expressions are bedded down. The food in airports is terrible, so they're not eating, and that keeps their jaws still. For years, I filled small sketch pads with the faces and sprawled bodies of my fellow travelers.

It was a luxury van Gogh missed. He constantly lamented in letters to his brother, Theo, "I am frustrated by a total lack of models." It was such a problem for van Gogh that when he considered committing himself to the asylum at Montevergues, one of his reasons was that the inmates there worked in the fields, where he might have chances to draw and paint them. Outside the asylum, if he stole up on a peasant working in the field, he found the peasant moved faster than he could see. He had no money to pay people to pose for him. If he did have the money, his personality was so shaggy that few people were willing to sit for him. And if he found a peasant desperate enough to sit, a village priest or family member would dissuade the would-be model, telling him that to sit under the madman's gaze—or for that matter any stranger's gaze—was humiliating and dangerous.

Gazing is, in all primate species, a language unto itself, and one that is full of threat and embarrassment. A direct stare is in all primates an aggressive act, something likely to lead to a fight. Staring has physical impacts on other people. Any gaze longer than ten seconds with no intent to communicate verbally will induce irritation or real discomfort. Studies show that being stared at raises our blood pressure and heart rate. Most of us are uncontrollably afraid of such stares. The behavioral rule is so deeply ingrained in us that it is thought to be the root of an actor's stage fright and the widespread fear of speaking in public.

On the other hand, eye contact is also the language of love. Mothers and infants look into each other's eyes to bond and reassure. Being looked at in such an inviting or reassuring way can induce physical pleasure. When lovers gaze into each other's eyes, the pupils dilate and shine with tears. Gazing like that is an offer of intimacy. Italian women used to apply belladona to their eyes to artificially dilate them and make their gazes more enticing. Today women apply mascara and eyeliner to their eyelashes and eyelids to look inviting.

We are, in all our dealings, extremely careful of what we do with our gazes. When passing strangers on the street, we typically avoid eye contact, glance briefly at them from a distance of sixteen to thirty feet—the range at which we must greet friends or risk offending them—and then glance away quickly. If you establish eye contact with a stranger, it means you want to talk. Street-corner solicitors and religious proselytizers learn that they can hook and reel in perfect strangers by gazing fixedly at them and smiling as if they're old friends.

Eye behavior is immensely complicated and busy. Researchers estimate that about two-thirds of communication between humans is nonverbal, and the eyes convey the most intense and subtle messages. In normal conversation, a speaker looks away from the listener, then glances when winding up a phrase or thought in order to gauge the listener's reaction. A listener glances at or even watches the speaker and intensifies the gaze to signal the desire to reply, much as one tries to catch the eye of a waiter when one wants to order or pay the bill. In typical conversation, the glances last about a second and the eye contact fills a third of the conversation time. We blink to punctuate the glances. The less confident we are, the longer the blinks are apt to be. We dart our gazes to some other part of the face or to the air around the face.

Whenever we're with someone we know, our eyes are chattering away without pause. This is probably especially true of people who have known each other a long time. A married cou-

ple's glances are constantly communicating their moods and intentions, constantly appraising or revealing the intensity of their desire to be with each other. A husband and wife may thus develop their own private eye language, a call and response that is as fundamental a part of their relationship as a hen's clucking to her chicks or a whale's song to its mates.

A gaze invites more intense engagement, and this can be a problem both for the artist looking intensely and for the person being observed. There is so much voltage in that conversation that some artists are uncomfortable drawing faces. Monet, whose life was much a quest for serenity, seldom looked deeply into a sitter's face, and generally his human figures are not individuals but parts of the landscape. Matisse held that "if you put in eyes, nose, mouth . . . doing so paralyzes the imagination of the spectator and obliges him to see a specific person, a certain resemblance, and so on." While he invariably drew from the model, he sought to generalize rather than to particularize the features. He wanted the passion the object aroused without the encumbrances of the conversation. As a young man, he entered the studio of Gabriel Ferrier. The first day there, he later recalled, "I did my utmost to depict the emotion that the sight of the female body gave me. The model had a pretty hand. I first painted the hand. How stupefied and indignant the professor was! By Saturday, the day when the professor came around to correct us, I abandoned that studio."

You would think that within the ease and familiarity of one's own family, the incendiary potential of gazing would abate and that it would be easy to get friends or family members to pose. You would be wrong.

I wanted badly to be able to draw my children. But getting them to pose was impossible. If they were young enough not to be bothered by my look of inward concentration, rather than the beacon glow of loving reassurance that is so much a part of

parenting, they couldn't hold still. Their attention spans could not contain their impulses. Stillness was as unnatural to them as levitation. Once they were old enough to sit motionless for fifteen minutes, they were so self-conscious, so uncertain of who they were at any given moment, that any scrutinizing gaze became unnerving. My children hated to be asked to pose and would only, and then with great sufferance, let me draw them when they were sitting in front of a television screen, looking drugged and stupid.

Spouses and friends are also tough customers. You may be lucky enough to enjoy a kind of honeymoon, say, when you first ask to draw someone else and that person feels flattered or comforted or stimulated by the close attention. But it doesn't last. You want to draw them a second and a third and a fourth time, to see the depths and passions that bind you. You're looking for the whole range of the person's expression, trying to see deeply enough to catch what is not naturally visible.

But your relationship is built on a steady exchange of gestures and expressions by which you constantly reassure each other that you are attentive and devoted. It's very hard for one to be under the other's gaze and not to respond with eyes and shoulders and hands. Asking a spouse to stop the nonverbal conversation and to submit the relationship to silence as you gaze so probingly is like asking her to control her heart rate or stop blinking.

The silence becomes a burden on your spouse. Your model discovers that drawing is recreation for you but work for her. At that point, your spouse will remember that there are bills to be paid, phone calls to be made, a television program to be watched, or that it's just too uncomfortable to have to sit still for the next hour. The household schedule is too busy to allow one to become an unpaid model. You draw only when your model is not previously obliged to work, children, dogs, the telephone, the laundry. I have one precious sketchbook that is

devoted to drawings of my wife. In every one of them, she's sleeping.

If you look back over the history of Western art, you'll find that few artists managed to repeatedly portray their own spouses. Rubens and Rembrandt did it magnificently. In both cases, the women they drew had been their models before they were wives. Once Renoir married his model, Aline Charigot, she gradually ceased modeling for him. Pierre Bonnard painted his reclusive and compulsively clean wife, Marthe, asleep in the bath. Picasso made modeling part of his relationship with a series of women, and he wore them all out.

You can go out in public and draw strangers. But you have to do it unobserved and from a distance. At a distance, most people won't object if they catch you doing it, as long as you're not staring too obtrusively and as long as you can seem polite about it. In bars and theaters and airport waiting rooms, I'll try to draw without attracting notice. I'll select someone whose attention is already committed in another direction. I'll take care not to stare, but to make quick and sweeping glances. As soon as a subject detects my surveillance, he or she shows it. If they're flattered by the attention, the expression changes, the eyes move, the head moves, and the drawing is over. If they're made uncomfortable by the attention, they turn away or get up and leave. Once in a while, someone will get angry and ask indignantly, "What are you doing?"

When drawing in public like that, you can't get close enough to see what you want to see. Your subjects seldom stay put. Most of your drawings end up half-finished. Bars are wonderful places in which to draw because people are animated and performing and the lighting can be dramatic. Bars are also difficult places in which to draw because people are animated and performing and the light levels are so low that it's hard to see.

The moral of the story is that you need models who are neither strangers nor loved ones. You need to draw a lot of them to

learn anatomy, to discover the lines that work for you, to store enough of both in memory to draw quickly when you work outside the studio.

And if you want expression, if you want drawings that take you beneath the skin, you need models who can lend themselves to you, in terms of both time and attention. You have to pay them for their time. But you only want them if they can be attentive, willing to sit still, to stay aware of where they are in space and how the light falls on their eyelids and cheeks and lips and to be absolutely untroubled by the possibility that your gaze is going to uncover some defect in their makeup. You only want them if they can remain honestly expressive of what they are and generous enough to let you search for that essence.

This is why it is best if the model chooses his or her own pose. It lets the model be expressive, lets the model explore his or her own mood or character, and that helps to make the job something more than drudgery. It also makes drawing a collaboration.

With the best of models, the models who bring some feeling to the pose and some sincerity with that feeling, the real skill is a matter of opening up to this scrutiny. When that happens, the model is saying, "This is what we'll talk about now."

But you talk with your eyes.

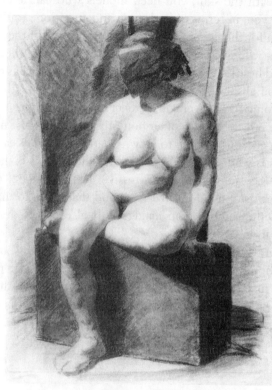

Thomas Eakins, "Seated Nude
Woman Wearing a Mask"

What Happened to the Models?

Merav Tzur is a tall Israeli-born woman with high cheekbones, dark eyes, pouty lips and a calm, almost regal dignity that makes you want to knock twice before intruding on her silence. She is one of the San Francisco Bay Area's leading art models, booked months in advance, described by a fellow model as "a model's model" and by an artist who books her often as "the queen of models." There is nothing common about her. And when she strides, long-legged in blue jeans and big black Doc Martin boots, into Michael Markowitz's 23rd Street Studio five minutes late, she is apologetic, but very much in command.

Markowitz, short, pale and slight of build, has been sprawling on the model's stand, worrying about the model. He has conducted drawing classes and drop-in sessions out of this small street-corner studio on the edge of San Francisco's Mission District for eleven years. The studio is set up like a classical atelier, with the model stand against one wall, on which there are ledges and ropes to prop up or dangle a model. Arrayed on the floor around it are wooden drawing benches for up to twenty people.

What attracts them, Markowitz feels, is the relaxed atmosphere, the camaraderie, the seriousness about drawing and, perhaps more than all the rest, the models. Markowitz auditions all his models and is very particular about whom he hires.

And when the model hasn't shown up on time, he's strung between concern for her well-being and his own sense of judgment about the reliability of his hires. As Merav walks in, he rises on the stand, blustering with relief, and leans down to give her a hug. He jokes that with her on the floor and himself on the stand, he is for once taller than she is. She returns the hug and apologizes. He insists that Merav choose whatever music will play during the session, and when she expresses no preference, he goes into the next room to put on a Bruce Springsteen album.

Merav peels off her boots, blue jeans and knit top and stands, thinking a moment, eyes downcast, back straight, stomach flat, her small, firm breasts and broad shoulders silky under the spotlights. She takes the first of five two-minute poses, holding onto a rope, leaning outward toward the artists, ankles crossed, her weight vanished, her body twisted at the waist, her eyes downcast but her gaze intense. There is enormous tension in the pose, but with her long, strong body, also enormous grace and poise. There is a rustling of newsprint, a creaking of wood as artists shift on drawing benches, and then the sound of charcoal and lead skittering across paper. The concentration in the room builds to a hum before the music comes on.

Second gesture: Merav stands on one foot, left knee raised, left foot tucked behind right knee, wrists crossed against the elevated knee, shoulders hunched, head thrust forward on her long neck. The pose requires balance, flexibility, strength and enormous self-confidence. Her inventiveness, her energy, her sense of drama are compelling. The artists draw furiously.

Third gesture: Merav reclines with her legs and hips on the stand and her torso twisted so that her weight rests on her right

shoulder, which is on the floor, eight inches below. Her up-turned face is wreathed in curled arms and splayed fingers. It is an almost impossibly challenging posture, a frozen dance movement the center of which you cannot find. You can't think your way into the pose. She is forcing you to draw what you see, to use your eyes.

A nonartist would watch this display with his or her heart in his or her throat, whimpering with mangled desire or admiration at the way she has thrown her beauty and grace into such unconventional postures. Were she to do these things while clothed, one would find them arresting. The nudity, the silence, the unfocused gaze are all erotic, but they are overwhelmed by her dignity, her power, her self-control. There is something more complicated than desire floating about the room. This is not burlesque; it is ballet. Ten men and six women draw with complete absorption.

Instead of lust or longing, what is sparking back and forth across the room is rather a kind of compassion. We are sharing the model's feeling. What is flowing into our eyes and, we hope, down our arms and onto our pages, is her boldness, her grace, her sense of freedom.

Merav is thirty-five. She has been modeling since she volunteered, at the age of eighteen in a drawing class in Israel, to fill in for a model who failed to show. She left Israel in 1987 for California, where she hoped to become a successful painter. Today she paints lively, colorful landscapes. She has her own studio, where several times a week she hosts her own private group, sometimes modeling for them, sometimes drawing alongside them from a model she has hired. She takes modeling and painting both quite seriously. "Modeling is just a form of art, like dancing or acting," she says. "I have my body as a tool for expressing myself."

She doesn't work with the art schools but prefers to work for small groups and individual artists, because "it's more inti-

mate. I'm more involved with the people I'm working for. The more energy exchange between me and the artists, the better I work."

She has an almost religious feeling about the work. She told Berkeley videographer Janet Martinez, "When I work in someone else's studio, I feel like I am going to church, like I'm in some kind of holy place. People that have the same ideas all together come to a place where they feel they can express those ideas. They can feel united with people who are the same in doing something that fulfills their lives and makes them feel whole. Something that makes them feel worthy and that makes them belong. I think art is just like a religion in that sense. But without the blind faith that you have in some kind of superhuman intelligence. It's more of believing in yourself and your ability."

Not every model has Merav's professionalism and commitment. There are models so lacking in confidence, or so oblivious to their role, that they project no feeling. There are sessions where a usually good model is too tired or self-absorbed to share much of anything. There are models too full of doubt or self-loathing to share anything of value or interest. When they pose, artists often get up, put their pencils and paper away and sneak out of the room, while those who stay draw as if their eyeglasses have fogged over.

At the Palo Alto Art Center one night, the model was scheduled for one long pose, without warm-up gestures, and before the pose, he stood off to the side, indrawn, looking like an athlete thinking out a race, apparently previsioning his pose. When he took the stand, he got onto his knees, pressed his chest against them, tucked his head into the notch between his knees and wrapped his arms around his legs. The model obviously thought the pose was a dramatic gesture of existential despair, but visually it offered as much interest as a canned ham. The artists were in a circle all around the stand, and no one had

anything to draw. One experienced artist sighed and said, "You can't just close up like that in a long pose." The artist gathered his charcoal, put away his paper and left the room. Others quietly followed.

And sometimes you get models whose own agenda makes them simply unavailable. Longtime Bay Area artist Bill Theophilus Brown recalls teaching a summer-school class at Stanford University, when a girl hired to model came into the studio, "and she was so full of radiating hate that the room emptied in half an hour. I've never seen such a violent reaction from a class."

But almost everywhere, there are models who share Merav's professionalism and expressiveness. That is something relatively new to the world. In recent years, art modeling has changed dramatically.

Artists have seldom had difficulty finding male models because males have traditionally posed in heroic and dignified postures, and there have always been athletes and soldiers who were proud of their bodies and happy to accept the affirmation offered by artists seeking to memorialize their grace, strength and confidence. Victor Hugo cheerfully posed nude for sculpture, as did, at the age of seventy, Voltaire. But female models have only recently overcome a long-standing perception that they were women of ill repute.

From Greek antiquity, when Phryne became the world's first supermodel, female models were exploited courtesans and poor working girls. Caterina, a sixteen-year-old prostitute, modeled for Cellini. In the eighteenth century, one of François Boucher's favorite models, Louise O'Murphy, was a *fille de joie*. The nude female models employed at the British Royal Academy in the eighteenth century were either prostitutes or women whose economic state left them desperate enough to make prostitution a job prospect. Wary of the shame attached to

employing prostitutes or even lower-class women, in 1773 British artist George Romney had to go to Rome to find a female to pose nude for him, and even then, the model's mother sat in on each session so that no suspicion would fall upon artist or model. In 1785 Joshua Reynolds was criticized for having used a live model to paint a Venus.

There have always been noble and irreproachable women who happily modeled nude for famous artists. Botticelli's "Venus" was Simonetta Cattaneo, wife of Mario Vespucci and sister-in-law of America's namesake, Amerigo Vespucci. The Duchess of Urbino posed nude for Titian. Helene Fourment, Rubens's wife, posed for over nine thousand paintings. Rembrandt's wife, Saskia, posed for him, and after she died, Hendrickje Stoffels, his servant and mistress, modeled for important paintings. Henry Moore drew his wife. A woman whose character was above reproach would be more likely to model for an artist of fame and fortune. But most of the models in history worked only for artists-in-progress, and there it was a different story.

The run-of-the-mill model—the academy model—more often than not has come from a lower stratum of society, where neither education nor wealth was likely to lead to more remunerative employment or alliances with men of power. Subordinate social standing is apt to leave its imprint on one's carriage and gestures. In 1958 art historian Kenneth Clark wrote in his study of the nude: "Anyone who has frequented art schools and seen the shapeless, pitiful models that the students are drawing will know that the naked human body is not in itself an object upon which the eye dwells with pleasure."

The first academies arose in Italy—the Accademia del Disegno in Florence in 1563, the Academia di San Luca in Rome in 1593. The French Académie Royale de Peinture et de Sculpture opened in Paris in 1648. The first English academy opened in 1673. All based their programs on the study of anatomy, the

study of antique Greek and Roman casts and the study of living models. There was more work for male models as male figures were more frequently represented in the historical and biblical paintings that patrons desired. Nude female models were forbidden in the French academy through the eighteenth century, so much study of the female form was based on copying casts of Greek and Roman statuary and copies of Greek and Roman paintings.

Given the deep subordination of women through most of Western history, artists had relatively little to say about them; the female body spoke to many of them only of desire and shame. Artists of the seventeenth and eighteenth centuries looked to classical poses for other themes. At the Royal Academy, students were instructed that when drawing feminine forms only certain extensions of the arms or inclinations of the head would be considered beautiful, and they were not urged to seek nobility of character in the models or to feel free to spontaneously express their own feelings in their drawings. Rembrandt was criticized in this era for the attitudes and proportions of his nudes, which were drawn from very ordinary-looking models; one critic in 1752 declared that they were "extremely disgusting to a person of true taste."

Even after the democratic revolutions swept Europe and artists began to look to common people for subject matter, there remained a class conflict in the studio. Drawing and painting had been considered genteel occupations. But the models still came from the working and agrarian classes. Elizabeth Siddal, Millais's "Ophelia," was the daughter of an ironmonger discovered working in a hat shop. Annie Miller, Hunt's model for *The Awakening Conscience* and for a time London's preeminent model, worked as a barmaid. Fanny Cornforth, Rossetti's "Found," was a farmer's daughter and prostitute.

The fact that models and artists had unequal social standing made the sexual issues more explosive. Nineteenth-century

English schools forbade students to speak with the models, and artists' studios often had separate entrances and staircases just for models. Millais's studio had a trapdoor in the floor to maintain propriety and social hierarchy. Even in France, models in general were not well respected. At the Académie Julian in Paris (where Bonnard, Vuillard, Maurice Denis and Matisse all studied), new models were selected on Mondays. Each candidate mounted a dais, one after another, while students hooted their approval or derision.

In nineteenth-century England, modeling also became a health issue. In the 1860s, the British became worried about an epidemic of venereal disease, and a campaign was launched to rein in prostitution. The Contagious Disease Acts of that decade criminalized prostitution, and nudity in art came under attack as a provocation to males. Since models were apt also to be prostitutes, schools that used them were open to criticism. In 1860, the British Parliament almost passed a law forbidding government funding to any school using live models. Though the bill failed, it brought such scrutiny to art schools that by 1863, only eight government-sponsored schools still had life-drawing classes. Meanwhile, art students resisted the changes. When the Manchester School of Design suspended life classes due to charges that women who posed nude lived on the premises, students set up their own classes in an attic room, and the underground sessions lasted for the next twenty years. When the Slade School of Fine Art was established in 1871, one of its primary goals was to provide life-drawing classes, and women were even permitted to work from seminude male models, a practice that would not be allowed at the Royal Academy for another twenty-three years.

Two things pushed European artists to see greater value in a skilled model. One was that as they looked increasingly upon art as something that stirred the soul, they embraced the idea that models might act as muses and channel sexual energy into one's work. The notion made at least juicy gossip. British

artists Edward Burne-Jones, William Holman Hunt and Dante Gabriel Rossetti assumed live-in relations with their models. Burne-Jones did not allow his family into his studio, where he carried on affairs with his models. Whistler and Tissot openly set up households with their model-mistresses. Rossetti made a show of model-mistresses as ornaments of the bohemian life and married Elizabeth Siddal, who succumbed, after two years of modeling, to an overdose of laudanum. Annie Miller had affairs with Millais and Rossetti.

The other thing that raised the fortunes of models was that in the nineteenth century newly mass-produced images of glamour and beauty built careers of celebrity. Lithographed images of the actress Lillie Langtry, for example, were widely circulated as advertisements for Pear's soap, greatly increasing her fame and linking beauty with commercial purpose in such a way as to give the eroticism of the image a new respect. Prince Leopold kept a Frank Miles sketch of Langtry over his bed, until Queen Victoria saw it and had it removed. Burne-Jones, Whistler and Millais all painted Langtry. As popular images of feminine faces and forms acquired commercial power, the economic value of models increased, and the idea that modeling was immodest receded.

Rossetti eventually declared that all models were whores. What he meant was that models were treacherous: they had bargaining power, the ability to withdraw or refuse. They were no longer simply prostitutes.

Thus, in a rough-and-tumble way, modeling became a profession. In Paris, each morning, would-be models paraded openly around the fountain at Place Pigalle, haggling with artists over the rate they would receive for posing, and at night, after posing, models showed up at the cafés and nightclubs of Montmartre, becoming fixtures in the bohemian lifestyle. By the 1890s Cafe Royale in Regent Street had become a labor exchange for English artists and models.

Increasing liberality pushed the boundaries. By the 1860s

female students in French ateliers were permitted to work with nude models. And Italian models—who for generations had passed the profession from father to son, mother to daughter— began to work in England after the Franco-Prussian War of 1870–71. The Artist Model's Association, a guild for art models, formed in England in the 1920s.

Models were even acquiring a new celebrity. British model Marguerite Kelsey came from a working-class background and would eventually be prized for her slenderness and elegance, and her ability to hold a pose without breaks for four hours. When John Singer Sargent met her, he told her, "We're going to make you tops," and indeed she became a celebrity, married a wealthy man and lived a respectable life. In her old age, Victorine Meurend advertised herself as the model for Manet's *Olympia*. Picasso's model-mistresses published a succession of successful memoirs.

The transformation to respectability was slower in America. In 1837 the National Academy of Design in New York became the first American school to offer drawing from live models. It simply could not find female models and had to advertise to find males who would pose. In the 1860s, when Thomas Eakins began drawing from live models at the Pennsylvania Academy of Fine Arts, female models were so difficult to obtain that they were paid twice what male models received and often wore masks to hide their identities. Most apparently were prostitutes. No conversation was permitted between artists and models. Eakins went on to study in Paris, where he became convinced that life studies were the heart of any artist's training. When Eakins returned from France, he brought a handful of his nude studies with him, but cut them apart and saved only the heads and shoulders, lest he run afoul of customs inspectors or disapproving friends.

Eakins himself was unabashed at nudity and posed nude for

photographs that his students could use to draw from. He drew twice a week with the Philadelphia Sketch Club, whose models were prostitutes he described as "coarse, flabby, ill-formed and unfit in every way." When the Pennsylvania Academy reorganized in 1876 and hired him to run the drawing program, he proposed they stop using prostitutes and advertise in local papers for women "of respectability," who might "on all occasions be accompanied by their mothers or other female relatives" and even wear masks when modeling to hide their identities. He persuaded Anna Williams, a schoolteacher, to pose nude for one of his best-known paintings and kept her identity a secret. (She went on to pose for the engravings by George T. Morgan that adorned the silver dollar, the half dollar, quarters and dimes for the next fifty years, became famous and still kept her teaching job.) He encouraged female students to pose for one another and then critiqued their drawings, a practice some found embarrassing and outsiders found scandalous. Eakins led the Pennsylvania Academy to allow female students to draw fully nude male models, an innovation that one coed's mother complained deprived students of their "maidenly delicacy" and "chaste and delicate thoughts." Opposition to Eakins's revolutionary attitude toward models festered to the point that the academy fired him in 1886.

But Eakins was immensely popular with his students and his views gained adherents. By the end of the century, it was less and less necessary to look to red-light districts for models. America had always identified with Greek and Roman states, and as it attained industrial and imperial standing in the world, it looked more and more to classical images, which increased the demand for nude models for paintings and sculptures. It became possible at the turn of the century for an American woman to build a respectable modeling career. Audrey Munson posed for New York sculptors in the 1910s and 1920s, at a time when nude and thinly draped classical statuary adorned civic

and commercial buildings. Her image still graces the New York Municipal Building, the United States Customs House, the monument to the battleship *Maine* in Columbus Circle, the Fireman's Memorial, the Manhattan Bridge and the fountain in front of the Plaza Hotel. She posed for three-quarters of the female statues at San Francisco's 1915 Panama-Pacific International Exposition and was the model for the images on the American dime and half dollar. At one time, there were thirty sculptures of her in the Metropolitan Museum of Art's collections. Munson tried to exploit her celebrity by taking lead dramatic roles in movies as a nude artist's model. That the films were not successful suggests both that she couldn't act and that the world wasn't quite ready to celebrate the nobility of art modeling.

The presumption that only a fallen woman would model nude continued to dog figurative art. The painter John Sloan felt compelled to explain to students as late as 1939 that "the important thing to bear in mind while drawing the figure is that the model is a human being, that it is alive, that it exists there on the stand. Look on the model with respect, appreciate his or her humanity. Be very humble before that human being. Be filled with wonder at its reality and life."

Richard Gayton has taught drawing at the California College of Arts and Crafts in Oakland since 1962. He recalls that even in the 1960s, the models were required to register with the Oakland Police Department, because local officials worried that the college was simply hiring prostitutes. Male models were still required to wear jockstraps. A friend of mine who took a life-drawing course at Stanford told me that one day a male model showed up without the required elasticized fig leaf and took his pose bravely without it. The students—male and female—drew contentedly, until an older professor stuck his head in the door, saw the model, expressed consternation and required the model to pull a gym sock over his genitals.

Artist Nathan Oliveira recalls drawing in Palo Alto in the 1950s and 1960s: "The models were terrible. People weren't interested in taking their clothes off. There wasn't much here, so you took what you got." He drew at Stanford University with Frank Lobdell and Keith Boyle, and more often than not they got friends to pose. Or they hired students who needed the money. "It wasn't anything organized at all."

He had drawn at the San Francisco Art Institute, where few of the models were professionals. Modeling there was of such uneven quality that Oliveira remembers that the Art Institute engaged a male model who had posed for the flexed biceps on the Arm & Hammer baking soda box to give an authoritative talk about modeling. Oliveira remembers being surprised and impressed to learn in the ensuing discussion that in European studios "they had all sorts of devices they used to suspend models in odd ways, flat boards they pressed up against, and things like that. There it was a profession. But in the days I drew in the Bay Area, it wasn't a profession. It was a matter of the people who became available."

So, what happened to bring about a new kind of model? Assuredly, the great social changes of the last fifty years have played key roles. The most important of these changes was probably the feminist movement, which allowed men and women alike to see that women's bodies are their own, not the property of men or objects to be controlled by men. That perception has allowed us to see more clearly that there is much more to feminine form than desire or shame. It has also invited women to use their bodies more freely as expressive vehicles. Today, many models are dancers and athletes who take up modeling as a way to increase their understanding and awareness of their own bodies.

A second factor has been the falling away of legal and conventional barriers that until the 1960s kept the human body

under wraps. Supreme Court decisions upheld the sale of books with sexual themes and scenes, such as D. H. Lawrence's *Lady Chatterley's Lover* and Henry Miller's *Tropic of Cancer*. Following those First Amendment decisions, magazines such as *Playboy* and later *Hustler* pushed back the limit of what was permissible exposure in magazines. Topless dancing in nightclubs pushed the limit further, and when movies depicting sex acts survived court challenges, a huge pornography industry began to build. Today, with more than two hundred thousand commercial pornography sites on the Internet, sexual imagery that would have put actors or producers in jail fifty years ago is freely available in almost every household in America. A 2003 Kaiser Family Foundation study found that one out of every six television shows either depicted or strongly implied sexual intercourse.

All of this has created a variety of legal—if not socially accepted—outlets for the images of desire and shame that once were thought to reside in the artist's studio. It brought nudity into movies, television and advertising, then pushed the limits far beyond anything artists were doing. It has created a clearer gap between drawing and sexual entertainment. Whatever artists were drawing, it was far tamer than what America's businessmen were watching nightly on Lodgenet in Hyatt and Marriott hotels, or what General Motors and AT&T were making millions of dollars from when they invested in media companies that produced sexually explicit entertainment. And all this has removed much of the burden of suspicion from the shoulders of artists who have an interest in the human figure. It has also removed inhibitions from models, making them much freer to be expressive and communicative.

Even with changes in value and outlook, it takes pioneering individuals to set examples that define the new behavior. Michael Markowitz believes what has most changed modeling has been the innovations of individual models. Says Markowitz, "It's attributable to a couple of models who just set a standard. They see modeling as artistic expression."

One of them was Florence Allen. She was tall, strongly built, dark black, and had a loud and familiar informality that translated quickly into an air of command. She had begun modeling in 1933, at the age of twenty. During the 1939 World's Fair on Treasure Island, she worked in a discreetly curtained booth, posing for photographers. She was witty and ironic and intensely convivial. Says Bill Brown, "She was a great character. She was big, about five foot ten inches tall. She was very good-natured but she could put on a very tough act. She could control a class if the instructor couldn't. She'd say one word and they'd go quiet. A woman in the class would say, 'Oh, please, put your left foot back an inch,' and she'd look at that woman and that woman would wilt."

Her family had been California pioneers, steeped in an assertive self-reliance that she readily projected. In 1892, her grandfather successfully sued the state of California to desegregate its schools. A sister started the first African-American travel agency in northern California. In the 1940s, Allen worked for Harry Bridges's longshoremen's union. In the 1950s, she marched in labor demonstrations. She had a brief fling as society columnist for a neighborhood tabloid. She worked as a hostess at several popular North Beach restaurants.

In a city that considered itself bohemian, sophisticated and fun-loving, she became a kind of celebrity. There are photographs of her with beat poets Lawrence Ferlinghetti and Allen Ginsberg, and with entertainers Harry Belafonte and Paul Newman. A list she once made of people she had hosted in one week at a restaurant included California's governor, newspaper columnist Herb Caen, the owner of the San Francisco Warriors basketball team, movie producer Michael Todd and actors Peter Fonda and Jack Nicholson. At the bottom she scribbled, "I bet I meet and greet more celebs in one week than the average meets in a year."

And she posed. By the 1960s, she had posed for a whole generation of San Francisco artists, including Diego Rivera,

Mark Rothko, Elmer Bischoff, Hassel Smith, Roy De Forest, Wayne Thiebaud, Eleanor Dickinson, Beth Van Hoesen, Mark Adams, Joan Brown, Frank Lobdell, William Wiley and Richard Diebenkorn. She was so in demand as a model, so assured of her professionalism and of her competence, that she once declared, "Honey, I *am* the San Francisco Art Institute."

Marian Parmenter, who has operated galleries in San Francisco since the 1960s, recalls going to the San Francisco Art Institute, where "I drew and drew and drew her. You could never draw her enough. She was so strong, so flamboyant, and she had such a gorgeous body."

What was different about Flo Allen, what endeared her to all the San Francisco artists who drew her, says Brown, was that "Flo Allen projected. She was always very, very there. She had a commanding presence. She was always available." Every pose was an effort to communicate, a sharing of her wit, her confidence, her delight, her whimsy, her strength of character.

She took modeling very seriously. Artist Ann Curran Turner remembers Allen modeling for a sculpting class at the University of California when someone came into the studio with the news that President John F. Kennedy had just been shot. "She continued in her pose, even though students quietly left in ones and twos," says Turner.

"There's an art to this business," said Allen. "There's a hell of a lot more to it than skin and bones. It's very difficult work. You find muscles you didn't know you had. Just when you think you're relaxed, the sweat starts running, and then you itch. The strain is tremendous."

Florence Allen did more than just set a good example. In 1946, she formed a models' guild in San Francisco, "to select, train and supervise the finest models of every age, sex and race, to provide the best subjects and inspiration to the artists of the bay area."

Charles Campbell, who opened his art gallery near the San

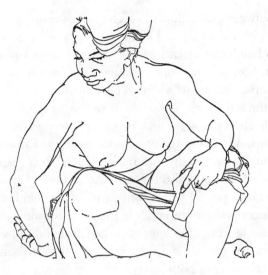

Eleanor Dickinson, "Florence Allen"

Francisco Art Institute in 1947, recalls that in those years there was no set pay for a model and drawing groups would often simply pass a hat at the end of a session. Artists, being generally broke, might or might not actually pay. "Flo said some groups would give her money and other groups would just stiff her," recalls Campbell. "She set it up so that there was a set price."

It was more than just the money. The idea of a guild was that artists needed models, and models needed artists, but that each had problems connecting with the other. There was no training course for a model; most typically started out by telling the lie that they had modeled for someone else. Without training, modeling is a hit-and-miss kind of thing, whereby a model may or may not know how expressive he or she may be, or how to pose for long periods without suffering muscle strain or fatigue. A model may not know that it is usual to show up at work with a timer and a robe or that usually one is not required to pose for more than twenty minutes without a five-minute

break between poses, during which the model may stretch, rest, snack or phone a friend. The model may not have a clear idea how to handle an artist who shows more than a professional interest, how to retain one's privacy when that is wanted, how to converse with artists when that is wanted.

At the same time, a model who arranges her own engagements is always at some risk of being subjected to unwanted attentions. A booking agent can ask questions of an artist that a model might be too shy, too inexperienced, too desperate for work to ask. A guild also serves artists who may have no idea how to find a person who is willing to pose unclothed, or may have concerns about the ethics or intentions of someone willing to disrobe in front of strangers. A models' guild can screen the artists for the models and the models for the artists and vouch for the character of both.

Conditions in San Francisco favored a guild. Bay Area artists are widely dispersed around a nine-county area and don't often talk to one another, so a central booking agency was a real advantage. There is a high degree of amateurism among Bay Area artists—of people who draw or paint as a hobby—and those people were also better served by having a model agency. And amateurs, having other employment, are generally willing to pay more than poor aspiring artists.

Florence Allen retired from modeling in 1968 and became model coordinator—hiring and scheduling models—for the California College of Arts and Crafts in Oakland. She taught a course there in modeling for men and women who aspired to that profession. She told students that the key to modeling was "knowing your body from stem to stern." When fashion models called to inquire about art modeling, she'd tell them, "This is with clothes off, baby. There's a big difference." She confided to a newspaper interviewer, "Besides, the students don't like the pretty, skinny ones. Artists prefer their models to have a lot of stuff on them."

For years, she still could be lured out of retirement on occasion. When Mark Adams, Beth Van Hoesen, Gordon Cook and Wayne Thiebaud started a drawing group in Adams's studio in 1976, Van Hoesen asked Flo Allen to model. Adams recalls, "She did it as a favor to Beth. She said, 'I'd like to do it, but you better get it before it melts.' "

Allen died in 1997. But the guild continues. The San Francisco Bay Area is so far the only metropolitan area in the nation to support an artist models' guild. In New York City, where there are more artists and there probably is more drawing going on than anywhere else in the nation, attempts to develop a booking agency for models have failed. In 1972, New York models banded together to form the Society for Art and Education, a union that would, like the Bay Area Models' Guild, act as a booking agent, train models and seek better working conditions and higher wages. It was never able to bargain with the art schools and colleges. Says Robert Speller, who has modeled in New York since 1960 and who served as an officer of the Society for Art and Education, "There were always too many people willing to model for less. If a job offered fifteen dollars, people offered to do it for ten dollars." By the early 1990s, the Society for Art and Education wasn't managing to book jobs or collect dues, and it disbanded in 1997.

Minerva Durham observes, "Models don't last very long in New York." Either they catch on in theater or dance and no longer need the work, or they give up, take another job and leave. Shifra Gassner, who modeled in New York, then in San Francisco, and has since returned to New York, found it hard to make a living modeling in New York. "You never get paid any more. You're just making enough to pay rent and you can't, if you want to, eat in a restaurant." She went back to school, got a teaching credential and now teaches full-time. Says Gassner, "In San Francisco, I felt very professional and respected. I could tell people I was an artist model. In New York, there's still that

stigma. I can't tell people I'm an artist model until I know how people are going to react. Modeling is not really a profession here."

The Bay Area Models' Guild, however, has survived nearly sixty years and has been an important force in Bay Area art. It improved modeling, passing on to models Florence Allen's professionalism and style and encouraging a succeeding generation of models to greater effort and expressiveness. It raised models' fees. Its success fostered guilds in Berkeley (which eventually merged with the Bay Area guild) and Palo Alto, which books about two hundred jobs a month. Additional guilds also surfaced briefly in Marin County, San Jose and Santa Cruz. Says Ogden Newton, booking coordinator for the Palo Alto Models' Guild, "This is a model's paradise."

Today, the Bay Area Models' Guild handles 300 to 350 bookings a month and regularly conducts auditions and training sessions for new members. Artists call and request a model usually by sex and body type (slender or heavy). Says Nona Refi, the guild's current booking coordinator, "Sometimes I get calls that sound very strange and suggest a sexual orientation." She tells such people, "We provide services to artists. We don't do anything that's related to the sexual entertainment industry." What models do, she says, is "create an image that will inspire an artist. It's not about sitting. We're creating a drama for the artist."

Refi has modeled for eleven years, and she says, "Standards have changed. We have better models. They have more stamina. They are more able to take and hold difficult poses. They are much more creative." Trained as a ballet dancer, she says, "I put the same energy into my poses that I put into dancing. We're in the art of communicating. I have to make contact. I have to create that drama."

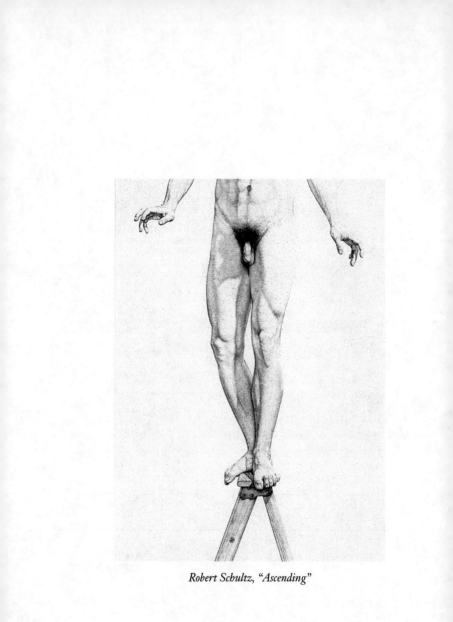

Robert Schultz, "Ascending"

Working Naked

Modeling has acquired its own literary form, a stock story in which a college student models for an art class and then writes about it for the student paper. I've seen at least a dozen of these stories, and they are usually about the writer taking off his or her clothes, sitting in silence for an hour or two, getting dressed and saying, "That wasn't so bad." The theme of the story is the pluck of the writer in an ordeal of nudity, and it misses entirely the point of modeling. It also leaves one wondering why anyone would choose to be a model.

As an occupation, art modeling is less than glamorous. Take the forty-two-year career of Carla Kandinsky, who started modeling in 1961 when she was twenty-three. She had come to California and desperately needed work. Employed for a while by a telephone answering service, she says, "My boss was a drunk. Sometimes she paid us and sometimes she just forgot." Her landlady, who had been a student at the California College of Arts and Crafts in Oakland and had gotten Carla to pose clothed for her, suggested, "You're really good at this. You're really still. You don't talk. You ought to apply at Berkeley for a job." Kandinsky went to the University of California's art

department and filled out a job application. "I lied," she recalls today. "I said I had modeled in Paris and at the University of Indiana."

In truth, she had grown up poor, the daughter of a janitor and a store clerk in Bloomington, Indiana. Her father had a sixth-grade education, her mother a high school diploma. She had dropped out in her second year of a religious college in Cincinnati, married a boy her parents disapproved of and at nineteen was divorced. She decided to flee to California.

She got the modeling job at Berkeley. It paid $2.05 an hour. "My first time, I was scared to death. Partly it was the new experience. And it was awfully cold. It was the first time for the students drawing a nude model, also, and the instructor, Robert Hartman's, first day teaching life drawing. I took a pose with my back to the class and my head turned, looking over my shoulder at them. I was thinking, 'Oh, my God, I'm *doing* this. It's awful.' " The pose lasted three hours. Then she came back Wednesday and again on Friday and repeated the same pose for three more hours each day.

It was before the feminist movement, before topless dancing had taken over San Francisco's North Beach nightclub strip. It was far from respectable work. Kandinsky feared telling people what she was doing for a living. "In the sixties," she says, "men thought, 'If this woman will take off her clothes in public, she'll do anything.' "

Of course she would not "do anything." When she was modeling at the San Francisco Art Institute, she was asked to fill in for a woman who worked as "the girl in the fishbowl," swimming topless in a large glass tank at Bimbo's, a supper club three blocks from the art school. She declined, "because people were there to look at the woman in the fishbowl in a different way than they were there to look at the Art Institute." Whenever she was asked to pose nude for photographs, she refused.

It took her a long time to get used to posing naked. "I think

I reached a point where I realized students were art students and they didn't think about it as naked. It was form and shadows. It was like looking at a Coke bottle."

But it had an air of the illicit—and it seemed risky. She recalls posing for several beat-era artists in a room at the Wentley Hotel. The group was run by Ed Hagedorn, a tall, heavy-drinking beatnik who talked in a whisper and shared Italian candies, all of which Kandinsky felt was a little creepy. She had the sense that anything might happen in his hotel room and that when she was there, no one who cared about her would know where she was. One night, she was posing for Hagedorn and two other artists when someone overloaded the electrical circuitry and the lights went out. She sat very still in the dark, listening to the heavy breathing of the artists, expecting at the very least to be groped by anonymous hands, until someone got up and changed the fuse, and the artists returned to their drawings.

She got more work. She joined the Bay Area Models' Guild. She posed with Florence Allen. She rode the bus all the way to Davis, California, leaving Oakland at 6:00 a.m., to work for the art department there. She worked for private groups. She viewed what she was doing as a profession, and sought to do it well. The models' guild booked her for a private group in Berkeley that included Richard Diebenkorn, Elmer Bischoff and Frank Lobdell. "I had no idea they were famous," Kandinsky recalls. "They were these three really nice guys who had a Wednesday-night drawing group in Bischoff's studio, upstairs in a former Volkswagen dealer's garage on Shattuck Avenue. They would ask for difficult poses. There was no dressing room, and one night as I was undressing, I was pulling a black slip over my head"—she poses with her arms crooked over her head and her neck bent, the imaginary slip covering her head— "and Bischoff stopped me and said, 'Oh, that would be lovely to draw.' " He asked her to hold it for a long pose, and she winces

remembering the pain in her back and arms. She modeled for Bischoff's classes at the University of California and for Diebenkorn's at the San Francisco Art Institute and rotated with other models at the Wednesday-night sessions. She loved the work. "The Berkeley studio was a great place. I just felt good."

She was willowy, smooth-skinned, gray-eyed, with a small Botticelli chin and a childlike expression that mixed whimsy and sadness. The pictures of her at that age convey a mixture of grace and humility.

Today, those images look down from the walls of museums and galleries and private collections all over the world. Drawings of her by these famous artists sell for twenty or thirty thousand dollars. She, of course, gets no royalties. She sees pictures of herself in coffee-table books about the artists, and says, "None of the models in those pictures has a name. It's *Nude at the Beach* or *Nude in a Chair*. The model is never credited.

"I never made a complete living as a model," she says. "No . . . when I first started back in the sixties, I think I did make a living, but my apartment was fifty-five dollars a month, all utilities paid." She has never owned a car, always ridden buses to her jobs. "I would do three bookings a day, Alameda in the morning, Holy Names in the afternoon, Berkeley in the evening." But for most of her forty-two years of modeling, she did other things to patch together a living. "I was doing house-cleaning. I make jewelry. I weave pine-needle baskets and sell them at crafts fairs." She lives in a small weathered Victorian apartment in the student ghetto of Berkeley.

She is soft-spoken and self-effacing. Recently she modeled for an introductory drawing class at the California College of Arts and Crafts. The instructor was half her age and the students a third her age. Most of them had never drawn from a live model before. She told them, as she often tells beginning classes, "Don't worry about what you're going to do to me, or

how you're going to make me look, because it has already been done. I'm not afraid of anything." She did a long, standing pose that must have left her stiff and sore after she dressed and left the building. The students wrestled with the way gravity pulled at her shoulders and hips and with the shadows under her eyes. But she still conveyed the same quiet grace and dignity. Neither the students nor the instructor had any idea that they were drawing a model who had collaborated with and inspired the Bay Area's best artists for four decades.

Modeling requires a lot of offstage preparation. All models watch their weight and most work out, not to keep slender, but to maintain strength, flexibility and stamina. That's the easy part. Onstage it is simply hard work.

A model at work must often preside over a complicated social relationship. Part of a model's professionalism is being able to recognize how much or how little distance to keep between themselves and the artists. Says Barbara Tooma, "Because you are nude in front of strangers, there is this barrier the models put up to keep their distance." Models wrap themselves in silence. When a model has worked for a while with a group or with individual artists, as more trust is built, the silence breaks down. And until then, for most, it's a dull routine of sitting still and concentrating on the pose.

While they're doing that, models often have to put up with artists who are inconsiderate or whining. Ogden Newton, who has modeled for more than forty years and is the booking agent for the Palo Alto Models' Guild, tells of taking a long pose for a private group of thirty, where several older ladies in the front row talked a lot. "I'm in the pose the third time. I had lined myself up with the door frame and some posts outside, and yet, each time I got back into the pose these women were griping about it: 'You moved this! You weren't that way!' I looked down and lined them up. At the next break, they complained again,

and I saw that *they* had all moved. I said, 'If *you* move back two feet to where *you* were, and if *you* move over there where *you* were, it would all be just right.' " But his anger clouded the rest of the session. It was a bad day for him.

A model often has to fit his or her feeling to that of the group. Says model Joan Carson, "You have to have confidence. If you go over the line—if you show off, there's not enough sharing. Not enough of wanting someone else to have some of his space. I ask questions when I'm modeling: Are my poses too complicated? Do they want me to be more linear? At the same time, I want to keep my freedom."

A model must be empathetic, must continually think about the artist who may be as silent as a stone and as watchfully appraising as an owl. "My energy is there for them to use," says male model Terry Koch. "Sometimes you might give them a specific idea [for example, he hunches a shoulder, bends his neck into a gargoyle pose of grotesqueness]. I think our job is to make them feel they want to draw. It's saying, 'I think it's great that you draw.' "

But the model has to lead. Says San Jose model Sterling Hoffmann, "I'm the writer. I'm the director. I'm the actor. I can set the mood. I can charge up the artist."

It is always collaborative. "You have to figure out quickly what they want and respond," says model Marianne Lucchesi. Some groups, like the animation sessions at San Jose State University, want dynamic, twisted poses that display muscles, while others, for instance, some of the older people in private groups, she says, "want a very languid, quiet pose."

There are constant adversities. A model puts up with cold. It's the bane of every studio. The artists are clothed and in motion. The model is nude and still, and so not generating body heat. "Teachers won't take you seriously when you're freezing," says longtime model Ginger Dunphy. "It's colder when you're stationary and nude." Once, while modeling at the San Fran-

cisco Art Institute, she was cold and asked for a heater. The instructor just smiled. She asked again, and declared, "I *need* a heater!" The instructor just smiled again. "I found out later he had taken acid before the class."

Unexpected things happen. And because the model is naked, the unexpected brings a greater sense of vulnerability. Carla Kandinsky recalls, "The first time I worked at Holy Names College, the art class was in a little cottage and they had beehives just outside, and the bees swarmed. They swarmed right in one window of the cottage. I was posing nude on the stand. The instructor said, 'Everybody freeze! They'll go right through the room! They've done this before!' They did."

Lurkers are a recurring problem. Says Dunphy, "Crazy people walk into the studio at the Art Institute with cameras and take pictures." Marianne Lucchesi was modeling at an evening session at San Jose State University when a creepy older man walked into the room, "snuck up" while she was posing "and tried to have a conversation" with her. She stopped posing, put on her robe and made the man leave.

A model has to hustle to find bookings. Typically, a model starts by working in art school and college art department classes, and hopes to appeal to the students and teachers enough to be asked back and to be recommended to friends who seek models for private drawing groups and individual projects. Most models don't belong to the guilds and have to proselytize for themselves. Rashmi Pierce, who started modeling for classes as an undergraduate at Michigan State University, might claim distinction for the most energetic pursuit of artists. She moved to New York City, where she got introductions to and work with Raphael Soyer and Philip Pearlstein. She learned that Salvador Dalí spent part of each year at the Dakota apartment building and hoped to pose for him. When a hardware store burned down near her flat in Brooklyn, she retrieved a melted clock, wrapped it up, wrote a poem to go

with it and took it as an offering to the Dakota. She didn't get the job, or even an audience with the famed surrealist.

Transportation is a major problem because bookings are few and far apart. On a typical day, Santa Cruz model Tracy Curtis, who lives entirely on her modeling earnings, gets into her car by 7:00 a.m., drives two hours to Oakland to pose for a two-and-a-half-hour class. She dresses, has a light lunch and drives another hour to San Jose, stopping along the way to work out at a gym, because she spends so much time sitting behind a steering wheel that she needs the workout to stay alert and flexible. In San Jose, she poses for a two-hour painting class. She grabs some dinner and drives up into the Santa Cruz mountains, where she poses for a two-hour private drawing group. By the time she returns home, it is ten o'clock and she is sore and tired. She has earned $151, less the cost of driving 175 miles.

All models worry about money. Curtis may work three jobs a day four days a week, but Fridays have fewer classes and almost no private drawing groups, and in summer months two-thirds of the work disappears because the schools are out of session. "It's a fly-by-night job," says Barbara Tooma. "All the models I know do something else. If you don't, you're going to wind up in debt or living with a bunch of roommates." And when you get old, there is no retirement plan. Ginger Dunphy jokes that when she retires she'll go to live in the Old Models' Home, the joke being that there never has been—never will be—such a place.

And always there is pain. "Any interesting pose will be painful," says Dunphy. "Anywhere you create tension is going to hurt. Anyone who does a ten-minute pose in their home can feel it. Almost everything I do as a model is exaggerated from life. It hurts where you're putting the weight or placing the hand and supporting the weight. Anything you cut the blood off to hurts. It doesn't get numb, it actually hurts." A model

who gets into a bad pose, a pose where the weight is poorly balanced, begins to sweat and then to shake. Circulation is cut off or a nerve is pinched. Terry Koch once got into a long lotus-position pose that seemed comfortable enough when he assumed it, "but within forty minutes the pain was so intense, I felt I was going to vomit."

It's especially a problem in classes or individual sessions where the instructor or the artist selects the pose. "People have all these expectations," says Dick Damian, who both models and draws. "They want to have someone holding a sword, like this." (He hefts an imaginary broadsword, two-handed, over his right shoulder, like a knight about to cleave a dragon in twain.) "But people can't do that. Twenty minutes is the limit and things begin to hurt." He strikes a pose on his right foot, left foot tucked behind right knee, both hands raised. "I can hold that pose for fifteen minutes because my weight is balanced." He strikes a fencer's stance, lunging with an imaginary rapier, then holding the pose at the end of the thrust. "About one and a half minutes is the limit of human capacity for holding a pose by muscle power," he says. "We're always trying to fight gravity. Gravity is a relentless force."

All models experience discomfort. Says Ogden Newton, "You learn through pain." And as you get older, it gets worse. Barbara Tooma, at fifty-four, has arthritis, high blood pressure and a bad back. She can't do the long poses she used to do. She often supports her body by clinging to the wall at the back of a modeling platform. "Most people quit because your body can't take it forever," she says. "Most of the models end up with injuries. A lot of models have bad back problems."

Given the wearying travel, the low pay, the demanding work and the pain, why do people continue to be models?

The answer seems to be that models are interested in the very thing artists are interested in: bodies.

They start out interested in their own bodies. For example,

a few years ago, when Jane Leo was an undergraduate at Washington University in St. Louis, she was asked by a fellow student to model nude for photographs for an art course assignment. She agreed to do it. "A big part of it was coming to terms with my sexuality," she says. "I think this is big in college girls. They feel there's an empowerment going on in front of the camera. You can sort of conquer the fear of being uncertain about your sexuality. I was very conflicted about my body and I wanted very much to accept it, and I thought that if I could be a model for somebody, that would prove that I was acceptable, regardless of what messages I was getting about what was sexy from the media." The pictures were shown in a student exhibit, and that made her feel uncomfortable. She saw that she had made herself "the subject of a photograph that anyone can look at and make whatever they want of it. Then it became clear that the act had nothing to do with my sexuality at all."

Just about everyone has some concern about how their bodies measure up to standards of power or beauty or desirability. The late State University of New York psychologist Seymour Fisher wrote in *Development and Structure of the Body Image*, "One's body is psychologically closer to the self than anything else, and thus the body is a prime target onto which one projects intense feelings. The body seems to be a maze of landmarks that are charged with meaning."

As modern society grows more and more media-driven, the meanings grow more and more uncertain. America's culture of celebrity turns especially on physical attributes. Cosmetics, fashion and dieting are billion-dollar industries because Americans experience increasing insecurity about the desirability of their own bodies. The ideal body form as expressed in a fashion model is 13 to 19 percent below a normal person's expected weight. A *Glamour* magazine survey found that 75 percent of women aged eighteen to thirty-five think they are fat, while only 25 percent are actually even moderately overweight. One

study reported 81 percent of ten-year-old schoolgirls had tried to diet at least once. A Kinsey survey found women to be more embarrassed when asked about their body weight than when asked about their masturbation practices or homosexual affairs.

It is a more serious issue for women than for men. A woman's attainments in society are largely defined in relationship to the attractiveness of her body and her ability to have children, so a woman more closely equates herself with her body than a man does. This helps to explain why there are as many women in the drawing groups as there are men, while 80 percent of the models are women. If women identify more with their bodies, they also are likely to have more to say when it comes to other women's bodies.

Most people start modeling because it makes them comfortable with bodies that don't fit the stereotypes. Elizabeth Page began modeling at the age of seventy-eight. Says Page, "When I was a teenager, I was a tomboy and I didn't feel femi-

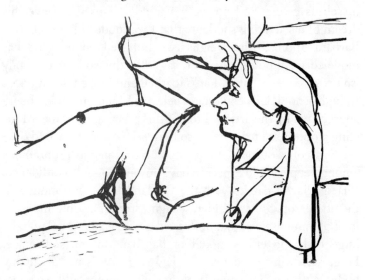

Richard Diebenkorn, "Untitled (Carla Kandinsky, 1963)"

nine." She felt even less happy with her body as she aged. "I've always had flabby thighs. I've got hanging flesh, spider veins and carbuncles now. But in the artist's world, it doesn't matter. I feel very appreciated. Modeling keeps me in touch with my sexuality. I feel very female."

Carla Kandinsky says, "I always thought of myself as really ugly, and I was always criticized by my mother for a lot of things. As a model, I fit into a place where I can be just as I am and they like me." When she started modeling, she wore makeup and eye shadow. "Then I was posing, and I thought: 'You should just look at them like you're the most gorgeous woman in the whole world.' " She stopped wearing makeup, and felt even better. "Sometimes," she says, still remembering the sense of surprise, "I felt physically beautiful."

Model Joan Carson says, "I always had problems with my body, being small and athletic." Model Sterling Hoffmann says, "All through high school I was a skinny kid, and I thought of myself as gangly and not very attractive. I used to have this dream of discovering suddenly that I was nude at high school." Barbara Tooma, who weighs two hundred pounds and has modeled forty pounds heavier, says, "In this society, my body isn't revered—it's hated. Fat is loathed and looked down upon. In high school, kids could be cruel. But I found my body being appreciated by the artists. I found this acceptance of me. Modeling stopped me from being self-conscious about my body."

Self-consciousness about one's body is just as pronounced among people you'd expect to have unwavering self-confidence. Phaedra Jarret dances with the Oakland Ballet and models in the off-season. She is slender, straight, strong, flexible and has a look of immense command. But, she says, "I cannot tell you the huge cathartic effect modeling has had on my self-image. Huge. Growing up dancing, I had so many issues about my body. With my body type a big major school would have discouraged me. They'd have told me, 'You're never going to

make it.' The ideal ballerina's body is extremely flexible, with hyperextended feet, and knees and hips very turned out, ultra turned out. The ideal ballerina is tall and trim, really like a racehorse. I didn't have all that. I still don't have all that. I've been, like every other girl in my dancing school, bulimic. Always heavy. Always fat. After I started modeling, that changed."

She would look at what artists had drawn and say, "Oh, this isn't bad. I'm pretty lucky with what I've got here." And often, she would look at a drawing and "seeing my body, seeing what they saw, say, 'Oh, my God, it's so beautiful!' You so appreciate how beautiful someone has made you. And I could see that was me. I could recognize my left breast or my thigh. That had tremendous effects on how I saw myself."

Consolation may be what starts people modeling, but it isn't what keeps them modeling. Once models find comfort with their bodies, they find, as model Molly Barrons did, that "the body is not just some sex object, not just for procreation. It's a vehicle for expression." As they discover this they experiment. "I started by trying to do the classical poses I saw in statues," says Marianne Lucchesi. "I just wanted to look pretty and feminine. After I had the confidence, I got more into doing my own expressions."

They find that there's a wide range of possible expression. Says model Semberlyn Crossley, "When you're an art model, you can make the slightest turn of your hand mean something. It's such an opportunity to say things you can't say in words."

It becomes a journey of exploration. Says Tracy Curtis, "I try to create a pose. I focus on what I feel and what I feel it would be like from the outside. I'm very interested in keeping my poses *my* poses. They're unique. They're me. I'm always trying to think of new ways to express myself through my body."

They find, as Molly Barrons found, that "everybody, male or female, young or old, is valuable, desirable and has some-

thing to offer." And in posing, that idea is flashed back to the artists. On a good day, it fills the studio: artist and model both feel, as Joan Carson puts it, that "the body is absolutely breathtaking. It's absolutely magnificent, and we all possess that magnificence. For me that's the beauty of being a model. It's a way of getting comfortable with myself and with each other."

Sometimes, it goes even deeper, perhaps stranger. One of the hints that this is so is something that a lot of the models say they have noticed: that artists tend to draw themselves in the model's pose. Barbara Tooma says, "The artists impose their likenesses on drawings of me. I think it's a common thing. If you looked at a drawing of me and a portrait of the artist, you'd see similarities. I think people project themselves onto the models. I don't think they're aware of it."

Ginger Dunphy says, "I notice a lot of people will put their own body proportions into their drawings. If you see someone hunches over, they'll put that into their drawings [and make the model hunch]."

"I'm a mirror," says Ogden Newton. "They're not seeing that [character they're drawing] in me. They're seeing it in themselves."

If they don't draw themselves reflected in the model, artists will project their own longings or anxieties into the drawing. Marianne Lucchesi says, "People portray you from their own experience. Fat women draw me heavier than I am. Men always draw me with bigger breasts than I have." Carla Kandinsky writes poetry about the experience of modeling, and in one poem describes old men who "draw their fantasies, making you years younger with thighs the likes of which you've never seen," cruel younger women wielding crayons "like razor blades to hack lines deep into your face and draw the droop of breasts with merciless accuracy" and older women dabbing in delicate watercolors "their own lost youth and sex reflected in your painted eyes."

The artists have the same interest and the same self-

consciousness about their bodies that the models have. One of the things they're surely doing in these studios is wrestling with their own body images. The difference between models and artists is that the models are very aware of their self-consciousness and can tick off in precise lists the ways their own bodies fail to fit popular stereotypes of power, beauty and desirability. Artists, perhaps because they are less verbal, perhaps because they are simply less able to look critically at themselves, are less able to confront their own nakedness.

And models are often scholars of self-consciousness and adept at recognizing this quality in others. Some see it quite clearly. Says Molly Barrons, "I think it's beautiful to see all these views of me. But I don't think it's me. It's their perspective of me. It's a very creative thing. And it's collaborative." Joan Carson adds, "What I'm hoping to do is get somebody connected with themself through me."

Phaedra Jarret tells about sitting for a painting with an individual artist. "He had the painting pretty much done. He had one part of my smile he was having trouble with. He kept kind of making me look older, as if he was seeing inside and pulling out my dark side. I was sitting there naked and he was staring at me, but I was watching *him* struggle. I realized how exposed *he* was and how vulnerable he was. Here I am a model physically exposing myself, but I am looking at the artists and seeing *their* struggle and *their* passion.

"When I tell people I'm an art model, everyone gets so, 'Oooh, how can you *do* that? Aren't you shy about being naked?' I go, '*I'm* not exposed being naked. It's all *those* people [the artists] who are exposed.'"

Artists and models alike are intensely interested in the body—in what it expresses and what it hides. We come week after week seeking the grace, strength, ease and gentility we hope animates us all. We come seeking some kind of harmony, some kind of identity in line and shadow.

Life-drawing sessions are most enjoyable when artist and

model seem to have an understanding of their common purpose and see themselves as equal participants. When Carla Kandinsky looks back upon the carefree days of modeling in Berkeley in the 1960s, she recalls that what she loved most was "that feeling of cohesiveness. We were all doing the same thing. We were all there to do that and nothing else."

It is that spirit of collaboration she has in mind when she thinks of art studios. And that is what keeps her coming back. She once told an interviewer, "When I die, I'll just be cremated and have my ashes strewn in the studios. Since they're never swept, they'll be there forever. I'll be immortal."

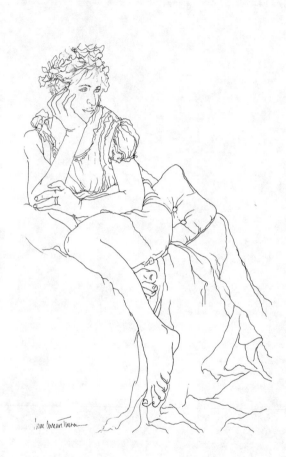

Ann Curran Turner, "Merav"

NINE

Waiting for a Muse

For two weeks I hadn't been drawing well. The lines were errant. I couldn't seem to find the touch to lay down shadows subtly or accurately. I couldn't see mouths; I would draw them, erase them, redraw them, look at the models' lips and see them disappear in a blur. I'd step back to look at the drawing and discover that I had compressed the legs so that the subject seemed deformed. The faces didn't resemble the models', and when resemblance crept in, there was no expression. They looked like bad taxidermy mounts.

It had seemed in the preceding weeks as if I had a warm and loyal relationship with the muse. Suddenly, she wasn't even returning my calls. What had I done to sour her?

Of course—in the ancient Athenian sense—there's no muse. Not for artists. The Greeks, who invented muses, recognized nine of them, all daughters of Zeus. They were singers, together constituting the full number of a formal Greek chorus. Each had her own specialty, singing or poetry or oratory, tragedy or comedy. When an orator or poet or singer of genius performed well, it was thought that the muses were singing through him. But there was no muse for a painter. Drawing was a skill, one of the crafts given to humankind by the goddess

Athena, and it was up to the artist to perfect that skill. An artist's inspiration is human and individual.

To find it, an artist has to be attentive in the right way. It requires an act of self-control, a blocking out of the noise that keeps the disparate parts of one's mind from working in concert with one another in order to draw. You don't get that self-control by divine intervention. It has to come from within. When the drawing is not going well, it's more like a brain dysfunction than a fall from grace.

It clouds your conscience. You feel you have failed to cultivate the right frame of mind. You want to go into the studio with an openness and attentiveness, an ability to see what is in front of you. An ability perhaps also to see what's inside you.

And for weeks, I hadn't had that. I had gone to New York, where the intensity of things always seems to recast my mind. There is the tension of business meetings by day, and then each night the manic pursuit of entertainment: dinner in a way-too-expensive restaurant, a Broadway show, jazz in a nightclub afterward. You are dealing in appearances and comparing yours with visages of incomparable brass and luster. New York City is a theme park devoted to ambition, and it becomes at once exhilarating and exhausting. My wife and I crawl back to the hotel room at one or two in the morning. By the third day, our internal clocks are ticking with a haste and edginess we don't really understand. Our sense of who we are is scrambled. When we get home, we're tired for weeks. And the drawing isn't alive.

This kind of thing seems to happen to all artists. Vincent van Gogh complained of days when artists felt "dull-witted in the face of nature or when nature seems to have stopped talking to us." Chick Takaha, a retired illustrator who draws several days a week, says, "There is a distinct up and down. If things are going well in your life, everything just falls into place." On some days, however, he says, "for no apparent reason, you feel nothing is working out today. It's hard to pinpoint how come."

But some days he'll look down at his drawing and ask, "How the hell did I do this?"

Drawing is not something you do perfunctorily. It's something you can do only if you are attentive. And practice is one of the things that keeps one attentive. If you stop drawing for a while, those fractious republics in the mind, the ones that must all carry on a polite conversation for one to draw well, stop talking to one another. Without the constant discipline of practice, they forget they ever knew one another. If you stop drawing, you lose your connections. Lots of events in life can alter your concentration. Poor health can do it. A change of scene can do it. A heightened emotional state or a depression can do it. I draw in bars. But I don't draw well in bars, especially with a second drink in front of me.

So my mind was not what it had been two weeks earlier. Whatever apparatus in the brain it is that spools out attentiveness had become cranky. It was as if someone had let a seven-year-old play with the control dials, and he had run off leaving all the preferences jumbled.

I am old enough to have patience, to believe I'll get my touch and rhythm and eye back. I know that I'll get them back if I do the right thing. I don't know exactly what the right thing is. But I know it is hidden there in the practice. So the answer is to keep at it. The answer to bad drawing is more drawing.

I watch as the model settles into her pose, watch her shift her footing and test her balance and consider whether the pose is expressive and whether she can hold it for twenty minutes. Watch her consider what to do with her arms: cross them over her head or let them dangle at her hips. Watch her consider where her gaze should go, down toward the floor, ahead and just beyond the artists?

All the time, I am trying to get an impression of the gesture, the mood behind it, the sense of connection I feel with it. And

I'm thinking about where it will go on the paper, where the center of interest will be, how the trailing limbs may draw attention from the corners of the page back to the face or whatever is the center of the drawing's focus. I do not translate any of this into words, and I do not want to draw with words in mind: this pose is not therefore "seductive" or "coy" or "athletic" or "pensive," though one might afterward say such things of the drawing. I'm not sure I avoid language here because I know I must shut down the language centers of my brain or because language just isn't a part of the act. I know I'm thinking, but I want to do it in a way that language cannot describe. I want to let the unraveling line push all the burdens of the day out of my head.

I am looking for an altered state.

I suspect all artists are looking for such a state. Chick Takaha says that when he is drawing well he feels "very buoyant." Others describe states that seem more meditative. Says John Goodman, "Time drops away so that you draw for twenty minutes and you feel there's no time there. You're really in the work." At such times, says Goodman, there may be ten other people in the room but he is not at all conscious of their presence. At its best, he says, "It's a very mindless state. When I get done with the thing, I'm very spent, and I don't know what I've done. I look at the drawing and I don't know how I've gotten there."

Artists frequently compare the way they feel when they're drawing to the sense of heightened awareness reported by practitioners of Yogic meditation or to the "high" runners experience. Jim Smyth, who has taught drawing for twenty years, says, "I believe the drawing process produces serotonin and endorphins in certain individuals. I see people who are not aware of their arthritis pain when they are drawing. When they are not drawing, it comes back." Smyth once let someone monitor his brain-wave activity while he drew. "When I was drawing, I would get alpha waves," he reports.

Alpha waves are electrical impulses in the brain that are associated with calm and focused attention. Studies of the brain-wave patterns in meditating yogis have shown increased alpha, theta (associated with reverie, imagination and creativity) and beta (associated with highly focused attention) waves. Meditation has also been shown to increase production of serotonin, a neurotransmitter, the lack of which is associated with depression, insomnia and migraine. (An excess of serotonin can lead to hallucinations.)

Smyth believes the chemically induced sensation of pleasure is what keeps many people drawing. "There must be some physical reward for some people," he says. "Otherwise, they wouldn't do it." And he feels he can often tell when they have slipped into an altered state: "You can see it. People's breathing rates change, their body language changes."

It is unlikely that artists who achieve deep concentration are doing the same thing that meditators do. Studies by Andrew Newberg at the University of Pennsylvania Medical Center suggest that meditation blocks cognitive and sensory input into areas of the brain that normally give one a sense of orientation in space and time, so that the meditator feels the boundaries between the self and the world begin to fade and he or she, in Buddhist terms, merges into "universal consciousness." Because artists must work with precise spatial awareness, perhaps something quite different is going on in their brains.

It is probably fair to say at least that there are states of mind in which different parts of the brain are competing for attention and states in which those parts most relevant to a task manage to keep the competing parts quiet. There are times when the mind seems full of aimless chatter and times when it seems to work with a smooth, effortless grace. University of Chicago psychologist Mihaly Csikszentmihalyi refers to the latter moments as "flow," and says that in such moments "one's skills are adequate to cope with the challenges at hand. . . . There is no other attention left over to think about anything irrelevant or to worry

about problems. . . . Self-consciousness disappears and the sense of time becomes distorted."

The meditative states of artists are, by their own varied accounts, highly individual. Ann Curran Turner describes hers as a feeling of supreme confidence. She draws assertively, with a bold line and no shading, without tonal values or patterns of light and dark. Everything depends upon the line, and it has to be true. When she draws well, the line is never simple, never abandoned as if she had stopped thinking about it and just let her arm carry the gesture across the paper and beyond its intended errand. It is never straight or ruled. It is always alert, always questioning, always driving, always changing. It is by turns lyrical, curvy, gracefully tapering or emphatic.

When she starts drawing, however, she is uncertain. She'll often lay the first lines down faintly, tentatively. She'll let the faint lines remain when she draws more definitive, more accurate, more confident lines next to them. She doesn't erase, feeling she must draw with conviction or not draw at all. The combination of questioning and more declarative lines stays on the paper, becoming a record of her conversation with this subject and giving her drawings more depth, complexity and interest.

Still, the line daunts her. When she paints, she'll brush the outlines in white paint onto the white-primed canvas so faintly that only she can see them. When she's drawing, those tentative lines sometimes seem like bad judgments. She is tormented when the lines don't seem to go where she wants them.

Occasionally she'll draw directly with black ink, and then she can't hide the exploratory lines. All the lines must be right. At such times, she says, "the black and white becomes frightening. You're so committed. It's no-holds-barred, and if the line doesn't take off" she feels crushed. When it's going well, however, she says, "it's sort of like the pencil is on the model's skin, very politely on her skin." It is as if the artist is not there, as if

the drawing implement were having its own conversation with the model. And when that happens, the drawing and the act of drawing seem perfect. "There's no bigger rush," says Turner. "All of a sudden it's beyond you. You have no control over it. And there's nothing more exhilarating."

Such states are not an everyday occurrence for Turner. Or for any artist. Whether one enters into a meditative state probably depends on what one brings to the studio on any given day. And what one brings must be carefully cultivated. Part of an artist's skill is the ability to find ways into these states. Says Takaha, "You can't just casually pursue drawing. It requires that you do it with a concentration and a focus. You can't be humming."

We all develop conscious strategies aimed at putting our minds into the right place. We all develop an order to the way we draw, ritualize it so that the judgments and calculations can

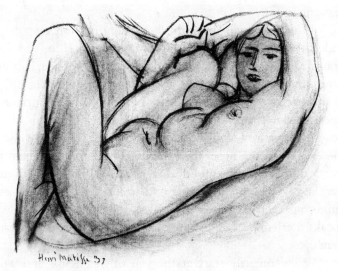

Henri Matisse, "Reclining Nude with Arm Behind Head"

cease to be conscious things. One way we do so is to draw features in a fixed order.

Most artists begin a figure drawing with the head. I think we do this for two reasons. One is that the eyes orient the head and the rest of the figure usually follows. Much of what a body does is aimed at giving a vantage point to the eye, and part of any gesture is devoted to putting the eyes where they can do the most good. We are naturally keyed to the eyes of others because their gaze tells us what their intentions are. (The eyes, too, hold much of one's individuality and mood, but not all artists are intent on portraiture.) The second reason most artists begin with the head is that one needs to establish a benchmark that will provide the scale and then measure out from it so that all the features are placed and sized proportionately. The head is usually held upright, and its height and width offer constants that can scale the rest of the drawing. So almost all artists start with the head, then move gradually downward, to the neck, the shoulders, the upper arms, the ribs, the abdomen, the hips, the legs and so on.

Most artists will draw the head faintly as an egg shape, wide through the forehead and narrow at the chin, and then draw a more exact contour over it, providing forehead, hairline, brow line and so on. If the model is facing me, I'm apt to draw that ovoid, then divide it into thirds with horizontal lines, marking the meridians of the chin, the bottom of the nose, the eyebrow and the hairline. Then I'll faintly draw in the eyes, then the nose, then the lips. I'll outline the hair. I'll worry more about the mouth than anything, perhaps because I have always had poor hearing and so learned to lip-read as a child and tend to watch a person's mouth when he or she speaks. Perhaps because of that I find mouths more expressive than eyes.

We customarily start at the top of the figure and work down. If the figure is reclining and the height of the head is no longer a convenient unit of measure, John Goodman will focus

on a point of high contrast, say, where the horizonlike curve of a hip is in strong light and the bend of the elbow just above and behind it casts a dark shadow. He'll draw that and make small explorations out from it, slanting down and left to the knee, curving down and right to the waist.

When the model is standing, I may draw the head in some detail before moving down to the body. Since my sense of proportion is often errant, I'll frequently hold up a pencil, put the tip level with the top of the head and place the end of my thumb against the pencil at the chin, then drop the pencil tip down to the chin in order to see where that point would fall on the model's breast, above or below the nipple. I'll mark that point faintly on the paper. Holding the same measure, I'll then move it down to see where the next span would fall above or at the hip and so on, marking off head heights all the way to the toes. Other artists are so adept that they never seem to need to make such measurements.

I'll move down the neck, out along the shoulders, down the upper arms. Before trying to draw the lower arms I'll draw the breasts and rib cage, where there are usually strong shadows, and take those lines down to the hips, before going back to the arms and wrists and hands so that I can see where the hands line up beside the hips or across a lap. Legs are always a challenge to me. They're at the bottom of the paper and closer to the eye, and if I'm not careful, the scale of the drawing will change there, and I'll make them too long or too short. Also, the shading on those larger leg muscles tends to be less definite and more difficult to see and draw well. If I'm not drawing spontaneously, I may have to measure the width of an arm or a leg, and usually I'll use the distance between pupils or the distance between the ear and the bridge of the nose as a horizontal unit of scale.

All of this seems quite calculated and self-conscious, more like work than like play. But when the muse isn't answering, when the drawing is not spontaneous, when I'm not seeing, I

have these calculations to fall back on. And if I do them correctly enough, I may slip into a better, less self-conscious frame of mind. It may nudge me into a more meditative state.

The only way I know how to get back into a drawing state of mind is to keep doing these calculated things. Eventually, my mind will start asserting the old connections again. I may have several days, even several weeks of drawing this way, and of going home with drawings that aren't worth saving, drawings I'm embarrassed to show to anybody. All I have to show for the time is the exercise in patience.

But eventually something will tip me back into the desired frame of mind. And I suspect that, more often than not, the tipping point is someone else's act of kindness. What I am doing in the practice is to some extent gnawing away at my own self-absorption, nudging myself open to that act of kindness. When it comes, the act of kindness is often the generosity of a good model.

Ann Curran Turner says she first began to experience that state of extraordinary concentration when she was drawing Katy Allen, a voluptuous two-hundred-pound woman of striking grace and wit. Allen would pose lavishly and flirtatiously in extravagant costumes of silk and satin and pearls. Drawing her, Turner recalls, "was having a great old time and loving what life is." In the late 1970s, Allen had inherited her grandmother's old Victorian house and had opened a boutique, where she worked six days a week. She stopped modeling except for private sessions she conducted with a few artists in her sprawling home. Says Turner, "She would pose for us on her days off from the store. We would go to her house." It was a daylong session, broken for a relaxed and lovingly prepared lunch. There would be three hour-long poses, each in a different room with a different elaborate setting Allen had staged for the artists. "The first pose was always a throwaway," says Turner. "I got tense and never got a good drawing. The third pose was always wonder-

ful." That was when she would toss aside her usual caution and draw with a steel-nibbed pen. And that is when she would experience the exhilaration, the sense of being part of the drawing. And she would come home with precise, lovely, lyrical, energetic drawings. She repeats the experience today only with models she has drawn a lot and feels very comfortable with.

John Goodman also talks of the connection he feels with the model when things are going well. "Something happens with me; I don't know if it happens with other drawers. When I'm looking at the model, in a very brief moment, it's almost as though I'm taking a tiny snapshot of only one point, maybe the way the arm falls or the shadow under a breast. When that happens it's as though the model enters into me." Each glance is a small slide projected onto the back of his brain. He has to step back from time to time to look at his drawing from a different perspective to see whether these translated images are being reassembled in the right proportions on the paper. But then he steps back up to the easel and resumes this semaphoric conversation with the model.

He knows that "this kind of visual communication between the model and myself" happens only with certain models. It is not the result of a long acquaintance or of employing models who work in certain ways. It is the result of some kind of compassion or generosity in the model, a quality he can't quite name. If a model has that quality, it is evident the first time he draws him or her. If the model doesn't convey this quality, he doesn't have that conversation and he does not ask the model back.

In a sense, then, there are muses. And at least some of the time they enter the room not with the artists, but with the models.

I don't fall into the deeper meditative states that Turner and Goodman describe. Perhaps it is not coincidental that I am not the artist that either of them is, am not nearly as intuitive or

inventive or liberated from the constraints of language. But I am deeply absorbed in what I'm doing when I draw and feel a sense of calm and well-being. If I am not quite transported, I am highly concentrated and attentive, very alive and confident and quiet.

And I have learned over the years that when this happens, it is quite often because the model has brought something indispensable to the drawing. I know, too, that you can never tell before drawing a person what sort of compassion they have to share. Sometimes it emerges from a person who, before posing, seemed aloof or self-absorbed. Neither the model's age nor gender seems to matter. Sometimes a body or a face that looks terribly ordinary when clothed becomes stunningly expressive when the model goes into a pose. I suspect that it is not just a matter of me being able to see, because sometimes it appears that the whole roomful of artists becomes so absorbed in drawing a model that it seems to hum. It is as if something the model is doing pulls us into the drawing, delivers us from the noise of the day and focuses our minds on the line and form and shadow.

One night the scheduled model failed to show up at the California College of Arts and Crafts. At ten minutes past the hour, Bruce Wolfe went outside to the pay phone to call him, and, if he failed to get an answer, to try to find a last-minute replacement. Artists milled around the room. Some grumbled and packed up their charcoal sticks and paper or paints and brushes. When Wolfe returned, we waited another ten minutes.

And then one of the artists, a slender, athletic woman in her early forties, volunteered. She had long been a member of the group, a sculptress and a painter, who usually sat quietly to one side working on closely observed portraits. She wore her blond hair in a medium-length bob, wreathing her forehead and temples but baring the neck. She often had a slightly harried look and had the reserve of someone who has felt at odds with the people around her.

But when she disrobed and started moving through a series of two-minute poses, something very confident and melodic settled over her expression. Her poses were not dynamic or athletic. They seemed wholly unself-conscious, unrehearsed, natural, graceful and confiding. She broke into a soft, almost beatific smile. And she was immediately easy to draw. I could see the lines of her face clearly, the way the light reflected up from the floorboards into her brows and hair, her balance and quiet poise. They were all turning up, effortlessly, in my drawings. I didn't find myself erasing, didn't have a sense of time running out on the pose, felt no haste. At the break, as I walked around the room looking at other people's drawings, it was clear that all of us were experiencing the same thing. Everyone in the room seemed to be drawing well.

Afterward, when several of the artists expressed gratitude to her, the model explained that she had done this once or twice before in private groups, filling in when the scheduled model failed to show up. And here, watching people disappointedly packing up their gear, she said to herself, "I might as well do this. It took me forty-five minutes to get here, and whether I pose or not, I'm not going to get to draw." She observed that if she didn't volunteer, "I'd have to go home, and all those people would have to pack up and go home, too."

She seemed unaware of the generosity of her act. And when I praised it, she said somewhat diffidently, "Besides, I'm vain. I work on my body. I do yoga and I used to run. I lift weights," she said, looking down appraisingly at her biceps.

And, she said, "I enjoyed posing. When I was modeling, I thought about poses I'd like to sculpt myself. I thought about poses that felt beautiful." And I think this means she envisioned herself at the moment as beautiful and shared that thought with us. In another context I might see this as narcissistic and boastful, perhaps even aggressive. But I think here it is not. She is not saying, "Look at what I've got!" but "Look what we can see

together." She's conjuring a feeling and sharing it with us. It does not seem like vanity, but like a species of generosity.

How does one share one's virtues and one's good thoughts? Mostly in gestures, in acts of patience or determination, sacrifice or care. We are not telepathic creatures. And yet we communicate ideas and feelings without verbalizing. We console, we soothe, we inspire one another in purely visual ways. The impromptu modeling that night seemed to me an act of care.

I think this, above all else, is what appeals to me about drawing models in a studio as opposed to unwitting subjects in bars and airport waiting rooms: that in the end, when it is really going well, it is an act of compassion, an act of sharing something with another human being. It's an act that requires dedication and self-discipline. You have to cultivate your eye, hone your skills, keep your mind open to the possibilities other people put before you. You have to look beyond the conventions behind which we hide the strangeness and discomfort we feel with others. You have to enjoy the otherness of the people around you. You have to be open to another's feelings.

It is perhaps sad that we practice this compassion in rare moments in the studio, in a ritual of disrobing and staring, but not in the streets with strangers in conventional dress. It would be lovely if we perfected this capacity and took it outside the studio. Maybe other artists do. I am not that perfect. I remain suspicious of others, critical, cynical, suspicious of myself.

But I practice it here.

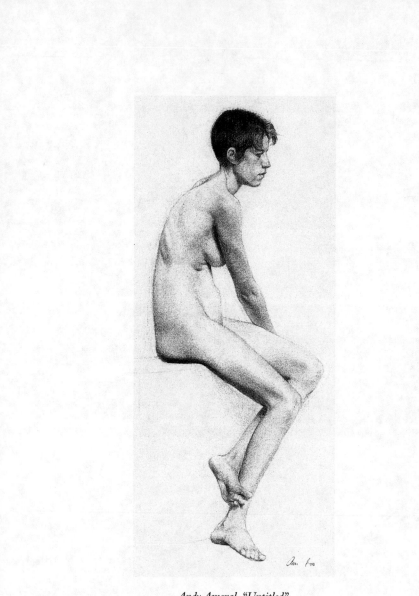

Andy Ameral, "Untitled"

Drawing Like Bargue

The Atelier School of Classical Realism is a studio in a second-floor walk-up in Oakland's Temescal neighborhood. The studio's side walls are a spidery clutter of parked easels, light stands and storage bins for canvases, but there is enough space for a dozen students to comfortably raise a skirmish line of easels around a model's stand at the far end of the room. David Hardy opened the Atelier in 1969 to offer "treasured understandings from the past" by teaching the drawing and painting techniques practiced by the old masters. Students here learn sight sizing, color temperature, drawing on toned paper to build both up and down in values, old master glazing techniques, even how to grind one's own pigments. Hardy, now seventy-three, is pale and white-bearded, with a folksy informality and cascading conversation, and a devotion to teaching "strong realistic art." Drawing is his passion. "It's a fatal disease," he says. "You have it for the rest of your life."

This Saturday morning is one of the three each month the Atelier devotes to the teaching of anatomy. Andy Ameral, a recent graduate of the nearby California College of Arts and Crafts, takes the students out into the hallway, where sun

streams through generous skylights and there is wall space on which to tape student drawings for critiques. He has taped to the wall a detailed diagram of facial muscles and a large color photocopy of a drawing by Charles Bargue. Bargue, a nineteenth-century French artist and student of the painter Jean-Léon Gérôme, transcribed a series of old master drawings into a widely used instructional book. Van Gogh copied the drawings and felt that their broad outlines and bold forms taught him to seek "the essential lines" in nature.

Next to the photocopy Ameral tapes a blank sheet of newsprint on which he will draw. Ameral is short and muscular, with a black T-shirt stretched across his broad chest and shoulders and a neatly trimmed Vandyke beard and mustache that wiggle as he chews gum. Small, oval, silver-framed eyeglasses and a black baseball cap turned backward on his head give him a prankish look. He talks with self-effacing modesty and affability. "When I was in school," he says, "I never read the books. I just looked at the pictures." Vincent Perez, who designed and ran the drawing program at CCAC—the only school in the West where one can get a master's degree in drawing—picked Ameral to be his teaching assistant, and Ameral became a devoted teacher.

Ameral talks briefly about how an arm muscle changes shape as the arm is turned and extended, and how one finds lines and shading to indicate that. Then he launches into a discussion of facial muscles, and he draws an oval face template, then bisects it with a horizontal line, "which is basically the eye line—it is actually a little higher than the middle." He divides the oval into thirds to position the hairline, brow line, bottom of nose and chin. He puts the lower line of the bottom lip midway between the chin and the bottom of the nose; one eye width separates the two eyes; a line from the inner edge of the pupil drops to the limit of the maxilla, while a line from the midpoint of the pupil drops to the limit of the mandible; the nostril's outer edge usually lines up with the inside corner of

the eye. "Ninety percent of drawing is measuring," he says. "Ten percent is the fun part, the rendering." As he draws, he describes the muscles under the skin, the masseter, the frontalis, the orbicularis oculi, the orbicularis oris and so on, considering how they bunch or stretch to move the jaw or give the face expression.

The meat of Ameral's lecture is in his preparation for the homework assignment, copying the Bargue drawing. It is a copy of an antique Greek torso, a male figure, headless and armless, cut off just above mid-thigh and planted in a block of stone, viewed from behind. There are two views. One is a quick chalked contour with faintly ruled construction lines framing the shoulders, the small of the back and the buttocks in such a way as to show that the figure is slightly inclined from the waist. Next to that is a subtly shaded finished drawing, the left shoulder, ribs and hips in deep shadow, the right side in strong light.

"The whole point of copying," he explains, "is not getting a good drawing. You've already got a good drawing, because you're copying a master. This is not about defining you as an artist. The point of copying the Bargue is developing your level of accuracy. This is a wonderful preparatory. Copying a drawing is being engaged in a personal discourse with a master artist."

He urges the students to make their copies on an easel and to do it without using grid lines, because "grid lines keep you from focusing on form." He urges them to use paper that is the tone of the original. "You want to do this as fairly as you can so you can see as fully as you can." He urges them to spend at least six hours on the task. "If you want to get better at drawing," he says, "draw all the time. *I'm* putting in six to eight hours every day.

"Start with a soft lead, which is easier to erase. Be conscious of how he turns form with line. Accuracy is all about line. Line that's down to a point." So draw with a sharp implement.

"If you find this process painful, you're doing it right. If you finish it in an hour, you're doing it wrong."

He starts to copy the xeroxed Bargue onto the blank sheet of paper. "Most of us are pretty good in the middle of a drawing. But a lot of us don't know how to start a drawing or how to finish it. Pointing to the ridge and shadow of the figure's back muscles, he says, "You've got to start off with a simple shape to get this complicated form. So you make a contour drawing first." With vine charcoal, he lightly follows the left-side contour, out from the neck, over and around the shoulders, down under the stump of the missing arm, curving out around the latissimus muscle, dropping to the waist, curving again over the oblique muscle just above the pelvis.

He completes an outline of the figure and sketches in faint lines indicating where the shadows will fall to the left of the scapula and down one side of the valley formed between the

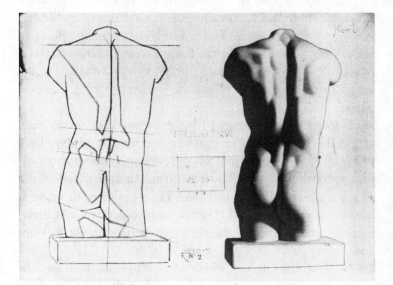

Charles Bargue, "Male Torso Viewed from Behind—Antique"

trapezius muscle and the spine. The real work of the exercise will be the shading in of these hills and valleys so that they give the texture and relief of muscle and skin. He shades in lightly, then darkens the deeper shadows, a little at a time. The drawing resembles the Bargue. It doesn't yet have any of the energy or sensitivity of the Bargue. To achieve that would take the rest of the day. Ameral urges the students again to take the time to do it the way Bargue would have done it.

"It's all about developing your eye," he concludes. "This is a classical realist school. Our real intention is accuracy. Be as accurate as you can now. Later, you can take what you learn here wherever you want to go."

Realism is the central idea of the Atelier, but the invitation to "take it wherever you want to go" is noteworthy. It suggests that the ultimate aim of this small private school is not so much to make students paint like Rubens or Raphael as "to gain freedom"—to allow artists to draw and paint well enough to express whatever ideas come their way. If you can't accurately draw objects that are outside your body, how can you expect to draw things that are inside your mind? The caution rings a little of rationalization, something faintly defensive, something you might tell other artists who question the wisdom of spending your Saturdays trying to draw as Leonardo drew.

You might expect that the idea of learning to draw objects as preparation for being able to draw what you feel would be hallowed in all art schools. But, in fact, few art schools emphasize drawing. Art today implies a much wider world than it did a century ago—and art schools teach conceptual art, video art, performance art, installation art. When they teach animation, it is often done on computers. It is quite possible for an art student to graduate from a four-year art program without having taken more than a rudimentary drawing course and without ever finishing a painting. The emphasis in many programs is on concepts or ideas rather than on execution.

And, indeed, that is why Hardy established this small school in the first place. He had become an artist only to find that the representational approach he espoused had been devalued and disparaged. The central event in the overthrow of the art he embraced, the most shattering revolution, was the substitution of abstraction for realism as the reigning American art form.

The change had been gradual, but inexorable. In the nineteenth century, as the camera displaced the artist as a recorder of fact, artists increasingly saw their function to be the interpretation of feeling. In the second half of the century, they were feverishly experimenting with new styles and new ideas about the purposes of art. Impressionists plunged into a world of color the camera had not yet found. Cubists ridiculed the camera's fixed point of view and depicted multiple visions that characterized the human mind in motion. Surrealists found psychological realms in which the camera lacked agility and deftness. And everywhere artists were increasingly committed to the romantic idea that the essential subject matter of painting and drawing was not the facts of the physical world, but the emotion those facts elicited. In 1790 Immanuel Kant, writing in *Critique of Judgment*, declared that what counted in painting was not meaning, but the feelings aroused in the viewer. By the twentieth century most artists agreed.

At the same time, with the rise of a working class with enough time and income to demand its own cultural artifacts, artists were drawn both to new subjects and to new markets. The result, critic Clement Greenberg wrote in the 1940s, was a period in which "it becomes increasingly difficult to assume anything. All the verities involved by religion, authority, tradition, style are thrown into question, and the writer or artist is no longer able to estimate the response of his audience to the symbols and references in which he works."

There followed a succession of rebellions and manifestos,

each new school causing discomfort to those who had already settled into an earlier school. In 1906, when Matisse exhibited *The Joy of Life*, a seven-foot canvas depicting a bacchanal on the grass, in which fat blocks of color emphasized some of the outlines of the nude figures, painter Paul Signac called it "disgusting." A year later, when Matisse saw Picasso's *Demoiselles d'Avignon*, he called it "a hoax." In 1936, when New York's Museum of Modern Art put on America's first big show of European cubism and abstract art, the U.S. Customs Service impounded nineteen of the sculptures, because "they did not show natural objects in their true proportions" and so did not qualify as objects of art.

At the beginning of the twentieth century, the world was in such flux that the subject matter of painting and drawing was uncertain. Greenberg held that the conventional subject matter had "lost its power to communicate on a profound level." By the middle of the twentieth century, he believed painters had shrunk from conventional subject matter to the point that "there is nothing to identify, connect, or think about, but everything to feel." Without natural subject matter and its symbolic impact, the artists were left only with emotion, which they sought to express exclusively in form and color.

Greenberg had come to art criticism by way of political commentary. Like other Marxists writing for the *Partisan Review* in the 1930s, he had opposed American engagement in World War II, urging instead an American socialist revolution that would so impress the Germans that they would bolt from Hitler. When America entered the war, *Partisan Review* writers wisely put their political views in a closet and concentrated in their writings on literary and artistic criticism. Much of New York's art criticism followed their lead, and much of it was implied—or even overt—criticism of American culture. Greenberg thus wrote of "the frustration and boredom" of middle-class America, "its inability to be spontaneous except when

drunk, its impersonal energy, and its desperate social aggressiveness." He added, "Not so long ago it was still possible to conceive of an attainable way of life possessing dignity and interest. [Today] we can scarcely even dream of it." And when critics like Greenberg looked at paintings, what they looked for was a sense of isolation and despair.

They found it in the New York abstract expressionists—in Jackson Pollock, Willem de Kooning, Robert Motherwell, Franz Kline, Mark Rothko, Adolph Gottlieb and others, who shared deep disillusionment with the world after the horrors of two world wars. They shared a rigid distrust of symbols and recognizable imagery, because objects seemed inevitably tied to reason as opposed to emotion. San Francisco abstract expressionist Edward Corbett explained that it was the rational side of the human mind that could "decide quite logically that extermination camps are the solution to political problems." Clyfford Still, who would lead the abstract expressionist revolution in San Francisco, similarly believed that facts, symbols and imagery would lead to totalitarian delusions. The only acceptable subject for a painting was one's deepest feelings, and they would be depicted using pure form and color. "I paint only myself, not nature," Still declared.

While one hears little mention of Rothko or Motherwell or Kline or Still in drawing groups, Clement Greenberg is still much discussed. He is vilified for his totalitarian views as to which expressionist painters were worth viewing and for accepting paintings from artists he praised and fees from galleries that sold them. In fairness, it must be said that he conceded that neither abstract nor representational art was inherently better. He wrote, "I think it one of the tragedies of our time that great painting has to do without recognizable subject matter." But, he declared, "the most ambitious and effective pictorial art of these times is abstract." The best art, he believed, released the feelings of the times, and abstraction did

that. "The naturalistic art of our time," he wrote, "is unredeemable."

In the 1940s, with European economies ruined by war and the American economy accelerating, New York overtook Paris as the world's leading market for art. And critics like Greenberg wielded enormous influence over the market. *Life* magazine could scarcely believe itself when, in 1951, convinced by Greenberg, it declared Jackson Pollock "the greatest living painter in the United States." To most Americans, Pollock's paintings were incomprehensible. Critic Leo Steinberg wrote of "the shock of discomfort or the bewilderment or the anger or the boredom which some people always feel, and all people sometimes feel, when confronted with an unfamiliar new style." But, he said, people would get over it. "No art seems to remain uncomfortable for very long. . . . This rapid domestication of the outrageous is the most characteristic feature of our artistic life."

But it wasn't going to be an easy domestication. Artists are anything but polite about their doctrinal differences. Abstractionists were sometimes totalitarian in their views and vicious in their responses to representational art. Adolph Gottlieb, for example, declared, "Representational painting today serves no social function at all, has no utility value—magic, religion, flattering the vanities of the rich, *et cetera* as it had in the past. We're going to have perhaps a thousand years of nonrepresentational painting now. Democracy doesn't demand the kind of visual expression useful to monarchies."

Gottlieb told writer Selden Rodman that "the average man is . . . enraged by . . . abstraction. Abstraction enrages him because it makes him feel inferior. And he *is* inferior."

Willem de Kooning characterized abstract artists as knights in shining armor, tilting at tired convention. "Disorder, casual morality and heavy drinking are perhaps an integral part of abstract expressionism, possibly a deliberate effort to exorcise

the stuffy middle-class average-mindedness and pecuniary values of America at midcentury by a show of total 'naturalness' and primitive emotion."

Sculptor David Smith told Rodman, "I'm a revolutionary and hope always to remain one. An arrogant independence to create is my only motivation. Only with other professionals do I feel any sense of equality."

On the other hand, critic Bernard Perlin said of the abstract expressionists, "*Their* painting is millionaire art. Who else can afford it? Or live with it?" He added, "A real hatred of society and humanity motivates most abstractionists. Behind many of these artists is an elitism inherited from one or another of the totalitarian ideologies."

One could take a beating from both sides. While some people criticized de Kooning for the violence and misogyny of his drawings of women, abstract expressionists took him to task for painting women at all, saying he yearned for "smug and familiar surroundings" and failed to avoid "the associative encumbrances of the subject."

Jackson Pollock's partner, Lee Krasner, recalled in a documentary film how one day the painter Hans Hofmann came to visit Pollock and, looking over his paintings, warned Pollock that because he didn't paint from nature he was in danger of repeating himself. Pollock flushed quickly to anger and declared, "I *am* nature!"

The vehemence and rigidity with which artists expressed themselves left little room for accommodation. As soon as abstract art was in ascendancy, drawing almost vanished.

You could see it perhaps more dramatically in San Francisco than in New York. Abstract expressionism had grown as naturally in San Francisco as in New York City. Susan Landauer, curator at the San Jose Museum of Art, points out that San Francisco hosted one-man shows for Arshile Gorky, Robert Motherwell and Jackson Pollock before New York did.

In 1941, *Art Digest* held that San Francisco was "the capital of ultra modern art in America." At the end of World War II, as returning veterans filled the art schools, the new trend quickly swept aside the socialist realism trend that had been strong in the 1930s. Douglas MacAgy, who in 1945 became director of the San Francisco Art Institute, was so devoted to abstraction that he hung a curtain over the fine Diego Rivera mural that graces the wall of the school's gallery. He hired abstract expressionist Clyfford Still, a West Coast artist with no formal training, to teach at the institute, and MacAgy's wife organized a solo show for Still at the Palace of the Legion of Honor. Still urged students to explore their own interiors rather than the world outside them. "I am not interested in illustrating my time," he declared. "I have no brief for signs or symbols or literary allusions in painting. They are just crutches for illustrators and politicians." Even Picasso was, in his estimation, merely "a commercial painter" and "an illustrator of his time."

MacAgy also hired abstract expressionists David Park, Hassel Smith and Elmer Bischoff to teach. Park taught students in his courses to do thirty-second drawings, urging them to draw more what they felt than what they saw. Eleanor Dickinson recalls that by the time she arrived in the Bay Area from Tennessee and enrolled in the San Francisco Art Institute, "they didn't give you any classical instruction. They sort of looked down on it. Generally, if people wanted drawing in art, they had to go to the old masters."

In New York, models found less and less work. Robert Speller, who began working as a model there in 1960 and went on to be model coordinator for the Parsons School of Design and booking agent for many of New York's colleges, recalls that there were fewer bookings at the colleges and art schools. He adds, "I noticed in the late 1960s and early 1970s that many of the painting and drawing classes were taught by abstract painters who had no experience with the figure. *I* knew so much

more than they did. Some would tell me they never had a figure class, just some experience with a drawing group." Says Minerva Durham, "I think the whole country slumped by the mid-1960s and '70s. Everybody stopped doing the figure and it was all in hiding."

Even commercial artists felt the change. Bob Levering, who now teaches drawing and painting at the Parsons School of Design in New York, worked in the 1950s at the Charles Cooper Studio, which produced illustrations for magazines and advertising campaigns. He specialized in illustrations for romance stories in magazines like the *Saturday Evening Post* and *Redbook*. As New York magazine and advertising art directors increasingly embraced the more personal styles arising out of abstraction, Levering, who had no art school background, felt intimidated. As he recalls, "Anybody who did the figure then, they said, 'Get out of here!' So I stopped doing all that. I wanted to grow." He went to study under Reuben Tam at the Brooklyn Museum of Art, where he learned a freer, more personal kind of drawing that kept him abreast of the changing market. But others working alongside him did not, and eventually Charles Cooper Studio closed.

Meanwhile, photography took over the business that commercial artists formerly enjoyed. Hawaiian artist Herb Kane was working as a commercial artist in Chicago in the 1960s, drawing, among other things, the Jolly Green Giant in ads. Says Kane, "Photography and the reproduction of photographs made such great advances that it became so much easier to do things with photography that previously you could do only with illustration. All those special effects that illustrators had discovered, special lighting, special background, photographers began to emulate them. And they could work faster."

For a time, artists flowed out of commercial studios in the eastern states looking for places where representational art still flourished. A number of those artists moved west to New Mex-

ico and Wyoming and became cowboy artists. In the American West, where ranchers and loggers are continually in conflict with government and corporations, the cowboy as a symbol of rugged individualism is still treated naturalistically. In the 1980s, Herb Kane moved back to his native Hawaii and began to interpret ancient Hawaiian traditions—a subject especially suited to the figure—in paintings of ancient Hawaiians braving vast seas and living confidently in the dramatic beauty of the island setting. Says Kane, "I'm trying to document something that has passed and open a window to that part of the past. If you don't open the window, nobody will ever be able to see it."

Abstract expressionism soon enough proved to have limits. Without the ability to look to nature for subjects, artists felt constrained. The promise, believed in by many artists, that abstract expressionism would lead to a universal language of pure form communicating feelings unadulterated by ideology or intellect was never fulfilled. Abstract artists began to sneak back to nature.

In San Francisco, Bischoff and his compatriot Richard Diebenkorn were already feeling limited by abstract expressionism's absolute rejection of drawing from nature, and both were about to return to drawing the figure. When Bischoff resumed the figure, he had to start by drawing himself in front of a mirror. Diebenkorn fled to New Mexico and Illinois, where he started painting landscapes—abstractly enough to deny he was painting landscapes, because he regarded accusations that he was painting from nature as a put-down.

In Illinois, Diebenkorn joined a drawing group with an English professor, a physicist and some members of the University of Illinois art department. When he returned to California, he started his own drawing group. He was already gaining fame, and his collectors urged him not to do the figure, fearing it would tarnish his reputation and cost them the investments

they had already made in his pictures. But by the mid-1950s, he was resolved to continue. Park and Bischoff also returned to the figure, and they drew with Diebenkorn at Bischoff's studio over an old automobile showroom on Berkeley's Shattuck Avenue. Eventually their "Bay Area Figurative" school would exhibit together, earn acclaim in New York and regain much of the ground that drawing from nature had lost.

Both in New York and in San Francisco, abstract expressionism soon gave way to pop art, which again embraced images. By 1975, New York artists were quietly returning to figurative drawing and reestablishing drawing groups. Says Robert Speller of the late 1970s to about 1990: "That was the period of the greatest number of model bookings. We used a lot of models. I was booking five hundred assignments a week at Parsons, Hunter College, Richmond College and others. We used to have sketch groups in galleries at night. Advertising companies had figurative groups. We had lots of sketch groups going on. Some, we had so many people we had to have models in more than one room. There'd be twelve or fifteen people calling looking to start sketch groups."

But drawing was hedged with cautions. The painter George Tooker told Selden Rodman, "I think there has to be an interplay between head and eye. Nature is so much richer than anything you can imagine." But, he said, "Painting, to be really convincing, has to come from strong emotions. I sometimes draw from the model, I never paint from one."

Abstraction freed artists to express themselves in more personal ways and to put feeling into pictures by abbreviating, distorting and revisualizing. And, because that new freedom can make drawings and paintings more powerfully appealing, we have come to accept abstraction as an essential part of our visual lives. Even magazine illustrators and advertising directors were quick to adopt the more personal style. But much of that acceptance has been more resignation than eager embrace. For art

has become more idiosyncratic, more personal, more rebellious, less and less interested in shared conviction and shared feeling. Tom Wolfe, in his angry essay on the elitism of modern art, *The Painted Word*, described his own oft-repeated experience of standing before a newly heralded masterwork in a gallery or a museum and waiting for some glimmer of comprehension or compassion to descend on him, but ultimately walking away feeling stupid or insensitive or uninformed. Recently, at the San Francisco Museum of Modern Art, I listened to a docent standing in front of Matisse's *Woman with the Hat* tell a flock of curious attendees that a century ago, when the painting was new, it was ridiculed for the green skin color and that they should keep this in mind and be tolerant of whatever else they might see in the museum that day. Increasingly, visual art has been displayed as if the viewer were a work in progress.

Part of the problem has been the emotional content of the paintings. Leo Steinberg wrote that modern art is "born in anxiety" and that "the function of modern art is to transmit that anxiety to the spectator." The discomfort that was the subject of the painting, in other words, was part of the discomfort of the viewer. But perhaps there is something more to the discomfort the viewer feels.

Perhaps there is also a biological aspect to the shift toward abstraction. The brain areas that support perception of complex geometrical patterns, spatial patterns and faces are principally located in the right hemisphere; verbal memory, reading, words, writing and speech are primarily in the left. Robert Solso speculates that one's preference for an abstract painting by, say, Piet Mondrian, or a realistic one, say, by Michelangelo, might have to do with how dominant one's right or left hemisphere is. One's taste in art might be determined by the way one's brain processes and organizes information.

And it may not be just a right-brain versus left-brain issue.

Psychology professor Semir Zeki observes that European painting since the Renaissance represented objects differently from the way we actually see those objects. Zeki points out that the appearance of an object changes from moment to moment, because our heads are moving or because we are walking around an object and thus seeing it from multiple points of view or because the light is always changing, causing shadows to creep across the faces of things. That, says Zeki, is how the brain views things, and it is the brain, not just the eye, that sees.

To some extent, the fluidity of perception in the brain that Zeki describes is the root of abstraction. It is present in non-Western art—say, in African masks or Australian aboriginal bark paintings, where distortions are freely accepted. Cubism took away the lighting and fixed perspective of classical Western drawing and painting, and introduced multiple points of view that are part of the way the brain actually works but left out or altered the stages whereby the brain integrates these views in an orderly way.

Zeki made brain scans of people looking at André Derain's view of Charing Cross Bridge, painted in intensely brilliant fauvist colors, and compared them to scans of people looking at representational pictures using more straightforward colors; he found that the two groups used different neurological pathways. Abstraction perhaps then appeals to a different kind of mind. We don't all have the same visual habits. We may not even all share the same visual neurocircuitry. And the result is that all these new styles of art present not just a cultural clash, but challenges to the way each of us sees. The conflicts arising over different approaches to drawing may be more than just matters of taste.

I see other evidence that this may be so. It is commonly said that a taste for abstract art is acquired and usually comes with a college education or a lot of time spent in galleries and museums. But in drawing groups you begin to suspect this is not so.

For one thing, you meet people who practice abstract techniques but will tell you how hard it was to learn them. Marguerite Fletcher, a Palo Alto artist who specializes in landscapes, recalls her student days at Stanford University studying under Frank Lobdell, who had spent his career searching for ways to express himself in pure forms. "I remember feeling threatened by all this being pushed at me," says Fletcher. "I can remember sitting in tears with Frank and fussing away on my drawings' lack of cohesiveness." She continued drawing with Lobdell long after she graduated and today regards his patience and encouragement as stunningly generous gifts. But, she says, it took her years to begin to see how to make these techniques work for her. "It's a hard leap to go beyond the image," she says.

And you meet others who are deeply schooled in art who have little liking for abstraction. Jim Smyth, a popular instructor of drawing and painting, has studied widely in Europe and spends his summers studying with Russian artists at the Repin Academy of Art in St. Petersburg. He sees the prestige enjoyed by abstract art as a kind of collusion between academics, gallery owners and museum staffs who all have a considerable financial interest in kiting the value of paintings they buy and sell. His view is that, in the nineteenth century, when states and churches were replaced by middle-class individuals as the chief buyers of paintings, there were no longer clear standards of quality. "The art schools, recognizing that they no longer had an educated buyer, no longer had a reason to produce an educated artist," he says. And writers like John Ruskin and Emile Zola, who held romantic notions of artistic passion rather than academy-trained standards of artistic achievement, stepped in to mediate the market. "Had not Monet been a lifelong friend of Emile Zola," says Smyth, "he would not have become a famous painter."

The fact of the matter is that we are of many minds, and we have a wide variety of pictorial interests. The public's taste in

contemporary art runs from Thomas Kinkade's thatch-and-waterfall hobbitscapes to Damien Hirst's revolting dissected cows and sharks. Galleries at least have figured out that there is a wide range of artistic approaches and artistic appetites. There are, accordingly, galleries that make a market in golf scenes, galleries that specialize in landscapes, galleries that specialize in pets, galleries that specialize in still life, and galleries that display only abstractions.

If it were simply a matter of acquiring a taste, you'd expect the debate between abstraction and realism to have ended years ago. But it hasn't. The old wounds haven't healed. Abstractionists and realists still argue. Recently, Janet Malcolm, a writer for *The New Yorker* who has taken up the making of collages, told a *New York Times* reviewer not to ask her what her collages meant, and she added that any work that told a story was "mere illustration," the implication being that illustration was not art. Hearing that, Chick Takaha, a San Francisco art school graduate and illustrator who has been drawing for more than fifty years, observed, "If someone is a good draftsman, they look at his drawings and say [disparagingly], 'That's photographic.' " Takaha's view is that "if someone else is coming to you and asking you, 'Will you document my product?' that's illustration; if you find the subject and the interpretation within yourself, that's art."

Jenny Keller says students at the University of California at Santa Cruz "come to me and say, 'I want to be an art major, but they discourage anyone who wants to draw.' Students say they've been told, 'Don't go over there [to science illustration]; it will stifle your creativity.' "

David Hardy is still stung by both the tone and the content of modern art's newer orthodoxies. The brochure he offers prospective students proclaims: "Competitive back-stabbing is not tolerated at any level. Mutual understanding and earned respect dominate the Atelier environment."

But his own view of what happened to realism is steely. "Basically [in art today]," he says, "the emphasis is on innovation and energy and shock value. There's no poetry. Beauty is found to be suspect. Most of the painting pretty much everywhere is impressionism or abstract. Establishment art is artificially cultured by academia, the media and museums. It's a closed circuit. It's self-aggrandizing and has gradually become more estranged from society. Most art has no meaning to those who haven't had a special indoctrination. For most people, going to a gallery is like going to a medical seminar for doctors."

The debate between abstraction and realism runs through all the drawing groups. You can look at the drawings and see in them the whole range of drawing styles. You can even tell to some extent, without actually seeing the work, who's drawing more abstractly and who more realistically, because the realists sit close where they can see details, the abstractionists farther back where they can see the forms. San Francisco painter John Goodman paints abstracted pictures based on natural subjects and draws several times a week. "I draw," he says, "not so much to find paintings but to get the forms and put them into the space they occupy. I draw to keep my eye." Shifra Gassner says she knows painters in New York who draw the figure several days a week in group sessions and then go home to paint abstractions at night. They draw the figure so that they might have access to things inside their own imaginations that are less objective and less easily seen.

You still see artists trained in abstraction sniffing disparagingly at representational drawings or, if they're disposed to be helpful, urging their cohorts to draw less literally. The most common request or pleading I think I hear in these groups is an artist showing a drawing and asking, "Is it loose enough?" But you also see young men and women, aspiring film animators and game designers, who ask, "Is it accurate?"

In all these groups there is, however, a deep respect for dif-

ferences. There is an overriding generosity that seems absent in the galleries, museums, art schools and academic departments. These artists have made their peace. We all agree that we look for subjects in nature and that we must learn to draw what is outside us before we can draw what is inside. That is reason enough to come to the studio.

Of course there are other reasons. We are summoned also by the purely human acts: the act of seeing, the act of compassion, the thought, the patience, the exercise of self-control and the discovery of faith in oneself. All these things add to human competence and human nobility.

And they're part of what Andy Ameral seeks. That's what he means when, at the Atelier in Oakland, he steps back from his copy of the Bargue drawing on the wall, admires the line in his copy, looks back at the Bargue and says, "This is how I want to draw. This is how I aspire to draw."

John Goodman, "Phaedra"

Desire

Model Ginger Dunphy recalls a polite suburban drawing group in Sonoma County where she was doing a long pose in costume while twenty-eight men and women quietly drew. The door to the studio flew open and, says Dunphy, "This woman runs in and starts telling people, 'I know what's going on here! People are having sex left and right!'

"It turned out she was about to be this guy Andy's ex. She said, 'I know Andy is having an affair with that woman!' and she went over to this woman and punched her.

"It turned out to be the wrong woman.

"Andy grabbed her, and they struggled. She threw this big jar of watercolor water. I said, 'Listen, lady, you've got to get specific about your anger here.'

"The lady finally left the room, and I went back to my pose. After some silence, I said, 'Nobody's having sex here that I've seen.' A guy about seventy-five years old in the back of the room said, 'Oh, no! You mean we're *not* going to have any sex?' "

Most of what we see of unclothed bodies in movies, on television, in magazine ads is calculated to arouse sexual interest, so

it is hard for those outside to believe that what's going on in the studio is anything but more of the same. There is, too, a view that creative energy is sublimated sexual desire, originating in the romantic nude paintings of the nineteenth century and later encouraged by Freudian psychology and evolutionary views that reduce human behavior to strategies for breeding advantage.

So, outsiders wonder, what kind of desire runs through these drawing groups?

There's no sex in the sense of copulation or touching or even talk that is preliminary to coupling. But is there sex in some other sense? Do people in the studio fantasize about sex with the model? From time to time you see hints of that.

One night a young man sat down next to me at the Mission Cultural Center in San Francisco, draped a windbreaker over the back of his chair and centered a large newsprint tablet in front of him. He was polite and chatty and told me he had recently started taking drawing courses at San Francisco State and was looking for places to draw. Once the model disrobed, he drew furiously, darting toward his big newsprint pad, leaning back to look at his slashing strokes of charcoal, darting forward again, hyperventilating. The model did ten two-minute gestures, and as she changed poses, he threw the top sheet of his pad noisily aside, each time covering my smaller pad completely. He was a blur, oblivious—or ostentatiously conscious—of my presence, a kind of parody of Jackson Pollock throwing paint at a canvas. All I could do was stop and watch him. Was he drawing to see or to be seen? He drew breasts and thighs and then tried to enclose them in some kind of contour. I judged he was drawing not the model, but his own desire.

And hiding his lubricity from himself in all the active movement. The frenzy of his action proclaimed his inexperience. Modern art is held up to us as a way to express our feelings. But our feelings are often blurred or murky. We have different abilities to recognize and name them. The lionizing of Jackson Pol-

lock and other "action painters" endorses creation as an act of frenzy, and many are perhaps drawn to art not because it seems to be a way to see, but because it seems to be a way to act, a way of being spontaneous, alive and full of authentic feeling. The more practiced artists, whether drawing abstractly or realistically, take time. They're absorbed by the subject but never overwhelmed by it. They know that it requires an enormous amount of conscious attention to draw well.

Edward Hill wrote, "Expression surely stands as the final objective of art. However it is expression of an individual's understanding of his art and his experience, not a catharsis of his emotions or sheer display of idiosyncratic personality. The student must set understanding as his goal, not self-expression. The latter will arise naturally from the former."

Perhaps it is the distinction between expression and understanding that draws the line between sexual and creative energies. You tend to see more signs of lust in people who are just beginning to draw. The view of most people in the studio—and especially of those who have been there awhile—is that whatever goes on there, it's not sex. Says Warren Lamm, a professional artist with whom I've drawn for fifteen years, "You can't do that [fantasize sex] and draw at the same time." Says Dick Damian, who draws, models and formerly ran the Palo Alto Models' Guild, "I can't draw and lust at the same time." John Goodman says, "Having a dental hygienist go in and clean my teeth with her fingers is more sexy than what we do in the studio."

Terry Koch, who both models and draws, says that when he's drawing, he loses a sense of the individual body. "I'm just interested in the line. I like joy and want to draw that. I'd like to be able to draw the joy and the energy instead of the body."

Says model Rashmi Pierce, "I'm there to have them draw. Not draw my contour, but my energy."

The few people I've thought were lusting, not drawing, did not persist. I suspect poor drawing taunted them, and they quickly found that there were less strenuous ways to indulge their desire. An unusually candid artist friend confessed that he once lugged a drawing pad and charcoal to The Lusty Lady, a San Francisco sex-entertainment club, where private booths let patrons watch nude women dance provocatively without having to reveal their own sexual engagement or activity. The artist laughed, a little embarrassed, at the experience. He would just get a drawing started, when the small window through which he was viewing the dancer would slam shut, and he would fumble for more quarters to feed into the slot in order to reopen it. In the end, he emerged with a couple of really bad drawings that focused especially on the dancers' genitals, and a deepened sense of his own human frailty. He didn't regard the experience as art.

Desire is surely present in the studio. It's a vastly important theme in the works of such artists as Courbet, Renoir, Rodin, Modigliani, Matisse and Picasso. Few painters of the human figure have not, at some time or other, considered it. A serious sixty-year-old artist turned to me while we were drawing a very beautiful young woman and, still looking at her, leaned over and whispered, "You know, the drawing is so much better when you're in love with your subject." But, unlike the young Jackson Pollock at the Mission Cultural Center, he was not lost inside himself. The drawing before him was more about the way light fell on the model's back and shoulders, more about beauty than it was about lust.

Some of the models experience desire, too. It is usually involuntary and more a problem with men, of course, because it shows. "The problem with men is erections," says Ogden Newton, who has modeled for forty years and who is the booking coordinator for the Palo Alto Models' Guild.

It has happened to Newton. The one time in his career that

he got aroused in the studio, he felt deeply humiliated. After it happened, he went to apologize to a woman who had been right in front of him, but as he approached her he saw that she had cheerfully drawn his erection, and drawn it beautifully. He was so embarrassed that he couldn't bring himself to speak to her.

Occasionally, when a model has gotten aroused in front of a class, the instructor will call Newton to complain. Newton will talk it over with the model. Some poses, he believes, make a model more vulnerable to arousal. Recently called by an instructor with a complaint about a model who had been visibly aroused, Newton talked with both the instructor and the model and determined that "there was no intent and it wasn't directed at anybody. I said, 'As a normal human being, being out in front of twenty people, it's natural.'" He counseled the model in ways to avoid a recurrence and assured the instructor that it was unlikely to happen again if he rehired the same model.

But he told the model, "Artists aren't interested in erections. They're here to draw. This is career threatening, so you've got to control it. It's mental. It's in the mind and you have to stop and deal with it."

Arousal happens to women, too. "Women are a lot more subtle about it," says model Sterling Hoffmann. A few female models are candid about this. "You get a long time on the stage," says a San Francisco model. "You've got to entertain yourself. If I'm trying to be in a seductive pose and I'm thinking about sex, that may trigger something. Or I'll look at someone in the room and feel tension in my body." Once she's aware of the arousal, she becomes concerned about showing it. "I'll compensate for it with other muscles. I can contract my muscles in a way that doesn't show I'm excited." But it's sometimes a struggle. "I worry about losing control of my bladder or, 'Oh, my God, am I juicing up or something?' But I don't want to control myself so much that I'm like a cadaver. It's not a good time to feel like you're excited."

And there are exhibitionists among the models. There are models who draw attention to their genitals, male models who show off erections or direct them at people in the room. One model remembered by people who drew him in the 1980s would deliberately have erections, which the artists, out of politeness and embarrassment, would refuse to draw. During the breaks, he would go around the room criticizing them for not drawing the erection, declaring, "That's the way I am!" But that kind of behavior would get one expelled from the guild, and it so limits a model's appeal that he would find little work. Exhibitionists are probably not expressive of the kind of desire we're talking about, anyway, but rather people who can only see themselves as alive when performing outrageously.

There are gay drawing groups that encourage the model to have erections for the artists to draw. These are not primarily drawing groups but groups more concerned with redefining homosexual subculture. Longtime San Francisco artist Bill Brown, who attended a few such groups, says he would not repeat them, and he admonished their members, "If you want to have sex, have sex. Why don't you go home and take out a porno film?"

All in all, displays of sexual arousal or desire seem uncommon in the studio. Most models say they never get aroused. Stephanie Caloia, who has modeled for thirty-five years, says, "For myself, there's no eroticism." Says model Marianne Lucchesi, "It's not what people think. It's very clinical." Says Ginger Dunphy, "People think nudity is sex. It's not about that at all. It's just not a situation for sex." Ogden Newton sometimes has to tell young men who inquire about becoming a model and seem to be interested chiefly in connecting with women, "The bottom line is it's the worst place in the world to pick up women."

Lucchesi agrees. "In an art class, the men quite often consider you unapproachable. There seems to be an enormous

respect for models, their comfort and dignity. There's far more than I get with my clothes on." Says Ashley Hayes, "In art groups, generally I find men are very respectful of your space. They're hesitant to come over and talk to you. They want to, but they don't want to seem like they're hitting on you. They wait for you to make conversation, to make the approach first, which is really, really cool."

There is, of course, the possibility that what draws many to drawing is *vorlust*, the pleasurable anticipation associated with sexual foreplay, the kind of sensation that a stripteaser or topless dancer seeks to kindle. Freud thought *vorlust* became a perversion if it supplanted rather than served as preparation for sexual aims. And we popularly think of it as passive and witless. I suspect all artists get quick stabs of this kind of pleasure. The men do undeniably; they would not be human if they didn't. And to some extent we expect it to enter the drawings. Kenneth Clark declared, "No nude, however abstract, should fail to arouse in the spectator some vestige of erotic feeling, even though it be only the faintest shadow. And if it does not do so it is bad art and false morals. The desire to grasp and be united with another human body is so fundamental a part of our nature that our judgment of what is known as 'pure form' is influenced by it, and one of the difficulties of the nude as a subject for art is that these instincts can't lie hidden."

The drawings you see when you walk around the studio during the breaks, however, don't often express a voyeuristic spirit. I suspect this is not because the artists lack the skill to express the feeling. Nor do I think that because we're drawing in public we're drawing politely and hiding our lusts.

A Freudian would probably say we're sublimating and that it is sublimation that generates creative energy. Freud's theory was that children in their earliest years experience the sensuality of contact with their mothers and the complete freedom of unrestrained sexual impulses. As children grow older, they lose

Pablo Picasso, "The Artist and His Model"

both the sensual contact with their mothers and the freedom. Their impulses are disciplined and restrained because society cannot function in the chaos of unbridled desire. So, we all repress our sexual thoughts. Freud thought this repression explained why most of us have no memories of early childhood. An artist, Freud thought, was a person less bound by the repressive nature of culture, a person who could tap through memory into the lost images and feelings of childhood.

Before Freud, artistic creation had been thought of as akin to dreaming. Freud thought dreams and artistic activity were different kinds of mental activity. Artistic creation sprang from symbols, which in Freud's view originated in different ways than dreams. Freud thought most symbols were sexual, fabrications of a subconscious mind seeking to get back to the unrestrained sexual impulses of childhood.

Freud was widely criticized for this theory. In 1925 Clive Bell declared that the artist "is not concerned with sublimation of his lusts because he is concerned with a problem which is quite outside normal experience. His object is to create a form which shall make an aesthetic conception, not to create a form which shall satisfy Dr. Freud's unappeased longings." Cézanne, he said, painted apples not because their shapes were sexually suggestive, but because apples did not rot quickly, so they could be studied and painted without haste or interruption.

Psychologist Ernst Kris felt that, in contrast to fantasy or dream, an artist's "repression" was rather a purposive and controlled interplay between creation and criticism. Indeed, balancing this interplay was one of the skills an artist had to master, for when imagination went too far, the symbols became too private, and when control was too strong, the work became mechanical and uninspired.

Critic Roger Fry held that artists instead were "seeking to make constructions which are completely self-sufficient, self-sustaining and self-contained—constructions which do not stand for something else, but appear to have ultimate value and in that sense to be real."

Philosopher–art historian Herbert Read thought our amnesia regarding early childhood was not due to repression of sexual impulse, but to "the encroachment of the already labeled world upon our spontaneous sensory and intellectual capacities." In other words, we forget childhood associations because they make too little sense to be worth remembering. Read held that the basic drive in artistic creation was to find coherence or clarity of form and that finding such coherence gave the artist something like the harmonious unity of "the primary mother-child relationship."

Freud gradually modified his view of sexuality to encompass the "eros" of Plato's *Symposium*. Plato believed that eros was a love that expanded outward from one's own body to

another, from corporeal love of ourselves to love of another, and ultimately to a love of beautiful knowledge. Through eros, then, one grew out of selfishness into lasting and expanding relations with others, and possibly from there to love of truth, humankind, nature, the world in general.

Ultimately, Freud's theory was that a healthy individual's sense of pleasure matured so that one found pleasure less and less in one's own sensuality and more and more in other people and in objects outside our skins. We grow beyond the self-centeredness of infancy, divert our feelings to other people, first to our mothers, then to people outside the family, then to a mate, and sometimes beyond that to all humankind. The power of eros was the power to find attachments to things and to people "out there." It was what made it possible to engage in marriage and family. It was also what made it possible to engage in loving contemplation of each other's thoughts and feelings, each other's work, each other's ideals.

And I think it's clear that this is one of the things going on in a drawing studio. To draw well, you have to find ways of working that go beyond impulse, that are considerate and compassionate. You come into the studio to extend your sense of the world. One of the ways you extend your sense is to go beyond conventions about desire. You are compelled to think about the body differently.

I think, too, the more one sees *of* the human body, the more one sees *in* the human body. In this sense, we come into the studio at first innocent of what the body has to say, and the more we draw, the more we feel we know and the more we may have to say. Artists who draw the human form often express this view. Says John Goodman, "You sit twice a week for three hours looking at a naked woman, concentrating, and it changes your conception of nudity. Nudity takes on a bunch of other meanings." You move from the erotic to something more compassionate.

Matisse wrote, "The emotional interest aroused in me by

[my models] does not appear particularly in the representation of their bodies, but often rather in the lines or special values distributed over the whole canvas or paper."

He added, "Feeling is an enemy only when one doesn't know how to express it. And it is necessary to express it *entirely*. An artist is an explorer. . . . He should begin by seeking himself, seeing himself act, then not restraining himself, and, above all, not being easily satisfied."

There are, however, childlike impulses in drawing. In the end we have to confess that drawing is a source of pleasure and that, in no small sense, we come to the studio to restore pleasure to our lives. You can describe that pleasure in Freudian terms, in the sense of unknotting childhood repressions. You can describe it in Read's terms, as pleasure in competence and understanding. It is often described as an alternative mental state, something akin to meditation. Says Minerva Durham, "Just as in exercise people go into a reverie, there's a pleasure one feels when one is drawing." Britt Marie Pazdirek, who draws or paints several nights a week after spending long, high-pressure days cooking at a busy restaurant, puts her palms to her temples to pantomime a headache to describe how she feels at the end of work. Then she pantomimes herself in a relaxing shower and says of drawing, "It's like pouring warm water over your shoulders. It's so cleansing! There's nothing like it."

The pleasure is undeniably sensuous. We play with the frivolity and dazzle of light. We delight in the surfaces of things, the roughness of stone, the silkiness of skin. We love the feel of carbon or charcoal sliding along the surface of paper. We feel the world through our fingertips, up through our wrists and arms and shoulders. Philosopher Herbert Marcuse pointed out that the original meaning of "aesthetics" was "of the senses" as opposed to "of reason." In aesthetic endeavors, he said, order is beauty and work is play. Aesthetic perception is pleasurable.

Immanuel Kant felt aesthetic endeavor was pleasurable because it was where the senses and the intellect met and made peace.

Modern life increasingly denies and represses the senses. It makes us deny the smell of things by deodorizing them, the sound of things by telling us to close the window if we don't want to hear the neighbor's leaf blower or loud stereo, the sight of things by keeping our eyes on the ground or straight ahead when we are in a crowd, the feel of things by bundling in clothing against the touch of strangers and so on.

To some extent, artists pose the order of sensuousness against the order of reason. That itself—without Freud's theory of tunneling backward through old repressions—is enough to link the experience with childlike qualities and to make us regard it as play. Society in general tends to excuse the artist's pursuit of pleasure because the result, the drawing or painting or sculpture, is thought to be unreal. So we allow artistic vision as play.

But as play, it is serious business. Drawing is an act of self-control. It is also a form of personal growth, part of which is understanding desire and weaving it, in its varied forms, felicitously and usefully into the fabric of one's own life.

Marguerite Fletcher, "In My Father's Garden"

Pictures

O n Tuesday nights, the Palo Alto Art Center drawing group employs two models. The studio is a large, high-ceilinged room with exposed rafters and ventilation ducts. Windows lining the south- and west-facing walls let in enough sunlight to read by. During life-drawing sessions, roller shades are pulled down. Waist-high workbenches form a rectangle around a five-foot-by-five-foot model's stand. The room is large enough and the models' fee low enough that on some nights as many as fifty people show up to draw. It is one of the more problematic drawing groups, because with that many people, it is harder for the models to establish a connection with the artists. They are surrounded and have to think about how they look from all sides and remember to rotate after each pose so that everybody in the room gets equal access to them. In the large room, too, the artists are farther from the models and it is harder for them to see details, a condition that favors abstraction.

Having two models presents a new set of problems to the artist. There is the technical problem of getting their poses together in some meaningful way. You may not see them from

such a vantage point that they comprise an interesting design. One may be looking directly at you, the other hidden behind the first or just a head floating in the background. You might see one torso crabbing about on four legs. More often than not, you just draw the one in the foreground.

Having more than one model also presents a psychological problem. Even if you have the two figures forming an interesting composition, there is always the question of what they mean together. Why are these two naked people occupying the same space? I think the difficulty of answering this question in an original way may be what Lucian Freud, the most prominent figure painter working today, meant when he said, "One of the most difficult things of all to do is to paint people together." Freud has gone so far as to paint just the bare knees of a second figure peeking out from under a bed. His close friend and fellow painter Francis Bacon almost never painted more than one person at a time into a picture. Part of Raphael's mastery was the ability to array whole crowds of figures into a meaningful composition with a sense of common psychological presence.

On most nights, the two models pose without any pretense of connection, one on this side of the stand, the other opposite and facing another part of the room. Occasionally they'll try to act out some vignette together. Since they are unclothed, there are limits to the ways they may interact on the stand. There is usually no touching. The models have to consider where their gazes go. If one of the models lacks sensitivity, you see awkward poses. One male model always tries to touch the female model by placing a hand on her arm or shoulder, and sometimes when he is doing this, you sense the female model's reluctance, resignation and embarrassment.

Models who have worked together and developed a certain rapport bring to the stand evident psychological connections. They may strike lyrical or whimsical dancing poses. I have seen couples strike a pose as if they were walking through some

marketplace looking at different objects or walking through the woods and came upon some object to which each has a different strong reaction, and these made psychological sense.

Every few months, Chuck Hepburn and Javier Salazar work the Tuesday-night session. Chuck has a round, close-cropped head, sloping shoulders and a smooth cherubic face that makes him appear childlike, though he lays claim to a graduate degree in physics. Javier is six foot three, dark complected, with narrow shoulders, broad hips and a basketball player's legs. Hawknosed and slightly squint-eyed, he is impassive, while Chuck seems rubber-faced and impulsive. Together they suggest a vaudeville comedy act, opposites in body form and temperament. When they work together they do gladiatorial poses. They'll huddle on the stand and talk over the pose like kids in a football huddle, one directing the other to go long, and then they'll break the huddle and Chuck will swing a roundhouse right hook at Javier, who dodges it, and the action is frozen in midring. After the next huddle, Javier stands stiffly thrusting a long bamboo pole like a spear at Chuck, who is on his back, propped on one elbow, grimacing and trying to ward off the mortal blow. He can hold an open-mouthed, tooth-bared, bugeyed expression like that credibly for twenty minutes.

The poses are as hokey as they come. The adolescent appeal of the simulated combat is more or less lost on many of the older artists. The high schoolers, who might otherwise find them exciting, are put off by the frankness of the models' nudity and by their own inability to draw quickly enough to capture the gestures. But, after shrugging off the theatricality and focusing instead on the models' good humor, their apparent pleasure at working together and their generosity as performers, I find the poses well worth drawing.

There is immediately a problem, however, of scale. When you draw two people together, you have to draw the second figure in proportion to the first. Some people see the forms so

clearly that they seem to have no difficulty integrating them proportionately. I usually have to measure, drawing the near figure first, then lining up the top and bottom of the other figure's head against some feature on the first. Measuring is mechanical and laborious, and it blocks the spontaneity of the drawing, but I'll do it always hoping that eventually I'll be good enough not to need to.

Drawing more than one person in the same frame requires you to explore a relationship, and that elevates the task to something more challenging than drawing. You can draw a face or a figure in such a way as to convey character or feeling, and that is reason enough to do it. Such a sketch gives a viewer pleasure in part because, as Eugène Delacroix pointed out, "each beholder can finish it as he chooses." But put a background behind the figure and you are saying something about its relationship to space and beginning thereby to express judgments about what the figure or the gesture might mean. Put two fig-

Kent Bellows, "Self-Portrait with Wine Glass (Gluttony, Study, 2000)"

ures together against a background and you add a psychological dimension.

At some point in this increasing complexity of purpose, you cross the line that separates drawing from picture making. The distinction is this: you draw to see; you make a picture to express relationships between the objects you have seen.

And once you do this, you begin to lose the spontaneity of drawing. You lose some of the sense of surprise. You lose some of your lightness of touch. You bring a viewer other than yourself into the process, and you ask how you can make that person see what you have seen. A picture requires calculation and premeditation.

Marguerite Fletcher makes pictures. On a spring afternoon, she squats on a curb in the shade of her van, looking up at Palo Alto's First Lutheran Church. It is a modest, two-story mission-style building with a red tile roof and a bell tower. The doorway is framed by broad red steps and three arches. The church fills a corner lot and is shaded front and side by large magnolia trees. Late-afternoon sun slants through the magnolias and dapples the church's pale stucco walls with shade spots. It is the sort of leafy suburban scene that Fletcher has become locally known for painting, and she is crouched at the edge of the street working out a pair of pastel views of the church that are to be presented as a gift to a departing pastor.

When she accepted this commission, she thought at first she would just do an exterior view of the church. She had been a member of the congregation for thirty years and had spent a lot of time in the building but had never drawn it. The commission had come at a difficult time in her life: her elderly mother had gone into the hospital with an uncertain prognosis, she had worries about money and she was about to go off to lead a three-week painting course in Italy. "I started doing the church—the facade, and I felt sick and bored," she says. "I couldn't start it as

long as I had this kind of bored, sick, resentful feeling. I had to get myself feeling in a different way. So I was thrashing around.

"And then I went inside the church. I go to church on average once every six weeks. I am very doubting Thomas. But I have huge affection and respect for the kind of sense of village and community that parishes represent and how they really are identified as a body of people."

It was a Sunday service, and she sat in the choir loft and sketched. She drew to see. "Sitting there with a pencil, while the church service was going on instead of the intellectual experience I get when I go to church, this was extremely visual." She holds up the rough pencil sketch she worked on through a two-hour service that day. She started just above the center of the page with a round stained-glass window behind the altar, then sketched the altar and the aisles and rows of pews, then the high, overarching exposed beams and rafters. She sketched in people sitting in the pews but didn't think it all that interesting until the parishioners got up to take communion and spaces opened up in the pews and the vertical figures in the aisles gave life to the scene. The sketch conveys a sense of community and activity and comfort.

"That's where my heart is," she says, pointing at the interior view. "Most of my memories of being in this space are quite transcendent, of being more than myself and of the relief and restfulness of being carried by some larger being."

She drew the interior and worked out a composition of the exterior to match it. The two works are laid out on a large piece of cardboard that teeters over the exposed tree roots at her feet. On the right is the interior view, from the choir loft, looking down on the congregation. On the left is the exterior view she is just beginning to draw. She takes a peach-colored pastel from one of the several trays full of pastels strewn on the ground and works with it to get the color of the church's stucco walls. After a few quick strokes, she drops it and picks up a pale purple pas-

tel to work in the shadows. Then she strokes in the gray sidewalk and the red steps of the church. She is working not in contours, but in masses of color.

Fletcher wears a faded gray shirt printed with tropical birds and banana leaves, white paint-stained trousers and heavy black shoes. Her graying hair drapes over the sides of her cheeks, and as she squints through small rimless glasses, her mouth opens slightly, giving her a look of concentration. She moves around as she draws. "I work from several points of view at once," she says. "We got permission to do this from the cubists. Every time we shift a few inches we see different angles and different shapes. It's tricky but you can do it and end up with a much more interesting view."

She could, she says, work from a photograph. But photographs flatten out the volumes, and they limit you to someone else's momentary experience of the place. (Matisse felt, too, that "photography has greatly disturbed the imagination because one has seen things devoid of feeling.") More important, Fletcher says, working from a photograph "doesn't give you any visual memory at all. When you're outside looking, there is a lot going on. Everything is moving. There are breezes. There is a huge amount of visual stimulus. I want to be working the whole thing, always being aware. If I'm going to make one value more sophisticated at one point, I'll end up moving all over the painting to bring the values into relationship with one another." She needs to have looked deeply into the scene to have enough memory to do that well.

She works awhile on the roofline, extending the peach color of the walls higher to change the form. She stands up, moves a foot to the left, leans into the tree trunk to steady herself and draws with a dark umber pastel to emphasize the outlines of the church.

Her eyes dart from the building before her to the drawings at her feet. "What I need to do is figure out what I mean to do

with the overhanging magnolias," she says, staring up at the branches that frame the church against a deep blue sky. She looks from the interior view to the exterior view because she wants the two pictures to work together, and to do that she has to find elements of composition and color to echo back and forth between them.

She is for a moment bothered by the vertical line of the bell tower, which almost seems to cut the exterior view down the middle. "I'll try to create a counterpoint," she says, "by extending this branch." With a dark green pastel she extends a branch at the top left corner toward the center of the picture. She wonders now what color exactly to make the magnolias that frame the left side of the building and draws their shapes a little lower than they actually are. Then she takes up a different pastel and lightens the blue she has already placed in the sky. "I knew I'd have a light bracketed by a dark here," she says, "and the echo of the triangle." She points to the top of the interior view, which depicts the exposed beams and rafters over the altar and aisle.

She worries for a moment that she has drawn the overhanging branches too straight. "I don't want that to be a horizontal thing," she says. "But I don't want a wide open space. I could put clouds up here." She takes out a very pale gray and tries it. The pastel is very forgiving of these changes, allowing her to draw right over a previous idea without having to erase.

While she is working, dog walkers go by, children ride bicycles and joggers trot between her and the church. A nurse pushes an elderly lady past in a wheelchair. Trucks rumble by on the street behind her.

She lays down a pool of blue to make the shadows on the pavement leading up to the steps and says, "Part of the beauty of this place is it is kind of an oasis. It's restful." And the sense of the remark is that it is the visual act that led her to the verbal discovery.

She steps back and considers that the exterior and interior views now seem to have quite different color schemes, and she wants to bring the exterior's colors closer to the interior's. "They have got to share more of the same palette," she says. She takes a rusty red-orange pastel and works over the blue-green that she used in the overhanging magnolia branches. "That will get me back closer to the palette in the interior." She uses a brighter orange on the roofline, and suddenly the left-hand image begins to echo the right-hand image.

She works on the flower bed she has sketched into the lower left to open up that area a little. She pinks over the greens she drew there earlier to indicate the flowers, and that, too, helps echo the colors she has used in the church interior.

She returns to the magnolia branches at the top, scratches short lines of a dark green into them and steps back to look. She nods with approval and says, "It's no way finished, but I'm thinking it's starting to have a relationship with the other piece. I have a choice here: I could darken the sky. I might try that and change my mind." She picks up an ultramarine pastel and works over the pale blue she has in the sky and then blends into it a little blue-green so that the sky pales as it gets closer to the church roof.

What Fletcher is doing is not really drawing, but painting. The difference is more than just the fact that she is working in color. As she would if she were merely drawing, she is trying to see the object. But she is trying to organize what she sees into a picture, to express what she has seen, to arrange elements in such a way as to give someone else the vision she has had.

She is composing. John Ruskin explained that "composition means, literally and simply, putting several things together so as to make one thing out of them. . . . A painter [paints] a picture by putting thoughts, forms and colors in a pleasant order. An intended unity must be the result of the composition."

So, Fletcher is not just exploring. She's deciding what unity

she seeks and pondering how to communicate that unity to a viewer. The act of painting here is a long, complicated process of posing problems and coming up with solutions, a process that goes on for days or weeks.

Ruskin urged on his students "some simple laws of arrangement" such as unity, repetition, contrast and continuity (by which he meant changing the size and shape of objects, say, as they receded into the distance). Fletcher uses all of these techniques. She points at the sky in the exterior view where she has changed the form by darkening and lightening the blue. She points to small echoing shapes defined by color masses in the detail of the foliage in the foreground and says, "Keeping track of a succession of smaller to medium to high forms in a larger composition is very important."

She will work several hours here, and then she'll take both pictures back to the studio and work them over again. "If I work here two or three different sessions, I get down a lot of basic information about the composition in terms of value and color relationships and the basic contours and geometric forms. By the time I've worked with it that much, it needs to be finished in a studio."

This distinction between drawing and painting is one artists have long mulled over. Eugène Delacroix, the nineteenth-century French romantic painter, declared, "The first idea, the sketch—the egg or embryo of the idea, so to speak—is nearly always far from complete. Everything is there, if you like, but everything has to be released, which simply means joining up the various parts."

Delacroix distinguished between the details and the painting, which was an amalgamation of such details. If one painted in the separate details just as one had drawn them, "the interest given to each separate object is lost in the general confusion, and an execution that seemed precise and suitable becomes dryness itself. . . . The greatest difficulty, therefore, when it comes

to tackling the picture, is this subordination of details, which nevertheless make up the composition and are the very warp and weft of the picture itself. If I am not mistaken, even the greatest artists have had tremendous struggles in overcoming this, the most serious difficulty of art." He added, "I am always going back over my work, redrawing and correcting."

It is a common refrain among painters of the nineteenth century. Ingres advised, "Draw for a long time before thinking of painting. When one builds on a solid foundation, one sleeps in peace." Auguste Renoir said, "If the painter works directly from nature, he ultimately looks for nothing but momentary effects; he does not compose, and so he gets monotonous." Degas declared, "Even when painting from Nature, one must compose."

Fletcher has had to learn not just to see, not just to draw, but also to paint. "The shift is to be able to see things in terms of visual language. It may communicate the same narrative [as language], but it's visual. It's contour, gesture, value, cast light, volumetric shape."

And the struggle to see in that new language, she says, encapsulates what art is about. "The purpose of visual art is helping people transcend the way they see. Not just mirroring back like a snapshot. Not just a memory of something."

That seems to me the statement not of a drawer, but of a painter. You can draw just to change your own mind; you are advised to paint to change someone else's. It's a more calculated, more laborious thing to ask others to share your vision, and it requires a kind of collaboration to do so.

This is why drawing is so widely seen as a lesser art than painting, so widely thought of as art not yet dressed and accorded less value than painting in galleries and museums. Declared Ruskin: "The gift of composition is not given at all to more than one man in a thousand; in its highest range, it does not occur above three or four times a century."

That's a daunting judgment. But it shouldn't discourage one from drawing. Drawing is seeing; it is engaging with things more attentively, more passionately, than one does in day-to-day experience. That engagement is the beginning of all art. Auguste Rodin said, "After all, the only principle in art is to copy what you see. Dealers in aesthetics to the contrary, every other method is fatal. There is no recipe for improving nature. The only thing is to see."

And, long before he was regularly producing paintings, van Gogh declared, "I am an artist. . . . It's self-evident that what that word implies is looking for something all the time without ever finding it in full. It is the opposite of saying, 'I know all about it. I've already found it.' As far as I'm concerned, the word means, 'I am looking. I am hunting for it, I am deeply involved.' "

Richard Elmore, "Front Entrance"

Ambition

My wife has clipped to the refrigerator door a sketch of a small potted lavender plant I drew on the paper table-cloth at a local restaurant. I often draw in bars and restaurants, usually trying furtively to catch the likeness of another patron. I carry a small sketch pad when we go out, but a paper tablecloth is a more expansive canvas. By the time the plates are cleared and my wife is lingering over her coffee, the drawing has been spattered with salad oil and gravy, ringed with water and blooded with wine. I leave it behind with the bread crumbs and a wadded-up napkin, like a message in a bottle, for the busboy to puzzle over. It sometimes feels, in the meekest, most pride-shorn way, as if I've shown my work.

My wife, however, liked the pencil drawing of the lavender and took it with us when we left the restaurant. I'm not sure what she sees in the sketch. It seems pretty ordinary—nothing in which a gallery owner would see any profit. It depicts the plant growing out of a three-inch terra-cotta pot, the glint of track lighting on the needlelike leaves, the form and texture of the blossoms, the cold impassive texture of the pot. All from the perspective of a diner waiting for the check to arrive. Flattering

myself, I'd say it was a picture of something small, smug and confident in its own little world.

What I like about seeing it when I pass through the kitchen is the sense of affirmation it gives me. All the years our children were growing up, my wife tacked their ardent rainbows and fierce beaming sunrises up on the walls, in part to celebrate the starbursts of their growing imaginations, in part as a ceremonious declaration to the kids that we believed in and welcomed their visions and liked the way they were growing into whatever they were growing into. Now, I get a spot on the refrigerator door. I read into it the same affirmation, and it feels good.

Drawing is an intensely personal activity. It is more often than not a conversation with oneself. One always wants to broaden that conversation, at the very least make it a dialogue between oneself and the object one is drawing. And most of us want to extend it to wives, husbands, friends, family. We'd like to be able to share what we're seeing and we'd like to have others say they think drawing is a good use of our time and energy. Some of us would like to be admired for it.

Affirmation, in American society, is often about money. We tend to think that if you're competent at something, you will be paid for it, the way a musician or an athlete or a salesman of superior attainment is paid. It is an expression of the Protestant view that a virtuous life brings earthly rewards. I think the most common response when a stranger sees me drawing in a bar or an airport waiting room is: "Are you an artist?" He doesn't mean to question the drawing but to compliment it. He wants to know whether I am good enough to make a living at this.

Relatively few artists sell their work at all. The number who manage to scrape together a living from their work is even smaller. The U.S. Census Bureau says there are something like 31 million Americans who draw, paint or sculpt. The Bureau of Labor Statistics says only about 250,000 of them make a living doing it—less than 1 in 100. And most of those are designers,

working toward commercial ends—art to be reproduced rather than one-of-a-kind originals.

A very small minority of graduates from art schools and four-year-college art programs go on to become painters. Few art schools track their graduates closely enough to be able to say what percentage actually continues to make art, much less make a living doing so. The Art Students League of New York makes no promises, awards no degrees and doesn't keep track of its alumni. A counselor at the San Francisco Art Institute says, "We don't have reliable data about where our graduates are or what they're doing," but guesses half of them "stay with the arts in some capacity, but not necessarily as working artists." They work in galleries, museums, art supply stores, advertising agencies and magazine art departments, as teachers—anywhere an artistic vocabulary is needed. The distinguished School of the Art Institute of Chicago's most recent survey suggested 70 percent of the previous year's graduates were working in art-related fields, that half of those people expected someday to be painters or sculptors, but that only 15 percent were actually practicing those arts professionally. (No one would guess what share of that 15 percent made a living at it.) New York's School of Visual Arts estimates 55 percent of its graduates are "working in a field related to their major." Falling back on teaching is a declining prospect: between 1970 and 1990, as school budgets tightened, the number of people employed as art teachers declined by 49 percent. Only one in four of them actually worked full-time. In the year 2000, there were still 15 percent fewer art teachers than there had been in 1970.

A career guide widely used by college and high school counselors warns that prospective artists "require talent, strong determination and a willingness to endure long periods of disappointment." It declares, "Establishing a career in the arts is extremely difficult. Most people who enter the field are not successful." That fact is so apparent to many fine-art school stu-

dents that they deny their own ambitions. Pam Highland, a career counselor at the San Francisco Art Institute, observes that a fair number of students "want to keep their creativity exclusively to themselves" and "are frankly scornful of using their skills to make money. They would rather do almost anything else. As soon as I mention the gallery world, they turn off."

Commercial galleries are far less likely to show drawings than paintings. "I think there's a certain hierarchy," explains John Berggruen, San Francisco's most prominent gallery owner. "It would be hard to make a living only by drawing. I think there are some people who are doing it, but I can't think of any names." As for showing drawings by someone who hasn't already made a name, Berggruen says, "Unknown people is not what we do."

Determined artists are adept at finding other places than galleries in which to display and sell their work. They look for juried shows to enter. They put up their own shows in coffeehouses and restaurants, where patrons can ask for their telephone number, then call and negotiate a purchase. Many communities—especially those that provide low-cost studios for artists by renting them space in abandoned school buildings or industrial sites—put on annual open-studio weekends, at which the artists display their work in their own studios and the public is invited, through newspaper ads and posters, to tour dozens or even hundreds of such studios and is provided with maps showing their locations. An artist friend who is not affiliated with such a program puts on a show once or twice a year in his own home; he sends out printed invitations and serves wine and lunch. Some artists rent booths at street fairs. Some just set up on the street in a tourist locale: Robert "Woody" Woodward has sold his paintings on the sidewalk under a venerable banyan tree in downtown Kailua, Hawaii, for thirty-seven years. There are artists who work entirely on commissions, as do most portrait painters, never having to come close to a gallery. Tens of

thousands of artists try to sell their work on the Internet, some through electronic galleries, some through their own Web pages, which they try to link far and wide to lure browsers launched on Google searches. It's a little like casting a baited hook into the open ocean and hoping some interested fish will swim by. Eleanor Dickinson tells of a student who loved to draw goats, put her work on a Web site and linked it to other sites that might be frequented by people with an interest in goats and earned a hundred thousand dollars one year just drawing and painting goats.

Some find ways to live by drawing without hanging paintings on other people's walls. I suspect that those who do so are individuals who, in the first place, are more deeply obliged to the visual than to the verbal parts of their minds. Take, for example, Richard Elmore, a designer whose home, bank and hotel remodelings are part of the architectural character of the San Francisco peninsula, and who has designed ski resorts in Idaho and beach resorts in Mexico. In Palo Alto, where he lives, he says he stopped counting the home remodels after he had done four hundred of them.

Elmore approaches pretty much everything in his life through drawing. He has never been confident relying wholly on language. "I found school very hard," Elmore says. "I'm very poor at memorizing. I'm a poor reader. I'm poor at memorizing groups of things. I'm terrible at mathematics. Terrible at time." It has been drawing that has seen him through. He thinks through it, communicates through it, figures himself out through it. If he is perplexed about something, he'll draw it. If he loves something, he'll draw it. If he wants to tell you how he feels, he'll draw it.

"I'll draw to kind of settle my life," he says. "It is a form of meditation. I have so many assignments and they're problems that I need to solve. I need to work it out visually, because words are not enough. So I will draw and I reach a resolution

through these drawings that lessens my burden of tension. I do this all over the place. I draw when I'm waiting someplace. I draw every day, somewhere, somehow."

The walls and bookshelves of his home are crowded with the results: a watercolor of a broad green wave breaking against a Mexican beach, a sepia-tinted wash of a canoe resting on a lakeshore at twilight, the interior of a cathedral in Venice, drawn on the back of a program while he sat there listening to a Vivaldi concert.

Elmore says, "I was drawing when I was a little kid. I learned to draw under the covers with a flashlight. I had an imaginary family when I was growing up. I would draw that imaginary family to life." He grew up on a Nebraska farm, before television and far from movie theaters and neighbor-hood playmates. For recreation, Elmore built things with his father. "They were toys: boats, airplanes, cars, guns. This was during the Second World War, and we lived in a community where the Union Pacific rolled through day and night with these huge trains loaded with ordnance. So it was about guns and boats and airplanes. I wanted realism in my toys. I learned to draw them realistically so I could build them realistically. We would make these fantastically realistic guns." And he drew whatever was around him. "I drew people. I've always loved to draw people, their environments and their conveyances."

He graduated from high school, but college was not invit-ing, so he joined the army. Stationed in Korea, he began read-ing the cartoons in *Stars and Stripes*, the army's newspaper. He felt he could draw better cartoons, so he wrote the newspaper's bureau in Tokyo to tell them so and sent along some samples. Within a few months he had convinced them so thoroughly that he was transferred to Tokyo, where he finished his tour of duty as a uniformed cartoonist.

Out of the army, he struggled with junior college in Cali-fornia for a year but dropped out. His drawings got him a scholarship to the San Francisco Art Institute. "It had almost

nothing to do with drawing or training me in a particular medium. But it introduced me to art history, which became a passion. And it trained me to see." The art institute was urging a kind of painting and drawing that didn't work for him. "I was going across their grain. I knew at the time that this wasn't going to be it, that I wasn't going to be a professional painter. But I found instructors who understood my viewpoint in print-making and etching, and I did well with them."

After art school he went to work as a graphic designer, doing typography and illustration. He designed, for example, the label for San Francisco's Anchor Steam Beer. Many of his clients were architects, planners and developers. Eventually he found he could do the architectural design work himself, and once he started, he quickly acquired clients.

Ask Elmore to redesign your home, and in a few days he'll fax you pages of elegant pen-and-ink drawings, drawings that are full of light and shadow, alive with the textures of wood and stone and brick. He'll give you a close-up detail of the texture where a glass shower wall meets the tile floor that will make you want to touch it. A view of your future living room will show how the stonework of the fireplace tucks into the tilework of the hearth and the woodwork of surrounding cabinets, and he bathes this view in a soft glow of morning sunlight streaming through the windows. The furniture is there, and so is the family dog, asleep by the fire, and some of the kids' toys left about.

Architectural drawing is not usually drawing in the sense that we have been considering it, not discovery, not emotional. But with Elmore, it is. While other designers work conceptually, arranging walls and counters and furniture in space defined by ruled lines, Elmore thinks it through almost entirely visually. He works more like a drawer than a designer.

He usually starts a job by sitting down with new clients in their homes and trying to get to know them. "I talk a lot with them, and I try to get out of them how they want it to work for them and what they want that space to give them back. I try to

find out as much as possible how they live, because that's what I'm here for—to help them live the way they live or want to live."

Then he tries to envision these particular people living in the remodeled space. "I'm kind of doing a cerebral movie," he says. "A lot of it is about how the automobile approaches the site, and once the automobile is there and stored, how do I get the food out of the trunk and into the kitchen. Where are they [the clients] going to be and how are they going to operate? There's a room off the kitchen where the TV is on or the homework is being done or all kinds of social things are carried out. So I always make sure the kitchen surfaces address that. Then there are other things like bedrooms and bathrooms and privacy. And how the flow of the house will support those needs."

He thinks it through by drawing. "When I pick up that pen, I know I have a task. I don't know what's going to happen. But it starts to happen almost instantly." He may sketch out a stairway leading to a second-story kitchen that shows how the stairway will work, where the kitchen cabinets are and how the glass, wood, wallboard and tile will all relate to one another.

He draws not only to generate a vision and to clarify it, but also to communicate it to the client. Often he'll show the clients his sketches on the spot to get their reaction. "There's a lot that's [just] visual that I don't like to talk about. Words are . . ." He shrugs to indicate "untrustworthy." "You never know what the client is thinking. I need to know what the other party is visualizing." By drawing their conversation, he gets them to leave language behind and work with him using the sense in which he is most fluent.

"I don't phone a lot," he says. "I fax a lot." He works in pen and ink rather than pencil because it travels more legibly through a fax line. "I know they need to have something on paper. I know they can't understand how I'm going to solve this

and I'm telling them about how I'm going to solve it, not only in terms of the structural components, but also of the design components. I have figured it out and now I'm trying to help them understand it. And this is how I just blow people away. Because they just don't get this kind of communication with other designers.

"I love to communicate. I love to see when they get it."

Like Elmore, Dugald Stermer drew as a child. He copied comics as an adolescent and was offered a scholarship to an art school, but chose to major in art and English at UCLA. He was always inclined toward realism, and when he found UCLA's art department leaning toward abstraction, he says, "I just didn't bother with it. I always thought I was missing something, but, what the hell, I was missing nuclear physics, too. I had to go to the Renaissance to find models I cared about, and even then I had to look at their prints and drawings more than I looked at their paintings." It was clear that drawing was his ambition.

Richard Elmore, "Self-Portrait with Sarah"

After graduation Stermer began working as a magazine designer. He was the art director for *Ramparts* magazine from 1965 to 1970 and spent the next ten years as a consultant redesigning magazines. In 1980 he became an illustrator and since then has done book jackets, covers for *Time, Rolling Stone,* and the *New York Times Book Review* and illustrations for his own nature books. He has made a successful business out of incisive portraits of literary personalities and meditative drawings of birds and flowers.

It hasn't been an easy road to success. "No illustrators are on payroll," he says. "All of them are pretty much freelance." They start by going to school. They assemble a portfolio and put it up on a Web site, enter competitions, call on magazines and ad agencies. He tells the students he teaches at the California College of the Arts to consider whether they have it in them to work hard enough to survive. "It requires amazing self-discipline to work when you have no work. You have to be kind of driven. If you can't take rejection or the time, you don't want to do this."

He isn't daunted by the fact that "ninety percent of our work accompanies text and is at the service of an idea. It's not meant to stand alone." He explains, "I never wanted to be a fine artist. I always wanted to carry on a conversation with the public. The real satisfaction is to do the job and see it in print and feel it is successful."

He is daunted, however, by what he has seen happen to illustration over the years. "Illustration has been marginalized in the last fifteen years," he says, "especially by computers." Magazine art directors "don't feel the need for illustrations anymore, because they're using photographs and using type as illustration." They now buy photographs for a few hundred dollars from stock houses and then, if necessary, alter them on their own computers. "The use of illustrations has gone down to nothing," he says, "and the fees have gone down, too."

But he feels privileged to be doing what he's doing. "I can't imagine a better life," he says. "I get to go into my studio, turn on the music and draw all day. It's a wonderful life."

People who actually live by drawing are extremely uncommon. You meet a few artists in drawing groups who sell enough of their work to pay for paint, studio space and models. You don't meet many of them. The fact is that successful artists are so rare as to live on the edge of mythology. Ask an American to name a successful artist and he is likely to come up with Vincent van Gogh, who sold only one painting in his lifetime. People who draw have to face the choice at some time in their lives whether this is a calling or just an enthusiasm.

And, if it is just an enthusiasm, what does one do to find affirmation?

For many drawers, the only way to express ambition is to give away drawings. Stermer often trades drawings with other illustrators, because, he says, it shows that "we like each other's work," and it is especially gratifying to have other professionals esteem it. But sharing drawings outside the studio can be problematic. We learn what is polite in conversation because we engage in conversation all our lives. It is harder to learn what is polite in drawing. It is harder to learn what visual thoughts may be shared or ought to be shared.

Elmore often shares his by drawing cartoons. "I get attention by doing that," he confesses. "I've done quite a few political cartoons. I'll do them and send them to the mayor or a councilperson." He shows me one depicting two of the commissioners of a municipal panel that reviews applications to remodel buildings that are considered historical, a panel he has often argued with. The cartoon depicts them in Nazi SS uniforms, haughty, sepulchral, with monacles and sneers, looming against a black sky over a modest Palo Alto home, one of them pointing a skeletal finger down at it in judgment. It's just over

the top enough to be comical rather than boorishly angry. He sent copies of the cartoon to all the members of the panel and many of them wrote back to thank him.

For most of us, cartoons are small talk. They usually aim at pretensions and misunderstandings, not at the deeper insight and more complex emotion we consider to be the aim of fine art. Consequently, they seem easier and less profound than fine art, and that less ambitious vision is perhaps more easily shared, just as jokes are more easily shared than essays. If only laughter is at stake, one feels less risk of rejection.

One's connections with a more serious drawing or a painting may be more emotional and more intimate. There, the risks of rejection are greater. Recently, someone recounted how an artist gave a friend of his a painting. The friend took it home and found that it was too large for the living-room wall. So she cut off a third of the work, including the painter's signature, reframed it and hung it on the wall. A few days later the artist called to say, "I liked that work a great deal but I forgot to photograph it, and I'd like to drop by this afternoon with my camera."

Ann Curran Turner recalls finding an exquisite drawing her father had done of her mother, which had lain for years in a drawer. "I said, 'Daddy, this is so beautiful, why isn't it framed?' He turned it over to show me that my grandmother had used it as a grocery list." Today, Turner says, "I only make a present of a drawing to someone who has bought my work or expressed a lot of interest in it."

We all fear rejection. Ask Elmore why, after all his success as a cartoonist, he didn't go into painting, and he'll tell you that he still aspires to be a painter but that when he was in art school "it became apparent to me that I didn't like the business of selling and marketing my work, because I was afraid of rejection. It would mean doing ten paintings, hanging them and waiting for someone to come by and like them. That fear kept me from becoming a fine artist. I did something where I was not going to be rejected."

Today, he says, if he could afford not to work, he'd just paint. But he still fears rejection. "I was talking to a friend who paints," he says, "and he said the hardest thing in a painter's life is to figure out what to paint." How do you keep up a purely visual conversation with people you've never met? How do you have the nerve to presume you'll always have something to say in this conversation? "If you're banking on that," Elmore adds, "it would be just gruesome."

If you don't sell them and you don't give them away, what do you do with the drawings? Most drawers keep them for themselves. We keep them as memories, much the way families keep photographs of the children growing up. Says Elmore, "I've kept a lot of drawings. They are usually nostalgic. Very vivid things are attached to them. A lot of drawings are about or to old friends. They're about things we've done or things we know about." Looking at them years later, he says, is like reviving the friendship.

More often, though, he keeps drawings because they are about drawing itself—more specifically about his own drawing. "Sometimes, solutions to other drawings I'm doing are in them," he explains. And more than that, he keeps them as memories of where he has been as a draftsman, almost as if drawing itself were an offspring, images of whose growth and development might fill a scrapbook. Looking at old drawings, he says, "is kind of checking up on my progress in my ability to draw. Because I feel like I'm getting better all the time. I'm proud of it and I appreciate my own work."

In the end, drawing is mostly soliloquy. Affirmation comes— if at all—in small packages. It is sometimes a pleasure to let someone look through my sketchbook and see that person linger over a drawing. It's nice when someone looks over my shoulder as I'm drawing and says, "That's very good" or "That really looks like her." But usually something other than approval will have to do.

I am consoled by the idea that failing to make a living at art has a long and honorable tradition. Ingres advised: "Do not concern yourself with other people. Concern yourself with your own work alone." Van Gogh declared, "The only thing to do is to go one's own way, to try one's best, to make the thing live." As long as one has a seriousness of purpose, one can fairly claim a kinship with such artists.

Even more than that, I am consoled by the thought that there is a great deal of human genius that is not rewarded materially, or at least not in proportion to its contribution to the general well-being. Parenting isn't. Nor is compassion. Nor is one's ability to see clearly into one's own heart. Drawing well makes me feel wiser and more intimately connected with the world. That's a huge reward.

In the end, I suspect most people draw because it is a calling. And I think a great many people are, to some extent, compelled to go on drawing, perhaps programmed by the peculiarities of their own minds. Drawing is a claim that keeps after us. I meet people who used to play the clarinet, used to tap dance, used to play tennis. I seldom meet people who used to draw. If they drew beyond the symbols of childhood, they might put it away for a while, but they eventually come back to it.

It seems to me that if drawing has this kind of a claim on you, you don't have to share it to justify it. If you draw in order to see, then draw in order to see. The connections you establish between the world outside and the world inside should be reward enough.

And if it connects now and then with some other person, so much the better. A refrigerator door can, in its own time and its own place, be the Louvre, the Uffizi, the Prado. Not a bad wall space. Not bad at all.

Richard Gayton, "Mitchell Canyon, Mt. Diablo"

Dispersers

Drawing groups are democratic in the sense that their members are diverse. Professional illustrators and animators sit next to high school sophomores who are just beginning to draw. Housewives with master of fine arts degrees sit next to carpenters and house painters you'd expect to see in sports bars. There are people who show their work in galleries next to people who have just signed up for their first night-school class in drawing. There are aging hippies still chasing a sense of liberation next to young engineers seeking a release from the certainties of numbers. There are college students with MP3 players plugged into their ears sitting next to retirees wearing hearing aids. At the Mission Cultural Center one night, I sat between a white-coiffed dowager who boasted she once ran a tony gallery in Carmel and a young Mexican immigrant who spoke no English and wore gangsta-rap clothing. They looked at each other's drawings and seemed like old friends. Almost any other group—a business convention, a medical conference, a Little League game—quickly sorts its participants into hierarchies, into management and labor or tenured and nontenured or starter and benchwarmer. Here, this does not happen.

There is about these groups an air of amateurism—a sense that we're all on a journey but that no one has yet arrived at the destination. Outside the studio, you meet people who will tell you how much they know about cars or diets or home mortgages or baseball—as an excuse to stand high on a pedestal. I never meet such people in drawing groups. The people I encounter there seem lined up next to me, and, no less than I am, seeking. At times, it seems as if we're all pilgrims on our way to some distant sacred place.

We stake out territories in the room, favorite spots from which to draw. When groups meet in public places there are always some artists lined up at the door, rushing in as soon as the doors open to claim their favorite seats. But we don't claim drawing as territory, don't contest with one another over how well one draws or over one's style or one's desire. We seem to share something of the uncertainty that van Gogh expressed when he confided, "Should my work be not good it will be my own fault."

I have a sense that we share more than just a love of drawing, that we share something deeper, and it sets us apart from other people. I think it may have to do with why we draw in the first place. Whatever it is that gives an individual the impulse to draw seriously is very much a mystery. But I'd like to offer a speculation.

I have come into the studio with a naturalist's eye and a naturalist's tendency to look for the evolutionary value in a trait or behavior. A naturalist believes that what we are is a response to challenges the world threw at us in generations past, possibly even before we could be described as human.

When it comes to drawing, the parallel I see with other species is not chimpanzees scribbling with crayons in zoos or bowerbirds ornamenting their breeding areas with bits of colored glass. It is rather the young eagle wandering away from its parents' nesting grounds or the bear going over the mountain, to see what he can see.

Most species feature a tendency to disperse out of the pools and valleys in which they were born, to carry their genes into areas that offer new space, new cover, new food sources, new horizons. Muskrats ramble and young red-tailed hawks wander, rather than stay in their parents' home territories where they would be competing with the bearers of their own genes. They drift about until they come to a place that isn't occupied by a possessive contender. Happy combinations often result from these wanderings—a disperser meeting in some Edenic setting a wanderer of the opposite sex and a new dynasty arising out of the adventure. Survival of the fittest in such circumstances may not be survival of the fiercest or strongest, but survival of the most speculative.

Not all individuals disperse. Especially among cooperative hunters, such as lions, wolves and humans, different individuals have different tendencies toward dispersal. Some become long-distance wanderers, setting out young in life on a journey, looking for their Shangri-las and promised lands. Others stay fixedly at home. Some wolves make prodigious solitary journeys, hundreds of miles from their birthplaces, while others are homebodies, rigidly loyal to the group, protective of the pack's territory and murderously intolerant of strangers. Likewise, there are humans who spend their entire lives in a single town and who could not move to save their lives; and there are humans who are so footloose that to stay in one place for a week is torture.

I think the impulses behind art might be the same impulses that send wolves and sparrows and toads wandering. They are the part of our nature that urges us outward, into uncharted territories, with the evolutionary hope of planting new families, new bloodlines, new dynasties and cultures. The urge to create is not just the urge to perpetuate one's genes; it's the urge to find new worlds. We do it both on the ground and in our imaginations. We wander both as explorers into real landscapes and as daydreamers imagining new possibilities.

Dispersal is an expression of temperament, of individual differences in personality, and we haven't yet developed an understanding of the material bases of personality, can't see the differences in DNA sequences or in the structure or chemistry of the brain, though such differences almost certainly exist. We haven't found ways to determine in advance which wolf cub or muskrat kit will become a disperser. We don't much understand dispersal in humans, either.

What does one feel that leads one to light out? A restlessness? A sense that one does not fit in? A desire for revision? A sense that somewhere else life could be better? All these seem to me to be the field marks of creative personalities.

At heart, creativity is a desire to experience things differently, even if differently means more mom, more flag and more apple pie. You can sometimes see other species express this desire for novelty. Attendants at a wolf park in Indiana found the wolves often liked being spun around or held upside down. They seemed to enjoy the momentarily novel point of view and would solicit the handlers to do this the way children will ask an adult to spin them around or hold them in the air by their heels.

California is a hard place to test the theory that artists are dispersers because most Californians are recent arrivals from someplace else. One doesn't meet many natives in drawing groups, but one doesn't meet many natives at school-board meetings or in supermarket checkout lines. Still, I'd have to say few of the artists I know have stayed in one place all their lives. Many of the artists I know are conspicuously marked by a history of migration and dispersal.

Take, for example, Yasmin Lambie-Simpson, a forty-two-year-old artist who hangs exhibits at Pier 23, a San Francisco waterfront café. Yasmin is an energetic woman of Trinidadian descent, with large dark eyes and a flashing white smile. Born and raised in London, she studied fabric design at a London art school. She became interested in the figure, concluded she

couldn't put figures on fabric and so sought instruction in draw-
ing and painting. In the 1980s she came to San Francisco and
attended the San Francisco School of Art, a small private group
run by a graduate of the San Francisco Art Institute who felt
that the institute wasn't giving students a thorough enough
grounding in drawing and anatomy. Yasmin later enrolled at
the institute.

She moved to Oakland, had three children and recommit-
ted herself to art. Today she draws with a small women's group
on Russian Hill. "There are a whole bunch of us who are work-
ing or who are parents. You need that space and time to create,"
she says. She knows a lot of artists and she says, "It feels like
we're a community apart, and we *are* different.

"My family loves me, but they think I'm weird. They seem
to say, 'When are you going to grow up and settle down?' I
mean, I'm almost forty-three and I draw naked people! They
don't understand why I draw naked people. I'm very private
about what I do. Because once I say I do this, people look at me
differently."

She talks about her family, and it begins to dawn on you
that perhaps she carries a gene for dispersal. Her great-great-
grandmother left Martinique with a daughter and migrated to
Trinidad, where she became the matriarch of a large extended
family. Her grandmother left Trinidad and emigrated to Lon-
don. "It's been the daughters who left to find this place," she
says, not the men, not fathers and sons. "I think that's a creative
thing. I think about it a lot: why the women left and whether
that has to do with my interest in art.

"I'm creating my life. I'm surrounded by these people who
have [more conventional] plans and I'm *thinking it out*, increas-
ingly, day by day. It's all connected, this discovery, this creativ-
ity. It's part of who I am."

And she says, "Maybe there's no promised land," no place
where she'll finally arrive and the landscape will turn out to be

her vision revealed and confirmed. "You have to get that Zen sense that it is what it is," she says, that it is the journey that matters, not the destination.

You hear similar tales of exploration from other artists. Indeed, the stories of artists getting up and moving are so common that art and travel seem inextricably tangled. Leonardo da Vinci shuttled between Florence, Milan and Rome. Dürer made long, difficult journeys from Nuremberg to Venice. Raphael seems to have been in constant motion from the age of seventeen; a contract for a painting executed in 1505 gives the painter no home address but says he might be looked for in Perugia, Assisi, Gubbio, Rome, Siena, Florence or Urbino. Rubens lived most of his third decade in Italy and Spain. In 1832 Delacroix traveled to Morocco and Algeria, filling his journal with hundreds of sketches and notations for sketches he wanted to make: "the ostriches . . . great big toad . . . the girls standing on the bed . . . the Iman calling for prayer in the evening . . . men firing off guns as they leap into the air." Whistler moved from Lowell, Massachusetts, to Saint Petersburg, Russia, at the age of nine, and for the next fifteen years bounced around: England, West Point, Washington, D.C., Paris, back to England. Audubon went from Haiti to Paris to Philadelphia to Kentucky. Gauguin traipsed off to Tahiti. By the age of sixteen, Jackson Pollock had moved nine times.

Vincent van Gogh, bordering on homeless from the age of twenty-one, articulated in letters to his brother sentiments one might attribute equally to an artist or a wolf: "It's as well to go out into the world from time to time," he wrote in 1880. But "one should retain something of the original character of a Robinson Crusoe . . . for otherwise one cannot be rooted in oneself. . . . So, let us go forward, quietly, each on his own path, forever making for the light."

Ten years into his journeying, Van Gogh's letters constantly link place, movement and artistic vision. He saw himself "wan-

dering from pillar to post," but "instead of succumbing to homesickness," he wrote his brother, "I told myself your land—your fatherland—is all round.

"I must continue to follow the path I take now," he wrote. "Keep going, keep going, come what may. But what is your final goal, you may ask. That goal will become clearer, will emerge slowly but surely, much as the draft turns into the sketch and the sketch into the painting, through the serious work done on it."

You sometimes also hear hints from models—who are almost all migrants—that art is an act of dispersal. Phaedra Jarrett, who dances with the Oakland Ballet and models in the off-season, is one of the few members of the San Francisco Models' Guild who actually grew up in the Bay Area. "My father, Richard Jarrett," she says, "grew up as poor as poor can be. My grandmother raised him by herself in Idaho and

Vincent van Gogh, "Starry Night with Cypress"

Oregon. They lived in very unsophisticated places, without having a lot of art in his life." Her grandmother moved to the Bay Area, and Richard Jarrett began to blossom. "He went to everything he could—opera, dance, theater, galleries." He enrolled at San Francisco State University and got degrees in history and writing and simply became devoted to art. He was gay and single, but he took people into his home—often people at odds with the rest of the world—and housed them. He took in a pregnant woman who was unmarried and planning on putting the baby up for adoption, and then he adopted the child, who was Phaedra.

Phaedra says her father, who is no longer living, told her that even as a child he had the feeling that there was something wondrous and enlivening out there waiting for him. "He said, 'I just knew there was more.'" And he passed this faith on to her. "My dad exposed me to everything he could. He took me to the ballet. He took me to the symphony. He showed me exercises for drawing. He was throwing everything at me and seeing what might stick." Like a father teaching a son to hunt or to farm or to work on automobiles, Richard Jarrett was passing the torch, bequeathing to Phaedra the skills that had mattered to him. "When I was ten, I went to the ballet and I would come out feeling so free and released and so joyous. And I felt if watching this stuff makes me so happy and makes me feel so free, what would it be like if I got into it and did it? I just wanted to be part of this magic."

And today when she defines "making art," she says it is "giving that space to people's lives where they are taken somewhere else."

"Space," here, is not just a colloquialism for privacy. A drawing is a mood or idea or concept arranged in space. It's a space that might open up onto a new world.

Artists are people with a strong drive to explore such spaces. The proof of a good visual image is that it seems to take us

somewhere else. That is, a good drawing lets one see into a space created in the artist's imagination in such a way as to make one believe in the truth of that space. The aim of drawing is not just to imitate nature, but to participate in it in such a way as to make new and believable worlds.

For the artist, finding the promised land is always a struggle. Most of what goes on inside our minds is chaotic, rebellious, meaningless or silly. So, most of what we draw and paint is chaotic, rebellious, meaningless or silly. To become an artist, just as to become a writer or a scientist or a businessman, one must learn discipline and develop critical faculties. One must find meaning. And to find meaning in something as familiar as the human body takes time, effort, insight and perhaps not a little luck. It is much like a long journey, full of adversity.

Add to those adversities the fact that there are places in which it is hard to live with a disperser's outlook. There are always nondispersers arrayed against whatever spaces an artist creates. There are always people who cling to tradition and view this wanderlust, this desire, this questioning and restlessness, as a threat to the smooth operation of society. It's a stay-at-home mentality, but it holds an equal claim, is equally valid as an evolutionary strategy. If you've got a good piece of habitat, you work hard to keep it. And, especially among social carnivores such as wolves, lions and humans, you impose strict orders. You invoke the powers of government or scripture, caution against errancy and urge everybody to look homeward.

That difference, too, may help explain why we are of such different minds about the human body and why some want to cover the nakedness of statues (as did the U.S. attorney general, who recently covered the bare-breasted statue of Justice in Washington, D.C.). Different outlooks give us different views of our bodies or of bodies in general. If one believes in the inherent fairness, intelligence and generosity of human beings, one is likely to find the body attractive and interesting. If one

takes a dimmer view of human nature, if one sees limited possibilities in it, one is likely to fear and revile the body. This is not necessarily a religious matter. You can believe in the Bible and believe in the body—as have most of the great figurative artists. But just as if you don't much like yourself you aren't likely to see nobility in your own body, if you fear someone else's imagination, you're not likely to see nobility in that person's body, either.

Artists tend to end up in cities, especially in cities of unusual liberality. Art centers like New York, Paris and San Francisco are cities that have been settled and built largely by dispersers, by people who didn't fit into the more rigid social structures of small towns and autocratic rules, by people who left their birthplaces voluntarily because they felt, like Richard Jarrett, that there was something better "out there." People who could sympathize with and tolerate idiosyncracy, confusion, muddled thinking and visionary chaos, because they believed that in doing so we can learn to live with our own irrationality and unpredictability, our own shame, our own desire. That out of this muddle, out of the errant lines and blurred form and imperfectly read values, come possibility and hope. And sometimes, too, a clear and reassuring light. A picture that gives form to feeling. A picture that envisions humankind in a fresh and promising way. A new space.

A naturalist goes into nature also looking for hope, for insight, for something that reassures and clarifies. We see nature not as something to be dominated or transformed, but as the original whole, of which we humans are a small part. It is what defines us, what animates us, what gives us form and movement and meaning. We see it as the repository of wisdom and energy, purpose and comfort.

As an artist, you could say the same thing about the human body, its grace, its power, our fascination with it, our feeling for it.

Notes

CHAPTER ONE

Allure

10 Hokusai: Quoted in Betty Edwards, *Drawing on the Right Side of the Brain* (Los Angeles: J. P. Tarcher, 1979), p. 223.

11 Degas: Paul Valéry, *Degas, Dance, Drawing* (New York: Pantheon, 1960), p. 64.

11 Matisse, Toulouse-Lautrec: Jack Flam, ed., *Matisse on Art* (New York: Phaidon, 1973), p. 145.

12 Cézanne: A. E. Gallatin, ed., *Of Art: Plato to Picasso: Aphorisms and Observations* (New York: Wittenborn and Company, 1963), p. 8.

12 Leonardo: Jean Paul Richter, ed., *The Literary Work of Leonardo da Vinci* (London: Phaidon, 1970), vol. 1, p. 38.

CHAPTER TWO

Ritual

22 Benesch: Otto Benesch, *Rembrandt as a Draftsman* (London: Phaidon, 1960), p. 30.

22 Hill: Edward Hill, *The Language of Drawing* (Englewood Cliffs, N.J.: Prentice-Hall, 1966), p. 82.

23 Matisse: Flam, *Matisse on Art*, p. 123.

23 few finished drawings from Venice: Charles De Tolnay, *History and Technique of Old Master Drawings* (New York: Hacker Art Books, 1972), p. 23.

23 none of Masaccio's . . . Verrocchios: Francis Ames-Lewis, *Drawing in Early Renaissance Italy* (New Haven, Conn.: Yale University Press, 1981), p. 180.

23 thirty-five Titians: De Tolnay, *History and Technique*, p. 50.

23 Vasari: Ibid., p. 6.

23 Zuccaro: Quoted ibid., p. 7.

24 Matisse: Flam, *Matisse on Art*, pp. 43, 123.

24 Levy: Mervyn Levy, ed., *The Artist and the Nude: An Anthology of Drawings* (London: Clarkson N. Potter, 1965), p. 7.

24 Dürer: William Martin Conway, ed., *The Writings of Albrecht Dürer* (New York: The Philosophical Library, 1958), p. 244.

CHAPTER THREE

Learning to Draw

37 Harth: Erich Harth, "The Emergence of Art and Language in the Human Brain," *Journal of Consciousness Studies* 6 (1999): 96–115.

38 Pinker and Donoghue: Quoted ibid., p. 106.

39 Solso: Robert Solso, *Cognition and the Visual Arts* (Cambridge, Mass.: MIT Press, 1994), p. 269.

39 happen in the same way at the same time in all cultures: Rhoda Kellogg, *What Children Scribble and Why* (Palo Alto, Calif.: National Press, 1959); Rhoda Kellogg and Scott O'Dell, *The Psychology of Children's Art* (New York: Random House, 1967).

40 Right-handed people draw: Peter Van Sommers, *Drawing and Cognition* (Cambridge, U.K.: Cambridge University Press, 1984).

40 a child draws a human: Kellogg and O'Dell, *Psychology of Children's Art*, p. 65.

40 Animals often begin as people with extra legs: Nigel Ingram, "Three into Two Won't Go: Symbolic and Spatial Coding Processes in Young Children's Drawing," in N. H. Freeman and M. V. Cox, eds., *Visual Order: The Nature and Development of Pictorial Representation* (Cambridge, U.K.: Cambridge University Press, 1985), p. 233.

40 drawing the same version over and over again: Edwards, *Right Side of the Brain*, p. 65; Van Sommers, *Drawing and Cognition*, pp. 204–11.

41 a symbol and not a likeness: Karen Vibeke Mortensen, *Form and Content in Children's Human Figure Drawings: Development, Sex Differences, and Body Experience* (New York: New York University Press, 1991), p. 20.

41 Sully: Quoted from *Studies of Childhood* (1895) in Frances Pratt, "A Perspective on Traditional Artistic Practice," in Freeman and Cox, *Visual Order*, pp. 265, 285–86.

41 children are not able to draw a model: Mortensen, *Form and Content*, p. 20.

41 teacup: Alyson M. Davis, "The Canonical Bias: Young Children's Drawings of Familiar Objects," in Freeman and Cox, *Visual Order*, p. 203.

41 five-year-old . . . can't detect and correct errors: Judith L. Laszlo and Pia A. Broderick, "The Perceptual-Motor Skill of Drawing," in Freeman and Cox, *Visual Order*, pp. 366–67.

42 Three-dimensionality is seldom mastered: May Jane Chen, "Young Children's Representational Drawings of Solid Objects: A Comparison of Drawing and Copying," in Freeman and Cox, *Visual Order*, p. 164; also Mortensen, *Form and Content*, p. 20.

42 At five or six, a child's designs . . . tell a story: Kellogg and O'Dell, *Psychology of Children's Art*, p. 55.

42 At about six, a child . . . begins to outline whole forms: Larry Fenson, "The Transition from Construction to Sketching in Children's Drawings," in Freeman and Cox, *Visual Order*, pp. 374–80.

42 increasing interest in humans and animals: Ingram, "Three into Two," p. 233; Juri Allik and Tiia Laak, "The Head Is Smaller Than the Body: But How Does It Join On?" in Freeman and Cox, *Visual Order*, p. 280.

42 trying to expand their visual vocabulary: Mortensen, *Form and Content*, pp. 20–22; Fenson, "Transition," p. 383.

42 stick figures: Kellogg and O'Dell, *Psychology of Children's Art*, p. 87.

42 disapproval from adults: Ibid.; Allik and Laak, "Head Is Smaller," p. 280.

42 feeling their own disapproval: Allik and Laak, "Head Is Smaller," p. 280.

42 Monet . . . wished he had been born blind: Quoted in Semir Zeki, "Art and the Brain," *Journal of Consciousness Studies* 6, no. 6 (1999): 82.

43 Matisse: Flam, *Matisse on Art*, p. 148.

43 most children find language more effective: Edwards, *Right Side of the Brain*, p. 76; Mortensen, *Form and Content*, pp. 20–22.

43 nearly half of our cerebral cortices: Christof Koch, "The Role of Single Neurons in Information Processing," *Nature Neuroscience* 3, no. 9 (2000): 45–46.

43 the brain lateralizes: Mortensen, *Form and Content*, pp. 20–21; Edwards, *Right Side of the Brain*, pp. 65–76.

44 drawing identifying tools or uniforms: Fenson, "Transition," pp. 374–80.

44 Girls mature earlier: Mortensen, *Form and Content*, pp. 222–340.

45 Rubens: Simon Schama, *Rembrandt's Eyes* (New York: Knopf, 1999), p. 78.

46 Solso: Solso, *Cognition and Visual Arts*, p. 235.

46 picture of a horse: Ibid., p. 240.

46 Zeki: Zeki, "Art and the Brain," pp. 76–96.

47 Edwards: Edwards, *Right Side of the Brain*.

47 Nicolaïdes: Kimon Nicolaïdes, *The Natural Way to Draw: A Working Plan for Art Study* (Boston: Houghton Mifflin, 1941), quoted ibid., p. 82.

47 Ruskin: John Ruskin, *The Elements of Drawing: In Three Letters to Beginners* (New York: John Wiley and Sons, 1877).

47 Speed: Harold Speed, *The Practice and Science of Drawing* (1917; New York: Dover Publications, 1972), p. 47.

48 Nadia: Lorna Selfe, "Anomalous Drawing Development: Some Clinical Studies," in Freeman and Cox, *Visual Order*, pp. 135–55; also discussed in Nicholas Humphrey, "Cave Art, Autism and the Evolution of the Human Mind," *Journal of Consciousness Studies* 6, no. 6 (1999): 116–43.

48 walls of Lascaux and other Stone Age sites: Humphrey, "Cave Art."

48 requires the ability to separate a figure: Francis Pratt, "A Perspective on Traditional Artistic Practices," in Freeman and Cox, *Visual Order*, pp. 32–55.

49 brain activities involved in drawing: Ibid., p. 35.

49 color being seen before form: Zeki, "Art and the Brain," pp. 76–96; Kenneth Beittel, *Mind and Context in the Art of Drawing: An Empirical and Speculative Account of the Drawing Process and the Drawing Series and of the Contexts in Which They Occur* (New York: Holt, Rinehart, and Winston, 1972), p. 49.

50 Beittel: Beittel, *Mind and Context*, p. 49.

50 Hill: Hill, *Language of Drawing*, p. 82.

50 Collingwood: R. G. Collingwood: Quoted in Beittel, *Mind and Context*, p. 120.

51 Valéry: Valéry, *Degas, Dance, Drawing*, p. 37.

51 Pratt: Pratt, "Traditional Artistic Practices," pp. 50–52.

52 Saccadic movement: Ibid.; David Nation and Lawrence Stark, "Eye Movement and Visual Perception," *Scientific American* 224 (1971): 34–43.

52 Whistler put the model: Winston Churchill, "Painting as a Pastime," in *Amid These Storms* (New York: Scribners, 1932), p. 318.

52 Nicolaïdes: Nicolaïdes, *Natural Way to Draw*, p. 41.

52 Delacroix: Baudelaire quoted by Matisse in Flam, *Matisse on Art*, p. 54.

52 An artist draws . . . to amass a brain record: Zeki, "Art and the Brain," pp. 76–96.

54 Van Sommers: Van Sommers, *Drawing and Cognition*, p. 246.

54 Humphrey Ocean: Robert Solso, "Brain Activities in a Skilled Versus a Novice Artist: An fMRI Study," *Leonardo* 34, no. 1 (2001): 31–34.

55 Matisse: Flam, *Matisse on Art*, pp. 77, 82.

56 Valéry: Valéry, *Degas, Dance, Drawing*, p. 66.

56 Degas: Götz Adriani, *Edgar Degas: Pastels, Oil Sketches, Drawings* (New York: Abbeville Press, 1985), p. 98.

CHAPTER FOUR

Connecting

59 Ruskin: Quoted in Wolfgang Kemp, *The Desire of My Eyes: The Life and Work of John Ruskin* (New York: Farrar, Straus and Giroux, 1990), pp. 20, 41, 17.

66 Matisse: Flam, *Matisse on Art*, p. 51.

66 "It is harder to see": Robert Henri, *The Art Spirit* (New York: Harper and Row, 1984), p. 87.

67 "The sketch hunter": Ibid., p. 17.

67 Van Gogh: Pierre Seghers, ed., *The Art of Painting from the Baroque Through Postimpressionism* (New York: Hawthorn Books, 1964), p. 287.

67 Beston: Henry Beston, *The Outermost House: A Year of Life on the*

Great Beach of Cape Cod (Garden City, N.Y.: Doubleday, 1928), p. 25.

68 Audubon: John James Audubon, *My Style of Drawing Birds* (Ardsley, N.Y.: Overland Press/Hayden Foundation, 1979), pp. 15, 17, 25.

69 Ruskin: Ruskin, *Elements of Drawing*, pp. 46, xi.

CHAPTER FIVE

Why the Figure?

73 Babies only a few minutes old: Daniel McNeill, *The Face* (Boston: Little, Brown, 1998), p. 8.

73 Within hours of birth: Ibid., p. 4.

73 brain cells dedicated to envisioning the human face: Ibid., p. 87.

73 Perrett: David Perrett et al., "Functional Organization of Visual Neurons Processing Face Identity," in Hayden D. Ellis et al., eds., *Aspects of Face Identity* (Boston: Martinus Nijhoff, NATO Scientific Affairs Division, 1986), pp. 187–98.

74 Jays respond: Bossema and Burgler (1980), cited in Vicki Bruce and Patrick Green, *Visual Perception, Physiology, Psychology and Ecology* (London: Lawrence Erlbaum, 1990), p. 346.

74 Johansson: Cited in Bruce and Green, *Visual Perception*, p. 327. Original paper is Gunnar Johansson, "Visual Perception of Biological Motion," *Perception and Psychophysics* 14 (1973): 201–11.

74 Subsequent studies: J. E. Cutting and Kozlowski (1977), cited in Bruce and Green, *Visual Perception*, p. 329.

75 Patients with damage to the amygdala: Ralph Adolphs, "Neural Systems for Recognizing Emotion," *Current Opinion in Neurobiology* 12 (2002): 169–77, and "Impaired Recognition of Emotion in Facial Expressions Following Bilateral Damage to the Human Amygdala," *Nature* 72, no. 6 (1994): 669–72.

75 Rizzolatti and other Italian researchers: Giacomo Rizzolatti, "Premotor Cortex and the Recognition of Motor Action," *Cognitive Brain Research*, no. 3 (1996): 131–34; Vittorio Gallese, Luciano Fadiga, Leonardo Fogassi and Giacomo Rizzolatti, "Action Recognition in the Premotor Cortex," *Brain* 119 (1996): 593–609; Ralph Adolphs, Hanna Damasio, Daniel Tranel, Greg Cooper and Antonio R. Damasio, "A Role for Somatosensory Cortices in the Visual Recognition of Emotion as Revealed by Three-Dimensional Lesion Mapping," *Journal of Neuroscience* 20, no. 7 (April 1, 2000): 2683–90.

76 increase of motor evoked potentials . . . PET scans: Gallese et al., "Action Recognition," p. 606.

77 About 5 percent of patients whose right-hemisphere strokes: V. S. Ramachandran, "Mirror Neurons and Imitation Learning as the Driving Force Behind the Great Leap Forward in Human Evolution," a talk given before the Society for Neuroscience in 1998, online at www.edge.org.

77 infants will look less at faces: T. M. Field, R. Woodson, R. Greenberg and D. Cohen, "Discrimination and Imitation of Facial Expressions by Neonates," *Science* 281, no. 4568 (1982): 179–81.

77 newborn babies will imitate facial expressions: A. N. Meltzoff and M. K. Moore, "Imitation of Facial and Manual Gestures by Human Neonates," *Science* 198, no. 4312 (1977): 75–78.

77 Adolphs: Ralph Adolphs, "A Role for Somatosensory Cortices in the Visual Recognition of Emotion," *Journal of Neuroscience* 20, no. 7 (2000): 2683–90.

77 forty-three facial muscles: McNeill, *Face*, p. 178.

78 Ekman . . . ten thousand different facial expressions: Julian Guthrie, "The Lie Detector: S. F. Psychologist Has Made a Science of Reading Facial Expressions," *San Francisco Chronicle*, Sept. 16, 2002, p. A6 (McNeill, *Face*, estimates six thousand); compare also Paul Ekman, "Facial Expressions," in T. Dalgleish and M. Power, eds., *Handbook of Cognition and Emotion* (New York: John Wiley, 1999).

78 woman who has wide cheekbones, narrow cheeks: McNeill, *Face*, p. 338.

79 Chimpanzees and orangutans: Ibid., p. 113.

80 oldest-known human portrait: Ibid., p. 117.

82 Pliny: K. Jex-Blake, trans., *The Elder Pliny's Chapters on the History of Art* (Chicago: Argonaut, 1968); Muriel Segal, *Painted Ladies: Models of the Great Artists* (New York: Stein and Day, 1972); and C. J. Bulliet, *The Courtezan Olympia: An Intimate Survey of Artists and Their Mistresses* (New York: Corici Frieden, 1930).

83 Greek depictions of Apollo: Kenneth Clark, *The Nude: A Study in Ideal Form* (Princeton, N.J.: Princeton University Press, 1956), p. 42.

83 Aphrodite was seven heads tall: Ibid., p. 75.

84 Dürer: Conway, *Writings of Albrecht Dürer:* Adam and Eve, p. 166; "devilish sorcery," p. 177; "sight of a fine human figure," p. 179; "liveth no man," p. 179; "God only knoweth," p. 152.

84 Leonardo: Frances Ames Lewis, *Drawing in Early Renaissance Italy* (New Haven, Conn.: Yale University Press, 1981), p. 114.

84 Alberti: Ibid., p. 9; Gill Saunders, *The Nude: A New Perspective* (New York: Harper and Row, 1989).

85 Leonardo kept cadavers: Segal, *Painted Ladies*, p. 50.

85 Michelangelo's figures of Night and Dawn: Saunders, *Nude*, p. 81.

85 The nude survived in the Renaissance: Clark, *Nude*, pp. 231–37.

86 curve of Aphrodite's hip, . . . curve of the stomach: Ibid., p. 318.

87 Pre-Raphaelite painters: Martin Postle and William Vaughan, *The Artist's Model from Etty to Spencer* (London: Merrell Holberton, 1999), p. 79.

87 Courbet's *The Artist's Studio:* The phrase "a real allegory" was the painting's subtitle. Sarah Faunce and Linda Nochlin, *Courbet Reconsidered* (Brooklyn: The Brooklyn Museum, 1988), p. 17.

87 Ingres's *La Source:* Tate Museum, Exposed: The Victorian Nude, an exhibition at the Tate Britain, London (text was online at www.tate.org.uk/britain/exhibitions/vicnude in September 2002).

88 the camera: Beaumont Newhall, *The History of Photography* (New York: Museum of Modern Art, 1964), pp. 1–66.

88 Leonardo: David Hockney, *Secret Knowledge: Rediscovery of the Lost Techniques of the Old Masters* (New York: Viking Studio, 2001), p. 206.

89 Talbot: Ibid., p. 34.

89 Daguerre: Ibid.

89 eighty-six portrait studios: Ibid., p. 26.

90 Actors and actresses routinely posed: Newhall, *History of Photography*, p. 57.

91 An artist is present in a drawing: American artist Charles Sheeler, who worked in both mediums, wrote: "Photography is nature seen from the eyes outward, painting from the eyes inward. Photography records unalterably the single image, while painting records a plurality of images willfully directed by the artist." Quoted in Deborah Weisgall, "To Paint or Photograph?" *New York Times*, July 27, 2003, sec. 4, p. 27.

92 Arnheim: Rudolf Arnheim, *Art and Visual Perception: A Psychology of the Creative Eye* (Berkeley: University of California Press, 1969), p. 433.

92 Hill: Hill, *Language of Drawing*, p. 82.

92 Valéry: Valéry, *Degas, Dance, Drawing*, pp. 197–99.

CHAPTER SIX

Faces

98 Van Gogh: Ronald de Leeuw, ed., *The Letters of Vincent van Gogh* (London: Allen Lane, Penguin Press, 1996), pp. 312, 492.

99 Ingres: Seghers, *Art of Painting*, p. 138.

100 Leonardo: Jean Paul Richter, ed., *The Notebooks of Leonardo da Vinci* (New York: Dover, 1970), vol. 1, p. 338; Martin Kemp, *Leonardo on Painting* (New Haven, Conn.: Yale University Press, 1989), p. 199.

102 Van Gogh: De Leeuw, *Letters of van Gogh*, pp. 472, 474, 486.

103 Eye behavior: Marjorie Fink Vargas, *Louder Than Words: An Introduction to Non-verbal Behavior* (Ames: University of Iowa Press, 1986); Patricia Webbink, *The Power of the Eyes* (New York: Springer Publishing, 1986).

104 Matisse: Flam, *Matisse on Art*, pp. 51, 54.

106 Bonnard: Segal, *Painted Ladies*, p. 158.

CHAPTER SEVEN

What Happened to the Models?

112 Martinez: Janet Martinez made the video as a student at the University of California, Berkeley.

113 Victor Hugo: Segal, *Painted Ladies*, p. 135.

113 Voltaire: France Borel, *The Seduction of Venus: Artists and Models* (New York: Rizzoli, 1990).

113 Caterina, Louise O'Murphy: Segal, *Painted Ladies*, p. 89.

113 nude female models employed at the British Royal Academy: Ilaria Bignamini and Martin Postle, *The Artist's Model: Its Role in British Art from Lely to Etty* (Nottingham, U.K.: Nottingham University Art Gallery, 1991), p. 19; David Manning, *Sir Joshua Reynolds: A Complete Catalogue of His Paintings* (New Haven, Conn.: Yale University Press, 2000), vol. 1, p. 553.

114 Romney: Bignamini and Postle, *Artist's Model*, p. 75.

114 Joshua Reynolds was criticized: Ibid.

114 Simonetta Cattaneo, Duchess of Urbino: Segal, *Painted Ladies*, pp. 29, 60.

114　Helene Fourment, Rembrandt's wife: Ibid., pp. 73, 80–81.

114　Clark: Clark, *Nude*, p. 8.

114　academies: Bignamini and Postle, *Artist's Model*, p. 9.

115　Nude female models were forbidden: Ibid., p. 12.

115　Royal Academy: Ibid., p. 18.

115　Rembrandt was criticized: Ibid.

115　Drawing and painting had been considered genteel occupations: Ann Bermingham, *Learning to Draw: Studies in the Cultural History of a Political and Useful Art* (New Haven, Conn.: Yale University Press, 1999).

115　Siddal: Postle and Vaughan, *Artist's Model*, p. 79.

115　Miller: Segal, *Painted Ladies*, p. 114.

115　Cornforth: Postle and Vaughan, *Artist's Model*, p. 80.

116　English schools forbade students to speak: Ibid., p. 10.

116　separate entrances and staircases: Ibid., p. 59.

116　Académie Julian: Ibid., p. 35.

116　Contagious Disease Acts: Ibid., p. 12.

116　law forbidding government funding, Manchester School of Design, Slade School of Fine Art: Ibid.

116　models might act as as muses: Ibid., p. 79.

117　Burne-Jones: Ibid., p. 56.

117　Whistler and Tissot: Ibid.

117　Rossetti, Siddal: Ibid., p. 80.

117　Miller had affairs: Ibid., p. 88.

117　Lillie Langtry: Segal, *Painted Ladies*, p. 153.

117　Rossetti . . . declared that all models were whores: Ibid., p. 108.

117　Place Pigalle: Ibid., p. 133.

117　Cafe Royale in Regent Street: Postle and Vaughan, *Artist's Model*, p. 83.

117　By the 1860s female students: Segal, *Painted Ladies*, p. 133.

118　Italian models: Ibid., p. 83.

118　Artist Model's Association: Ibid., p. 18.

118　Marguerite Kelsey: Ibid., p. 84.

118　Meurend: Eunice Lipton, *Alias Olympia* (New York: Meridian Books, 1994).

118　Picasso's model-mistresses: See, for example, Fernande Olivier, *Loving Picasso: The Private Journal of Fernande Olivier* (New York: Abrams, 2001).

118　National Academy of Design: Smithsonian Institution Archives of Art, *Artists and Models* (Washington, D.C., 1975).

118 Eakins: Lloyd Goodrich, *Thomas Eakins* (Cambridge, Mass.: Harvard University Press, 1982).

119 Munson: See Diane Rozas and Anita Bourne Gottehrer, *American Venus* (Los Angeles: Balcony Press, 1999).

120 Sloan: Smithsonian Institution Archives of Art, *Artists and Models*, p. 27.

122 more than two hundred thousand commercial pornography sites: Michael Kirk and Peter J. Boyer, "American Porn," *Frontline*, WGBH Boston, February 7, 2002. (A review of this television program is in Caryn James, "Assessing Pornography, Brashly but Gingerly," *New York Times*, February 7, 2002.)

122 Kaiser Family Foundation study: Cited in the *New York Times*, July 27, 2003, sec. 4, p. 1.

122 Lodgenet in Hyatt and Marriott hotels, General Motors and AT&T: Kirk and Boyer, "American Porn."

123 Florence Allen: Details from various clips from San Francisco newspapers and documents on file under her name at the Smithsonian Archives of American Art.

124 "to select, train and supervise": The quote is from an unnamed, undated San Francisco newspaper article, apparently paraphrasing Florence Allen in the 1960s.

127 only metropolitan area . . . to support an artist models' guild: In 2002 David Quammen, a political organizer who took up modeling, started the Figure Models' Guild in Washington, D.C. It was not a labor exchange like the San Francisco guilds, but an effort to professionalize D.C.-area models. At monthly meetings, members welcome anyone interested in becoming a model, talk about modeling and share their experience by posing for artists, who are invited to come to draw for free. Quammen compiles a directory of models who seem enthusiastic and reliable, and he shares it with artists he knows and trusts. The artists may then contract privately with the models.

CHAPTER EIGHT

Working Naked

140 Fisher: Quoted in Mortensen, *Form and Content*, p. 238, citing Seymour Fisher, *Development and Structure of the Body Image* (Hillsdale, N.J.: Lawrence Erlbaum, 1986), p. 39.

140 ideal body form, *Glamour* magazine survey: Liz Dittrich, Ph.D.,

"About-Face Facts on Body Image," www.about-face.org/r/facts/bi/html. See also L. M. Mellin, S. Scully and C. E. Irwin, "Disordered Eating Characteristics in Pre-Adolescent Girls," Abstract, Meeting of the American Dietetic Association, Las Vegas, 1986; Alfred C. Kinsey, *The Sexual Behavior of the Human Female* (Philadelphia: Saunders, 1953).

144 Carla Kandinsky writes poetry about the experience of modeling: Carla Kandinsky, *Nekkid ladies, plumbers and other people* (St. Paul, Calif.: Immaculate Conception Janitorial Services, 1979).

CHAPTER NINE

Waiting for a Muse

150 Van Gogh: de Leeuw, *Letters of Van Gogh*, p. 203.

153 Newberg: Andrew Newberg, *Why God Won't Go Away* (New York: Ballantine, 2001).

153 Csikszentmihalyi: Mihaly Csikszentmihalyi, *Flow: The Psychology of Optimal Experience* (New York: Harper and Row, 1990), p. 71.

CHAPTER TEN

Drawing Like Bargue

166 Van Gogh copied the drawings: Albert Boime, "The Teaching of Fine Art and the Avant-garde in France During the Second Half of the Nineteenth Century," *Arts Magazine* 60 (Dec. 1985): 53.

170 Kant: Discussed in Herbert Marcuse, *Eros and Creativity* (Boston: Beacon Press, 1966).

170 Greenberg: Quoted in Florence Rubenfeld, *Clement Greenberg: A Life* (New York: Scribners, 1997), p. 55.

171 Matisse, *The Joy of Life;* Picasso, *Demoiselles d'Avignon:* Leo Steinberg, *Other Criteria: Confrontations with Twentieth-Century Art* (London: Oxford University Press, 1972), p. 4.

171 U.S. Customs Service: Rubenfeld, *Clement Greenberg*, p. 54.

171 "lost its power to communicate": Ibid., pp. 56–59.

171 *Partisan Review:* Ibid., pp. 47–67.

171 "its inability to be spontaneous": Ibid., p. 77.

172 Corbett: Quoted in Susan Landauer, *The San Francisco School of*

Abstract Expressionism (Berkeley and Los Angeles: University of California Press, 1996), p. 62.

172 Still: Quoted ibid., p. 64.

172 Greenberg . . . is vilified for his totalitarian views: Rubenfeld, *Clement Greenberg*, pp. 224–27.

172 "I think it one of the tragedies": Ibid., pp. 108–9.

172 "the most ambitious and effective pictorial art": Ibid., p. 76.

173 "The naturalistic art of our time": Ibid., p. 109.

173 *Life* magazine: Ibid.

173 Steinberg: Steinberg, *Other Criteria*, pp. 4–10.

173 Gottlieb . . . declared, "Representational painting today serves no social function": Selden Rodman, *Conversations with Artists* (New York: Capricorn Books, 1961), p. 91.

173 "the average man": Ibid., p. 90.

173 De Kooning: Ibid., p. 101.

174 Smith: Ibid., p. 128.

174 Perlin: Ibid., p. 186.

174 "the associative encumbrances": De Kooning quoted in Caroline A. Jones, *Bay Area Figurative Art, 1950–1965* (Berkeley: University of California Press, 1990), p. 5.

174 Lee Krasner recalled in a documentary film: *Jackson Pollock: Love and Death on Long Island*, BBC documentary, produced by Teresa Griffiths, 1999.

174 Landauer: Landauer, *San Francisco School*, pp. 14–15.

175 *Art Digest:* Ibid., p. 31.

175 MacAgy: Jones, *Bay Area*, pp. 5–6.

175 Still: Landauer, *San Francisco School*, p. 66.

175 "I am not interested in illustrating my time": Still quoted in Thomas Kellein, *Clyfford Still, 1904–1980* (Munich: Prestel Verlag, 1992), pp. 162, 94.

177 Bischoff and Diebenkorn: Jones, *Bay Area*, pp. 25–27.

178 Tooker: Quoted in Rodman, *Conversations with Artists*, p. 209.

179 Wolfe: Tom Wolfe, *The Painted Word* (New York: Farrar, Straus and Giroux, 1975).

179 Steinberg: Steinberg, *Other Criteria*, p. 10.

179 brain areas: Edwards, *Right Side of the Brain;* Zeki, "Art and the Brain"; Solso, *Cognition and Visual Arts*, pp. 42–43.

180 Zeki: Zeki, "Art and the Brain," pp. 76–96.

182 Malcolm: Blake Eskin, "A Journalist Learns Art Can Be Fast but Hard to Fasten," *New York Times*, Jan. 20, 2002.

CHAPTER ELEVEN

Desire

189 Hill: Hill, *Language of Drawing*, p. 117.

193 Freud: Jack Spector, *The Aesthetics of Freud* (New York: Praeger, 1973), p. 215.

193 Clark: Clark, *Nude*, p. 8.

194 artistic creation had been thought of as akin to dreaming: Ibid., pp. 92–93.

195 Bell: Ibid., p. 105.

195 Kris: Ibid., p. 107.

195 Fry: Ibid., p. 98.

195 Read: Ibid., p. 109.

196 "The emotional interest aroused in me": Flam, *Matisse on Art*, p. 82.

197 "Feeling is an enemy": Ibid., p. 104.

197 Marcuse: Marcuse, *Eros and Creativity*, p. 171.

198 Kant: Ibid.

CHAPTER TWELVE

Pictures

202 Lucian Freud: William Feaver, *Lucian Freud* (London: Tate Publishing Company, 2002), p. 38.

202 Bacon: Ibid.

202 Raphael: Roger Jones and Nicholas Penny, *Raphael* (New Haven, Conn.: Yale University Press, 1983).

204 Delacroix: Seghers, *Art of Painting*, p. 200.

207 Matisse: Flam, *Matisse on Art*, p. 66.

209 Ruskin: Ruskin, *Elements of Drawing*, pp. 167, 169.

210 Delacroix: Seghers, *Art of Painting*, pp. 203–6, 159.

211 Ingres: Ibid., p. 139.

211 Renoir: Ibid., pp. 269–70.

211 Degas: Ibid., p. 315.

211 Ruskin: Ruskin, *Elements of Drawing*, p. 169.

212 Rodin: Seghers, *Art of Painting*, p. 322.

212 Van Gogh: De Leeuw, *Letters of van Gogh*, p. 150.

CHAPTER THIRTEEN

Ambition

217 Falling back on teaching is a declining prospect: Diane C. Ellis and John C. Beresford, "Trends in Artist Occupations 1970–90" (Research Division Report no. 29, August 1992); National Endowment for the Arts, "Artist Employment in 2001," Research Note no. 80 (May 2002), p. 9.

217 career guide: *Career Information Center,* vol. 2, Communication and the Arts (MacMillan Reference, 1999), p. 13.

228 Ingres: Seghers, *Art of Painting,* p. 134.

228 Van Gogh: Ibid., p. 286.

CHAPTER FOURTEEN

Dispersers

232 Van Gogh: De Leeuw, *Letters of van Gogh,* p. 81.

236 Leonardo, Dürer, Whistler, Audubon, Pollock: Jane Turner, *The Dictionary of Art* (New York: Grove Press, 1996).

236 Raphael: Jones and Penny, *Raphael,* p. 21.

236 Delacroix: Walter Pach, trans., *The Journal of Eugène Delacroix* (New York: Grove Press, 1961), pp. 100–124.

236 Van Gogh: De Leeuw, *Letters of van Gogh,* pp. 53–54, 55, 66, 67, 68.

Drawings

70 Fred Dalkey, "Diane Observing," sanguine conte crayon. Copyright © 2003 by Fred Dalkey. Courtesy of the artist and Paul Thiebaud Gallery, San Francisco.

76 Leonardo da Vinci, "Studies of Hands for the Uffizi Adoration," metalpoint on reddish prepared paper. Windsor Castle RL 12616. The Royal Collection copyright © 2003, Her Majesty Queen Elizabeth II.

88 Margaret Wade, "Cynthia," graphite. Copyright © 2003 by Margaret Wade. Courtesy of the artist.

96 Margaret Wade, "Merav," graphite. Copyright © 2003 by Margaret Wade. Courtesy of the artist.

101 Michael Markowitz, "Untitled," charcoal. Copyright © 2003 by Michael Markowitz. Courtesy of the artist.

108 Thomas Eakins, "Seated Nude Woman Wearing a Mask," 1863–66, charcoal and black crayon. Philadelphia Museum of Art: Gift of Mrs. Thomas Eakins and Miss Mary Adeline Williams.

125 Eleanor Dickinson, "Florence Allen," pen and ink. Copyright © 2003 by Eleanor Dickinson. Courtesy of the artist.

130 Robert Schultz, "Ascending," graphite. Copyright © 2003 by Robert Schultz. From the collection of James Landé, Washington, D.C.

141 Richard Diebenkorn, "Untitled (Carla Kandinsky, 1963)," ink on paper. Copyright © 2003, the Estate of Richard Diebenkorn. Phyllis Diebenkorn, Trustee.

148 Ann Curran Turner, "Merav," pen and ink. Copyright © 2003 by Ann Curran Turner. Courtesy of the artist.

155 Henri Matisse, "Reclining Nude with Arm Behind Head," 1937, charcoal. The Baltimore Museum of Art, The Cone Collection, formed by Dr. Claribel Cone and Miss Etta Cone of Baltimore, Maryland (BMA 1950.12.50). Copyright © 2004, Succession H. Matisse, Paris/Artists Rights Society (ARS), New York.

164 Andy Ameral, "Untitled," graphite. Copyright © 2003 by Andy Ameral. Collection of Bruce Wolfe. Courtesy of Andy Ameral and Bruce Wolfe.

168 Charles Bargue, "Male Torso Viewed from Behind—
Antique," lithograph. From Charles Bargue, *Cours de Desin*,
vol. 1 (modéles d'après le bosse), pl. 56, 1868. Impression
avant la lettre. Inv. 90.1.1.636 (1), Musée Goupil: Direction
des Etablissements culturels de Bordeaux. Copyright ©
Cliché Goupil Bordeaux.

186 John Goodman, "Phaedra," graphite. Copyright © 2003 by
John Goodman. Courtesy of the artist.

194 Pablo Picasso, "The Artist and His Model," Chinese crayon
on paper. (Musée Picasso, Paris, accession number
MP1050.) Photo: Réunion des Musées Nationaux and Art
Resources, New York. Copyright © 2004 Estate of Pablo
Picasso/Artists Rights Society (ARS), New York.

200 Marguerite Fletcher, "In My Father's Garden," charcoal.
Copyright © 2003 by Marguerite Fletcher. Courtesy of the
artist.

204 Kent Bellows, "Self-Portrait with Wine Glass (Gluttony,
Study, 2000)," pastel and charcoal. Copyright © Kent
Bellows. Courtesy of Forum Gallery, New York.

214 Richard Elmore, "Front Entrance," pencil, marking pen on
paper. Copyright © 2003 by Richard Elmore. Courtesy of
the artist.

223 Richard Elmore, "Self-Portrait with Sarah" pen and ink.
Copyright © 2003 by Richard Elmore. Courtesy of the
artist.

230 Richard Gayton, "Mitchell Canyon, Mt. Diablo," pencil and
wash. Copyright © 2003 by Richard Gayton. Courtesy of
the artist.

237 Vincent van Gogh, "Starry Night with Cypress," ink on
paper. Kunsthalle Bremen, inventory number 18/52 (lost
during Second World War). Courtesy Kunsthalle Bremen.

Acknowledgments

I would like to express my gratitude to the following people whose assistance made this book possible. Artists Ann Curran Turner, John Goodman, Eleanor Dickinson, Henry Bridges, Marguerite Fletcher, Richard Elmore, Jenny Keller, Chick Takaha, Bill Brown, Nathan Oliveira, Michael Markowitz, Bruce Wolfe, Richard Gayton and Minerva Durham generously contributed their insight and experience. Models Carla Kandinsky, Barbara Tooma, Stephanie Caloia, Ginger Dunphy, Merav Tzur, Phaedra Jarrett, Ashley Hayes, Ogden Newton, Sterling Hoffmann, Tracy Curtis, Semberlyn Crossley, Marianne Lucchesi, Molly Barrons, Joan Carson and Shifra Gassner shared with me their pain and their pride, their wit and wisdom. Gallery owners Charles Campbell, Allan Stone and John Berggruen liberally opened up their considerable treasure of experience. Thanks to artist/model Dick Damian, who several years ago urged me to write about models. Thanks also to historian Gerald Ackerman and artist Henry Mobley, who helped me to locate drawings, and to Ronald Hurl, who read files for me at the Smithsonian Institution in Washington, D.C. Thanks as well to Palo Alto designer Michael Parsons for his advice and skill in Adobe Photoshop, and to Kang Le of Jungle Copy for his assistance in scanning drawings for reproduction. I am indebted to my editor, Robin Desser, for her care and enthusiasm, and to her able assistants, Margaux Wexberg and Diana Tejerina. Never last nor least, thanks to my wife, Judy, who listened patiently and skeptically to hours of speculative babble, scowled freely and tried, as always, to keep me honest.

Peter Steinhart

DECEMBER 2003